STENDHAL

AND THE ARTS

I have written the lives of several great men: Mozart, Rossini, Michelangelo, Leonardo da Vinci. This was the kind of work I enjoyed best. I no longer have enough patience to search out documents and weigh contradictory evidence, and so I have decided to write the biography of a person whose life I know down to the smallest detail. Unfortunately nobody has heard of this person, for it is myself.

I was born in Grenoble on 23 January 1783 . . .

STENDHAL, *Essais d'Autobiographie*, II, 1813

STENDHAL
AND THE ARTS

SELECTED & EDITED BY
DAVID WAKEFIELD

PHAIDON

Phaidon Press Limited, 5 Cromwell Place, London SW7

Published in the United States of America by Phaidon Publishers, Inc.
and distributed by Praeger Publishers, Inc.
111 Fourth Avenue, New York, N.Y. 10003

First published 1973
All rights reserved

ISBN 0 7148 1554 3
Library of Congress Catalog Card Number: 72–86574

Printed in Great Britain
Text printed by Western Printing Services Ltd, Bristol
Plates printed by The Pitman Press, Bath

Contents

Preface

The choice of texts to be translated was an extremely difficult one. On the one hand I have tried to present Stendhal's art-criticism in its scope and variety, but on the other I wanted to offer the texts in a reasonably complete form. The result is a compromise, and in view of the sheer volume of Stendhal's writing on the fine arts alone, some mutilation was inevitable. As a guide to the reader who might like to refer to the original French, the solution I have adopted is to present roughly one third of the *Histoire de la Peinture en Italie*, giving chapter headings, and nearly half of the *Salon of 1824*; with the latter I have selected Stendhal's passages on the most prominent pictures, or those comments which seemed particularly interesting. The two final sections, quoting some of Stendhal's opinions on his fellow critics and art-historians, and passages from his travel literature, are shorter and intended as light relief. For reasons of space, I have regrettably been unable to include the essay *Des beaux-arts et du caractère français*, or anything from the *Écoles italiennes de peinture*, even though both contain much excellent material. The important pamphlet *Racine et Shakespeare* is available in an English translation, as are the two novels, *Le Rouge et le Noir* and *La Chartreuse de Parme*.

The footnotes to the text of the *Histoire de la Peinture en Italie* are Stendhal's own. Most of the titles of chapter headings are Stendhal's, but in cases where they are so cryptic as to be unintelligible, I have slightly altered or amplified them.

I should like to express my gratitude to Dr Anita Brookner, of the Courtauld Institute of Art, to whose teaching and recently published book, *The Genius of the Future* (Phaidon, 1971), the present work owes a great deal; to Professor Francis Haskell, of Oxford University, for his friendly help and patience in dealing with persistent enquiries, and for allowing me free access to his departmental library, indispensable to any student of the nineteenth century; and to Christopher Wright, of the Witt Library, for his help in the difficult matter of obtaining photographs.

Paris, March 1973 D.W.

List of Illustrations

1 Introduction

STENDHAL AS A NOVELIST is too familiar a figure to need much introduction. *Le Rouge et le Noir* and *La Chartreuse de Parme*, after the relative obscurity which hung over them during the author's lifetime, have finally emerged from neglect and become nearly household words. They have amply fulfilled Stendhal's prediction that he would be better appreciated by the twentieth century than by his own contemporaries. And yet despite this rediscovery of his fiction, a substantial part of his writing remains unaccountably overlooked by all but the most fanatical *Stendhaliens*. This is true of his other essays in fiction, notably *Armance* and *Lucien Leuwen* (unfinished), and also of a vast corpus of critical writing, literary, dramatic, political and aesthetic, in addition to works of history and biography, several autobiographical essays and a voluminous correspondence. Fiction counts for only a fairly small part of his total output and was perhaps not even his primary concern. Stendhal was first of all a critic and intellectual, who turned his hand to writing novels relatively late in life. *Le Rouge et le Noir* appeared in 1830, when the author was already forty-seven and had a considerable amount of other writing behind him. The art-criticism to which this book is mainly devoted belongs to the early period of his intellectual fermentation, when his mind was still in the process of being formed.

The *Histoire de la Peinture en Italie*, begun in 1811 and finished in 1817, made an important contribution to early nineteenth-century critical theory, while the *Salon of 1824* represents Stendhal's personal contribution to the crucial years of French Romanticism in painting. The writing on the fine arts shows us another aspect of this multi-faceted man, who always had an opinion on everything, and could never resist the pleasure of stating his views in the most candid and often truculent terms. The value of Stendhal's criticism is still open to debate. The professional art-critics of his own time, including E.-J. Delécluze and Prosper Mérimée, tended to rate it low, while more recently Bernard Berenson took him to task for his failure to distinguish between art and real life.[1] The injustice of this kind of partial appraisal, and the positive value of Stendhal's criticism should become apparent later, but for the moment it should be said that Stendhal never claimed to be a specialist's critic, but rather a spokesman for the ordinary man of taste. He is an amateur in the best sense of the term,

standing for the common spectator's right to express his own views. Although Stendhal believed that painting as an art demands a special initiation, at the same time he treats it as a medium of expression with a human core common to the other arts which makes it immediately and universally intelligible, if read correctly. That is why Stendhal goes straight for the psychological or dramatic content of a painting, this being the obvious common ground for an appreciation of art. This consistent emphasis on the subject-matter, with only a secondary attention given to the medium, may partly explain why Stendhal has not been taken seriously as a critic. Mérimée formulated the charge against Stendhal:

> He remains, however, very French in his views on painting, even though he claims to judge it as an Italian. He appreciates the Masters with French ideas, that is, from a literary point of view. The pictures of the Italian schools are analysed by him as if they were dramas. This is still the way of judging art in France, where there is neither feeling for form nor an innate taste for colour. You need a special sensibility and prolonged practice in order to love form and colour. Beyle [Stendhal] endows a Raphael Virgin with the emotions of drama.[2]

These criticisms carry some weight, but they need not be taken in too hostile a sense. Stendhal might well have replied that the dramatic and literary points of view were the best from which to consider painting. Whether we agree or not, we are always aware with Stendhal that his opinions are those of an intelligent and well-informed man.

In addition to its biographical interest, Stendhal's art-criticism has the historical value of a contemporary witness to a particularly interesting phase of French literary and artistic evolution. Between 1820 and 1830 the Romantic movement emerged triumphant in all genres, and Stendhal was actively engaged in the polemics and aesthetic debates of the period. He repeatedly advocated the need for new art forms to suit a new post-Revolutionary era, and even if he was not entirely certain of the direction painting ought to take, he saw the absurdity of trying to perpetuate outmoded forms in the name of tradition. Like most of the other French art-critics from Diderot to Zola, Stendhal was always on the look-out for the

2

great artist of the age, although his expectations were never altogether fulfilled.

Of all the major writers, Stendhal was one of the most obsessed with his own biography and the definition of his own personality. His various attempts at autobiography—*La Vie de Henry Brulard*, which covers the first part of his life in Grenoble, then the *Journal*, taking the story up to 1818, and finally the *Souvenirs d'Égotisme*, as well as several fragments— all testify to this passion. The opening chapter of *La Vie de Henry Brulard* tells how the author paused sadly on the steps outside St Peter's in Rome and mused on the problem of his own identity: 'I shall soon be fifty and it will be high time I knew myself. Who was I, what am I? I should really find it very hard to say.'[3]

If this metaphysical problem remains unsolved, fortunately the facts of Stendhal's life are relatively clear. Stendhal, whose real name was Henri Beyle, was born in Grenoble in 1783 into a well-to-do middle-class professional family. His mother, for whom he later admitted having an incestuous attachment, died when he was seven; he detested his father, Chérubin Beyle, but revered his grandfather Gagnon, a typical, enlightened, eighteenth-century sceptic, who first aroused the young Henri's interest in the Encyclopaedists. At the École Centrale at Grenoble Stendhal received a sound classical education and some instruction in drawing, but his main passion at this stage was for mathematics. For him mathematics was the embodiment of logic, and he regarded it as a means of intellectual emancipation from the prevalent woolly-mindedness and obscurantism of Grenoble society. At a tender age Stendhal had already begun to react violently against what seemed to him the bourgeois conformity of his own family, and he records proudly how he scandalized its other members by exclaiming triumphantly at the news of Louis XVI's execution. In his eyes his first tutor, the Abbé Raillane, was the incarnation of clerical reaction, and all his life he was to remain a relentless anti-clerical, a sort of professional *frondeur*.

In 1799 Stendhal left Grenoble for Paris, determined to take the capital by storm. He first went to live with his cousin Noël Daru, who found him work in the War Ministry. The following year he was in Italy as a second-lieutenant in a cavalry regiment. Back in Paris in 1802, he resigned his

3

commission and began the sort of *dolce far niente* he had dreamt of in Grenoble—a constant round of theatres, cafés and talk. As a young man about town who fancied himself as something of a Don Juan, a mistress was part of the essential equipment, a role which fell to the young actress Mélanie Guilbert. But these years were by no means wasted in dissipation, for his mind was always active, and after an evening's entertainment he would frequently settle down to a long session with his favourite authors, Claude Helvétius and Comte Destutt de Tracy. Above all he was plotting how to realize his greatest ambition: to become the Molière of the nineteenth century. But this ardent theatre-goer never achieved the slightest success in the field of drama. In 1805, following Mélanie to Marseille, he did a short spell of work in an export grocery business, but after the break-up of their relationship he resumed his military career.

Between 1806 and 1814 Stendhal travelled the length and breadth of Europe in the wake of the Napoleonic army. He achieved some distinction as a civil servant, and in 1810 was appointed Auditeur au Conseil d'État and Inspecteur du Mobilier et des Bâtiments de la Couronne. This last post was concerned with Museum administration and brought him into contact with Vivant Denon, the man in charge of the French National Museums under Napoleon. Stendhal was responsible for making an inventory of the Louvre collections, and in an entry of the *Journal* for 1814 he left a vivid account of the last moments before the pictures acquired by Napoleon were finally surrendered and of his own fruitless efforts to persuade Denon to keep Raphael's *Madonna della Sedia*. In 1812 Stendhal took part in Napoleon's disastrous Russian campaign, an experience which marked him profoundly for the rest of his life. After the collapse of the Empire, he found himself without a job, and to while away the terrible prospect of boredom which suddenly confronted him he started writing in earnest. Back in Milan with Angela Pietragrua, he resumed work on the *Histoire de la Peinture en Italie*. This had been begun in 1811, but he had lost the manuscript on the Russian campaign. At the same time he dashed off a piece of popular musicology, the *Lives of Haydn, Mozart and Metastasio*, which was published in 1815. This was a happy time in Stendhal's life and it was spent mostly in Italy, the country he came to regard as his adopted country, where he still found the qualities of charm and spontaneity that

had vanished from France since the Restoration. He travelled widely during these years and left a charming account of his activities in *Rome, Naples et Florence* (1817). In Milan he met Lord Byron, with whom he held long discussions. He was also in close contact with Italian liberal circles, until they suspected him of being a police spy. By a cruel irony, he was finally expelled from Milan in 1821 by the Austrian government as a dangerous radical.

Forced to return to Paris, Stendhal continued his life as an intellectual and journalist, and sent regular reviews of the Parisian literary scene to various English periodicals, published as the *Courrier Anglais*. He was also a keen reader of the *Edinburgh Review*, and his own ideas on Romanticism owe a great deal to studies on Shakespeare and Byron which appeared in this paper. During his stay in Paris Stendhal was a regular visitor to the house of E.-J. Delécluze, the pupil and biographer of David and well-known as the art-critic for the *Journal des Débats*. The two men had something in common, both being keen advocates of Shakespeare, and passionate Italophiles and liberals, but on the matter of painting they never saw eye to eye. All Stendhal's attacks on the *Journal des Débats* in his *Salon of 1824* were directed against his fellow critic, who consistently defended David's principles of drawing and composition. At the same time Stendhal also frequented the fashionable salon of the Baron Gérard. Then, after a brief visit to London, during which he saw a performance of Shakespeare on the stage for the first time, Stendhal joined in the current discussions on Romanticism with *Racine et Shakespeare* in 1823. In 1824, in addition to a *Life of Rossini*, he wrote a review of the Salon, which was followed by the second half of *Racine et Shakespeare* in 1825. In 1827 he published *Des beaux-arts et du caractère français*, a short essay partly prompted by a work by Auguste Jal, *Esquisses, croquis, pochades, ou tout ce qu'on voudra sur le Salon de 1827*. Stendhal's second piece of contemporary criticism is not, however, so much a review of the current exhibition as a restatement of general principles already expounded in the *Histoire de la Peinture* and the previous *Salon*.

After so much history, criticism and biography, Stendhal made a belated entry into fiction in 1827 with *Armance*. Two years later, in 1829, came the initial impulse for *Le Rouge et le Noir* when Stendhal read in the

Gazette des Tribunaux an account of a young cabinet-maker, Adrien Laffargue, who shot his mistress after a quarrel. The case obviously obsessed Stendhal, since he alludes to it several times in the *Promenades dans Rome*, which was published in 1829, a year before *Le Rouge et le Noir* appeared. He concludes his reflections on the Laffargue case with the statement: 'Henceforward all great men will probably emerge from the class to which M. Laffargue belongs.'[4] It confirmed him in his belief that the provincial proletariat was the only source of energy left in France, and out of this notion he fashioned the story of Julien Sorel, the carpenter's son who seduces his employer's wife, Mme de Rênal, and quickly rises to the highest ranks of society until he brings about his own downfall by shooting his former mistress in a fit of rage. Despite the differences between Stendhal and his hero, there is a strong measure of self-identification in Julien's determined search for honours and success. The novel's sub-title, *Chronique du XIXe. Siècle*, indicates Stendhal's intention of pitting his central character against the dull, grey, conformist backcloth of French society under the Restoration. When *Le Rouge et le Noir* came out in 1830 it failed to attract much attention, and Stendhal was thus not able to live by his writing, as he had hoped to do. He returned to the Civil Service and spent a year as French Consul in Trieste, until Metternich objected to the appointment on the grounds of Stendhal's suspect political past. He was then transferred to Civitavecchia. There he was to spend the last eleven years of his life—rather sad, lonely years, if we imagine the portly, middle-aged Consul looking back wistfully on the happy period earlier in Milan and the excitement of La Scala. This inveterate bachelor even toyed for a moment with the idea of marriage, but his plans came to nothing. There was no amusement or stimulus of any kind in Civitavecchia, and even nearby Rome must have seemed moribund after the general intellectual ferment in Italy before 1820.

Stendhal's main contact with artistic life came through his friendship with the Genevan painter Abraham Constantin, with whom he collaborated on a guide to Italian painting entitled *Idées italiennes sur quelques tableaux célèbres*. It was also through Constantin that he was introduced to a group of French artists in Rome, which included the military painter Horace Vernet, then Director of the French Academy at the Villa Médicis.

But Stendhal's principal occupation during these years was writing, and they were the most productive of his entire lifetime. This last decade saw a steady stream of autobiography, besides *Lucien Leuwen*, written between 1834 and 1835, and two substantial volumes of travel literature, *Les Mémoires d'un Touriste* (1838), an account of a journey in the French provinces Stendhal made during two years' leave of absence. The final culmination of his career was marked by *La Chartreuse de Parme*, written in 1838 in less than two months, the most radiant and youthful of all his works, the product of the author's nostalgia for the happy period in his own life. Stendhal's health had been deteriorating for some time, and he died in 1842 after an attack of apoplexy.

Stendhal's art-criticism falls into three broad categories: art-history, criticism of contemporary painting and travel literature, and they can most conveniently be considered in this order. First of all, what were Stendhal's qualifications for his chosen role as art-critic, and why did he decide to begin his literary career as an art-historian? His own family apparently had no interest in the visual arts and there were not even the usual engravings in the house. At the École Centrale at Grenoble he received drawing lessons from a M. Jay, who taught his pupils to draw the conventional eighteenth-century academic nude figures. M. Jay himself, according to Stendhal, drew in the style of Moreau le Jeune and Cochin, and this is how the pupil later described his master's *têtes d'expression*: 'The great merit of these heads, which measured eighteen inches tall, was that they were hatched in good, parallel lines; but as far as the imitation of Nature went, there was no trace of it.'[5] The other art teacher at the school, M. Le Roy, sketched views of the surrounding countryside which displayed slightly greater freedom of technique. Neither of these men can be said to have aroused in the young Stendhal a passion for painting, and at the end of his schooldays he had acquired no more than an ordinary competence in drawing. In retrospect, he dated his experience of visual pleasure back to a painting shown to him by M. Le Roy, which seemed to express his own ideal of happiness and awakened in him 'a mixture of tender emotion and sweet voluptuousness'.[6] This unidentified work, presumably a mythological painting with naked women in a luxuriant landscape, thus started the train of thought which caused Stendhal to equate

beauty with sensuous pleasure, and he may have had it at the back of his mind when, in *De l'Amour*, he defined beauty as the 'promise of happiness'. To this period also belongs Stendhal's first reading in aesthetics, when he received as a school prize a copy of Dubos's *Réflexions critiques sur la Poésie et la Peinture*, a work which made an immediate and lasting impression. On his arrival in Paris, Stendhal enlisted as a student at the *École des Beaux-Arts* under the painter Regnault, a Neoclassical contemporary of David and creator of the *Three Graces* in the Louvre; but he remained only two months, hardly long enough to gain any real insight into the painter's profession. On his first visit to Italy in 1800 he showed no particular interest in the country's art, and his Journal covering the years of this period has few references to painting other than the conventional homage to Raphael. Back in Paris he began to make regular visits to the Louvre, which at that time included the vast addition of Italian paintings plundered by the Emperor on his European campaigns. And during the course of his military career Stendhal had ample chance to enlarge his knowledge of painting; it was in Dresden, in 1813, that he had the crucial revelation of Correggio, the artist who was to remain his first love all his life. But when Stendhal began his *Histoire de la Peinture en Italie* in 1811, he was by no means an ardent devotee of painting, and his knowledge of the subject was extremely slender. Even after the work was well under way, he could not tell the difference between a Bronzino and a Guercino. His theoretical education was equally shaky. Apart from Dubos, he had read the work of the German philosopher-painter Anton-Raphael Mengs in 1807, possibly Reynolds's *Discourses* soon after, and in 1810 Burke's *On the Sublime and the Beautiful*. He was ill-equipped to tackle a comprehensive history of Italian art.

In order to understand the real originality of Stendhal's *Histoire*, some knowledge of its genesis is necessary. For this work, which, its author fondly hoped, would provide him with a quick and easy means to fame, gradually developed into a major undertaking, and became the repository for all his early intellectual preoccupations. Even though, as Paul Arbelet discovered nearly fifty years ago, a large part of the book is directly or indirectly borrowed from earlier monographs and aesthetic treatises, it is far from being a worthless piece of plagiarism. Merely as a collection of

textual quotations from other writers, it would be of considerable interest; for Stendhal believed that a theory or idea, if correct, is an acquired fact and therefore common property, originality for him being the way old ideas are combined and re-used. Nor, it should be said, was it his original intention to write an original work, since he began the *Histoire* as a modest translation of the *Storia Pittorica* by Lanzi; then, widening his field, Stendhal bought and read other histories by Bossi, Bianconi, Bellori and the eleven volumes of Vasari. As the work grew he supplemented these by extensive reading from a wide variety of more recent critics, historians and writers on aesthetics; these included Richard Payne Knight's *An Analytical Inquiry into the Principles of Taste*, Winckelmann's *Gedanken über die Nachahmung der Griechen* and his *Geschichte der Kunst des Altertums*, and works by Quatremère de Quincy, Cabanis the physiologist and many others. All of these writers left their mark on Stendhal in varying degrees. This would not be the place to show his indebtedness to each of them in turn (especially since this was done so thoroughly by Arbelet), but as a general indication, the straightforward historical and biographical sections of the book are usually second-hand. The dull and uninspired exposition of the evolution of Italian art up to Giotto and Cimabue is mostly taken straight out of Lanzi, while the greater part of the biography of Leonardo da Vinci was lifted from a recent study of the artist by Amoretti (the one historian whom Stendhal fails, characteristically, to mention in his bibliography, whereas others he had probably not read are all carefully named). The book only comes to life with Masaccio, whom Stendhal regards as the pioneer of modern, expressive art. (Giotto, incidentally, he sees as a remnant of the medieval past, not as a forerunner of the Renaissance.) In fact the problem of recognizing Stendhal's original passages is not difficult; bold generalization takes the place of dreary, factual accounts, and the text immediately bristles with aphorisms, incongruous episodes and a wealth of concrete examples and illustration.

As Stendhal originally conceived the *Histoire* in 1811, it was to have been a complete account of Italian painting up to the nineteenth century, including the Venetian and Bolognese schools. It was finally published in 1817 in a considerably truncated form, and as it now stands there is only a history of Florentine painting up to, and culminating in, a Life of

Michelangelo. Stendhal had already prepared notes for the subsequent volumes; these have been published by Henri Martineau as the *Écoles italiennes de peinture*, but they contain relatively little of Stendhal's own work, except for some excellent passages on the Bolognese painters. The first volume of the *Histoire* consists of an Introduction (written in 1814) and an account of Italian painting up to and including Leonardo da Vinci: the second opens with a section contrasting classical and modern conceptions of beauty, which Stendhal justifiably claimed to be his most original contribution to aesthetics, rounded off by the life of Michelangelo. This last contains some of Stendhal's most profound thoughts on the arts. Such a simple-sounding plan gives no idea of the baffling, idiosyncratic nature of the book. Its strangely uneven quality can partly be attributed to Stendhal's departure from his original plan, partly to an unscrupulous attitude to scholarship in passing off second-hand sources as original ones; but most of all, perhaps, to that laconic brevity of style which skips from one idea to the next, omitting the intermediate stages of an argument. Stendhal was the first to admit that patience was not his particular virtue, and his literary habits apparently remained unchanged, for in 1840 he wrote to Balzac on the subject of *La Chartreuse de Parme*: 'Making a plan paralyses my imagination.'[7] Finally, Stendhal was constantly at work revising and expanding his text, and his working habits were extremely erratic. He would often begin a topic before he had completed the necessary documentation, and as late as 1816 there was still a vital gap to be filled, for he had still not seen the Sistine Chapel. At other times he wrote descriptions of pictures he had either never seen or seen only from engravings. When he finally handed over the manuscript to his friend Louis Crozet in 1817 for him to prepare for publication, he can hardly have regarded the text as final, since he gave him almost complete freedom to make alterations and additions.

In the end the book had cost Stendhal far more trouble than he had ever predicted. While he was capable of producing scamped musical biographies in a matter of weeks, this history of Italian painting had taken him six years. From his correspondence it is clear that he had conceived considerable hopes for the work, predicting that 'Opus' (as he referred to it) would mark a new departure in French aesthetic thought, and deal a death blow

to current theories derived from Winckelmann about the origins of Greek art and beauty. But before considering the book's significance to art history and theory, it is worth while viewing it first in the overall context of Stendhal's literary evolution, especially since it was his first major published work. First of all it shows Stendhal in search of a personal style. For there is no doubt that the writer who was later to boast that the act of writing came to him as easily as smoking a cigar experienced considerable difficulties at this stage. The question was to find a suitable model. On a manuscript dated 12 August 1814, Stendhal expressed his determination to get away from the sonorous phrases of Rousseau and Madame de Staël, and to pack as many ideas into as little space as possible: 'My own style must not let slip so much as half a page of commonplace ideas. . . . I shall simply attempt to describe my thoughts accurately.'[8] This new ideal of prose—bald, colourless, intended for exposition rather than evocation—demands great agility on the part of the reader. It is a deliberate rejection of the descriptive purple passages which Stendhal detested in Chateaubriand, and a reversion to the precise, aphoristic prose of the mid-eighteenth-century writers, notably Montesquieu. Simplicity had to be matched by variety, and at the time of writing the *Histoire de la Peinture* Stendhal confessed to Crozet that his stylistic allegiance was divided between Montesquieu and Fénelon.[9] He clearly saw the need to adapt his language and rhythm to the artist in question, and for his prose to reflect the emotions certain kinds of painting aroused in him. His solution seems to have been to retain the laconic precision of Montesquieu for the theoretical passages, while modelling himself on the tender, mellifluous flow of Fénelon's prose for artists like Correggio and Leonardo. Fénelon's influence is particularly marked in the account of the *Last Supper*, where Stendhal writes in unusually long sustained periods.

From a purely literary point of view, the *Histoire de la Peinture* is interesting too because it contains in embryonic form several of the elements of Stendhal's fiction. In particular, the conception, formulated in the Introduction, of the Italian Renaissance as an age of despotic governments and vehement passions provides the background for the *Chroniques Italiennes* and *La Chartreuse de Parme*. This last novel, especially, consistently illustrates Stendhal's belief that the finest human qualities are

brought out, not by democracy, but by tyranny, which forces men to rely entirely on their own resources. Stendhal closely anticipates Nietzsche in his notion that people become emasculated by an excess of refinement and civilization. Moreover, when he writes in the section on the modern ideal of beauty that the most valuable qualities in the nineteenth century are wit, intelligence, an alert expression and a nimble body, Stendhal seems to have defined his own heroes in advance. For these are the attributes of Stendhal's two idealized self-portraits in Julien Sorel and Fabrice del Dongo. There is another clear prefiguration of Julien in the contrast between the fresh complexion of the young provincial new to the metropolis, and his cool, urbane, unhealthy-looking Parisian counterpart. We can see how Julien's character was already taking shape in Stendhal's mind more than fifteen years before he finally wrote *Le Rouge et le Noir*, and how, in a sense, Julien grew out of Stendhal's aesthetic theory.

The *Histoire de la Peinture* is important not only as a stage in the writer's evolution, but also in its own right as a contribution to thought on the fine arts. Despite the large number of passages lifted from other writers, Stendhal deserves credit for seeing that the study of art demands familiarity with many different fields of knowledge. For this reason he draws on Cabanis for physiology, Lavater for physiognomy and phrenology, Montesquieu for sociology, and Benvenuto Cellini for history and memoirs —all this and more, quite apart from the standard monographs and art-historical sources like Vasari. Stendhal's history of Italian art represents an extremely ambitious, although badly co-ordinated, attempt at a synthesis of all the relevant areas of study. Many of its single elements can be found in previous works; the section on the different temperaments, for example, was closely inspired by Cabanis's *Traité du physique et du moral de l'homme* (1802), and the theory of climate and environment by Montesquieu's *L'Esprit des Lois*. But Stendhal's originality was to have applied the discoveries of eighteenth-century thought and science to painting, and to have placed the study of art in the overall context of civilization. He can be seen, therefore, as a pioneer of the type of cultural history which, after the middle of the nineteenth century, was to culminate in the work of Hippolyte Taine and the Swiss historian Jacob Burckhardt. All the ingredients of Taine's environmental theory ('*race, milieu, moment*') are

present in the *Histoire de la Peinture en Italie*. Burckhardt's general picture of the Italian Renaissance as an amoral period of strong passions and spectacular crimes may well have been coloured by Stendhal's Introduction, and Burckhardt uses a similar technique of characterizing a period by little pieces of anecdote and graphic historical detail. Like Stendhal too, Burkhardt makes extensive use of contemporary memoirs to give his Renaissance a particular flavour. The influence of the *Histoire de la Peinture* seems to extend as far as Pater's *Renaissance*, for in his Conclusion Pater directly echoes Stendhal when he writes that the quality of life must be measured by the intensity of its individual moments: 'A counted number of pulses only is given to us of a variegated, dramatic life. How may we see in them all that is to be seen in them by the finest senses?' At the same time, Stendhal can claim to have been an early exponent of sociology applied to art and literature. In this respect he may have been prompted to some extent by his great contemporary Mme de Staël (notably by her *De la Littérature* of 1800), whom he criticized as a stylist but respected as a thinker. He agrees with Mme de Staël in regarding the work of art as an expression of social values, and the one vital question he always asks of a nation, institution or individual is its or his conception of happiness. Art provides a ready answer to this question, being an obvious receptacle of human aspirations. In the opening section of the second volume of the *Histoire de la Peinture* Stendhal seeks to illustrate this theory by showing how early Greek sculpture reflected an advancing civilization: the gods gradually evolved from images of retribution into the expression of paternal benevolence. Another of Mme de Staël's preoccupations which Stendhal shared was the pattern of cultural contrasts between northern and Mediterranean civilizations—an antithesis running throughout Stendhal's work, especially in *La Chartreuse de Parme*, where he frequently draws parallels between the French and Italian temperaments to the detriment of his own countrymen. Artists are like plants which only flourish in a particular soil and landscape. Women painted by Rubens, to quote one of Stendhal's examples, would be inconceivable from an Italian artist in an Italian setting.

On the one hand, therefore, Stendhal prefigures much in later nineteenth-century thought, but on the other he is deeply rooted in the

eighteenth-century sensualist tradition. For him a picture is, quite simply, a form of giving visual pleasure by means of the senses. He seems to have hardly any inkling of the Romantic concept of the imagination as an autonomous faculty—'the Queen of the Faculties', as it was to become for Baudelaire.[10] In this emphasis on immediate sensation, Stendhal's *éminence grise* appears to be the Abbé Dubos's *Réflexions critiques sur la Poésie et la Peinture*. At first sight it may seem hard to see why this apparently conventional eighteenth-century treatise should have held any attraction for Stendhal. But its superficial dryness belies ideas of considerable interest which evidently helped to direct Stendhal's thoughts along certain lines. In particular Dubos taught Stendhal that the primary object of aesthetics should be to concentrate on the psychology of the spectator, to ask why we react to a scene or drama in a particular way. The notion that aesthetic responses can be measured almost quantitatively often leads Stendhal to write of himself as a barometer registering the degree of success or failure of a work of art. At the beginning of his book Dubos seeks to explain why art can bring pleasure while representing suffering, and he summarizes the aim of his inquiry in strikingly Stendhalian terms: 'Thus I could hardly win the reader's approval if I did not manage to explain to him what happens inside himself; in short, the most intimate movements of his own soul.'[11] This shift of emphasis from the work of art to the recipient can be found throughout Stendhal's writing on the fine arts, and one of his favourite illustrations is to compare the reader of a novel to the sounding-board of a violin. A work of art, for him, is not a self-contained end product, but something to be completed and amplified by the receiver: hence the need for a full emotional response. Another important tenet of Dubos's book is that, of all the arts, painting makes the most immediate impact on the senses. Poetry, because it relies on the artificial convention of language, operates at one remove from its subject, whereas the forms in a painting *are* the objects they represent. The painter, therefore, should exploit the full potential of his medium by choosing the climactic moment of a human drama or event. The maximum intensity of expression: this was always Stendhal's criterion of a great artist, an ideal he found rarely achieved in the nineteenth century. The outstanding exception in his eyes was Gros's *Plague-stricken at Jaffa*

(Plate 9). 'Expression is everything in art,' he writes, because the portrayal of human suffering makes the strongest demands on the spectator's participation. Stendhal's ideal reader must be capable of reliving the drama enacted in front of him.

Comparisons between the respective merits of poetry and painting were commonplace in the eighteenth century, and this is to be expected from Dubos's book, with its sub-title *Ut pictura poesis*.[12] In most eighteenth-century writers on aesthetics this much-quoted adage from Horace was taken to mean that the two arts were virtually interchangeable: painting was seen as a kind of silent poetry, while poetry became a form of painting in words. The result was a confusion of the genres. The credit for having redrawn the natural barriers between the arts is usually given to Lessing's *Laocoön*, but the distinction is already clearly made by Dubos, when, for example, he writes that certain subjects are more suitable for painting and others for literature. The relevance of this academic debate to Stendhal is only apparent when we notice how deeply rooted he was in the eighteenth-century habit of drawing parallels between literature and the visual arts. In a remarkable piece of stylistic criticism he makes a striking comparison between Bossuet's apocalyptic images of terror and Michelangelo's Prophets in the Sistine Chapel.[13] He frequently writes of style in language as the equivalent of colour in painting. 'Style ought to be like a transparent varnish.'[14] But at the same time Stendhal seems to have heeded the warnings in Dubos and Lessing not to neglect the natural boundaries of the arts. If poetry, he writes, tried to rival Raphael's *Madonna della Seggiola* it would only manage to produce a long enumeration of physical qualities, which would be tiresome to read. As an instance of painting trying to ape literature he quotes Poussin's *Coriolanus*. On the same grounds as Dubos, Stendhal complains that allegory tends to degenerate into clever enigmas, designed to tax the reader's ingenuity, whereas good painting ought to be immediately legible and make a direct appeal to the emotions.

It is a paradoxical fact that Stendhal, a self-declared radical in his views on painting, should nevertheless have strong links with French Academic theory as it was formulated in the seventeenth century. There are frequent echoes of Lebrun's *Theory of the Passions* in his concern for action, facial expression and appropriate gesture. This is the traditional aspect of

Stendhal's art-criticism, which may not endear him to all modern readers but which must be recognized. The other, forward-looking aspect is that of campaigner for a new, specifically nineteenth-century form of art. The *Histoire de la Peinture en Italie* has rightly been called the 'first Romantic manifesto', and in a sense the entire historical exposition of the book is only a prelude to the call for a new Raphael and the forecast of the twentieth-century revolution in the arts. Adopting a viewpoint of historical relativity, Stendhal attempted to show how the artists of the Italian Renaissance painted in a manner appropriate to their own times. In the second volume he applies the same principle to his own age, and argues that the ideal of classical sculpture, based on the physical beauty and strength of the naked warrior, is no longer valid in the nineteenth century. The new art must reflect the greater psychological complexity of a later stage of civilization, and even human emotions change from age to age. Stendhal, the self-appointed specialist of love in *De l'Amour*, recognized that this was no longer the exclusively carnal affair it had been with the Greeks, and that characters like Werther would have been inconceivable in earlier times. He rightly predicted that the outstanding characteristic of the nineteenth century would be 'an ever increasing thirst for strong emotions', and that this quest would lead his contemporaries back to the works of Michelangelo. Here Stendhal's forecast was prophetic, for in 1819, only a few years after these lines were written, Géricault produced his great work of Michelangelesque inspiration, *The Raft of the Medusa*, and this was quickly followed, in 1822, by Delacroix's *Dante and Virgil crossing the Styx*. Throughout the century Michelangelo continued to inspire writers from Vigny, in his epic poem *Moïse*, down to Michelet[15] and Zola,[16] all of whom looked back to the great Renaissance artist for an expression of the greatness of human endeavour, the epic nostalgia which haunted the Romantic imagination. For Stendhal, Michelangelo was one of the few artists who seemed to measure up to the reality of life; when he first caught sight of the Sistine Chapel (Plate 3), he was instantly reminded of the sensation he had experienced during the retreat from Smolensk of being alone, face to face with destiny.

The debate on Romanticism is resumed by Stendhal in *Racine et Shakespeare*, an ephemeral piece of writing, but of considerable importance

in the literary context of the mid 1820s. During his stay in Italy before 1821, Stendhal had been in close contact with leading Italian liberals like Manzoni, Visconti and Silvio Pellico, who wanted to combine nationalism with a modern literature. As a regular reader of the *Edinburgh Review*, he found Shakespeare, Byron and Scott extolled at the expense of French classical literature. On his return to Paris, Stendhal was disappointed to see that the current French notion of Romanticism was both conservative and religious, represented in poetry by Hugo and Lamartine, and with *La Muse Française* as its official mouthpiece. This particular brand of Romanticism was once defined by Sainte-Beuve as royalism in politics, Catholicism in religion and Platonism in love[17]—the exact antithesis of Stendhal's views on all three counts. The reactionary, mystical strain in French literature of those years was, in its turn, a derivation of the German Romantic movement, founded largely by the Schlegel brothers and popularized in France by Mme de Staël's *De l'Allemagne* (1813). There was no love lost between Stendhal and Mme de Staël, but his real *bêtes noires* were the Schlegels. In a letter to Crozet he complains that the Germans have monopolized the term Romanticism and perverted its meaning. His pamphlet *Racine et Shakespeare* can be seen as a rejoinder to the Germans and Germanophiles, and an attempt to substitute his own definition of the term, at once modern, democratic and realistic. The central theme is stated under the heading: What is Romanticism? 'Romanticism is the art of presenting to the nations those works of literature which, in the present state of their habits and beliefs, are likely to give them the greatest pleasure.' This definition follows logically from the premise, set out in the *Histoire de la Peinture*, that each age produces, or must be encouraged to produce, forms of art appropriate to its way of life and mental outlook. According to this (unwittingly) Hegelian assumption of art as the expression of a period, Racine provided a type of tragedy suitable to the courtly, hierarchical society of Louis XIV. But to try to perpetuate the conventions of classical tragedy in 1823, as some playwrights were still doing, was an absurdity. On the grounds that his French contemporaries had more in common with Elizabethan England than the Grand Siècle, Stendhal proposes Shakespeare as a more fitting model of inspiration. Shakespeare, in his view, has the added advantage of being a

great realist. This, then, is Stendhal's recipe for a modern, national tragedy: abolition of the unities of time, place and action, prose instead of verse, and subject-matter drawn from French national history (in particular the heroic periods of Henri IV and Louis XIII). Instead of the static pleasure derived from listening to elegant poetic diction, Stendhal wants his audience to participate actively in the human drama. But the type of play is less important than the spirit in which the artist tackles the venture. 'You need courage to be a Romantic, for you must take risks.' Stendhal believed that all artists are men of passion; hence his statement that all writers, Racine included, were Romantics in their time. *Racine et Shakespeare* is a plea for the same kind of emancipation in drama that Stendhal had already shown to be active in the visual arts: the artist must have the courage to be himself, and his first duty is to his own vision. The followers of Raphael, of David and of Racine all evade the issue by their slavish imitation of a precedent, but the great innovators in the history of art, from Masaccio to David, broke with the past and imposed a new vision on their contemporaries. 'M. David taught painting to desert the footsteps of Lebrun and Mignard, and to be bold enough to show Brutus and the Horatii.' To reduce the question of artistic innovation to one of personal courage may be an over-simplification, but what mattered in *Racine et Shakespeare* was the author's militant tone and hearty contempt for the self-styled dictators of literary taste (notably La Harpe). The pamphlet was an open invitation, to writers and public alike, to create and enjoy the kind of art which frankly appealed to them, without respect for precedent, taste, or convention. As such it was well in tune with the incipient Battle of Romanticism, and helped to generate a combative spirit among artists.

In a more specific sense *Racine et Shakespeare* was less influential, for in 1827 Victor Hugo, in the *Préface de Cromwell*, declared himself in favour of the retention of Alexandrine verse in drama. Nor would Hugo's plea for the rights of ugliness and the grotesque to be represented in art have been much to Stendhal's taste. In the end Hugo won the day with the triumph of *Hernani* in 1830, and Stendhal was forced to admit that he had failed to impose his own conception of Romantic tragedy. Madame Jules Gaulthier wrote to him that his own rational type of Romanticism had been sup-

planted by a 'roaring monster' and urged him to turn to something else.[18] Certainly for the next two decades French art and literature continued to be dominated by the fantastic and the supernatural, all of which would have been repellent to Stendhal. As for his contribution to the establishment of Shakespeare's reputation in France, this may not be easy to determine exactly. But it is clear that after the publication of the first part of *Racine et Shakespeare* in 1823, the group of English actors who had performed *Othello* in Paris in 1822 to a violently hostile public found that the tide had changed on their return in 1827 and were greeted with general acclaim. Henceforward Shakespeare became a standard source of inspiration for Delacroix and a host of minor Romantic artists, whereas subjects from Racine, which had been popular with artists of one generation earlier, like Prud'hon, Girodet and Guérin, quickly disappear from the repertory. The one notable Romantic exception is Sigalon, whose *Narcissus* (Plate 31), inspired by some lines from Racine's *Britannicus*, is commented on at length by Stendhal in the *Salon of 1824*; the *Athalie*, his last exhibited work, was shown in 1827.

Racine et Shakespeare was even more influential on later French art-criticism. In particular Baudelaire, who once described Stendhal as 'an impertinent, teasing, even a disagreeable critic, but one whose impertinences are often a useful spur to reflection',[19] picks up and adapts for his own use several of his predecessor's ideas.[20] Some passages in Baudelaire's *Salon of 1846* on style and the use of the model in portraiture are even a direct borrowing from Chapter 109 of Stendhal's *Histoire de la Peinture*; not all of this is acknowledged. Another, perhaps more important, section in the same Salon, entitled *What is Romanticism?*, is also closely inspired by Stendhal's example in the *Histoire* and in *Racine et Shakespeare*, where Romanticism is consistently equated with modern feeling. Baudelaire writes that Romanticism 'is precisely situated neither in choice of subjects, nor in exact truth, but in a mode of feeling'.[21] He concludes: 'For me, Romanticism is the most recent, the latest expression of the beautiful. There are as many kinds of beauty as there are habitual ways of seeking happiness.'[22] The point of all this is not merely to show that Baudelaire was just as good a plagiarist as Stendhal, but that the concept of the relativity of beauty, most clearly formulated by Stendhal, had evidently taken

a firm hold of Baudelaire's mind. He became no less zealous than Stendhal in his denunciation of all attempts to impose immutable aesthetic canons, and his attacks on Winckelmann and the 'professors of aesthetics' in the *Exposition Universelle de 1855* are a direct consequence of the belief that each nation and each age produce their own specific ideal. Today the idea that modern art or drama may be just as good, if not better, than works of the past has become a commonplace; but in Stendhal's day it was by no means universally accepted, and the weight of classical precedent still lay heavy on artists and critics. The issue was only a distant repercussion of the age-old Quarrel of the Ancients and the Moderns, which came to a head in late seventeenth-century France when Perrault, in defiance of traditionalists like Boileau and La Bruyère, dared to assert in his *Parallels* that the art of his contemporaries was technically more advanced than that of the time of Raphael. Even in the eighteenth century the victory of the Moderns was by no means assured, and Stendhal, in this context, was perhaps one of the first writers to place complete faith in the art of his own time. Even as late as the 1820s, Winckelmann's theory of a universal, timeless beauty (vaguely based on the *Apollo Belvedere*) was staunchly defended in France by men like Quatremère de Quincy. Few would have dared to flaunt the conventions of classical tragedy as Stendhal does in *Racine et Shakespeare*, or to say with him in the *Salon of 1824*: 'What do I care about classical bas-reliefs?'

The *Salon of 1824* is in many ways a companion piece to *Racine et Shakespeare* and applies similar principles to painting. It was first published as a series of seventeen unsigned articles in the *Journal de Paris*, and marks Stendhal's venture into the field of contemporary art-criticism. This Salon is important for two main reasons. In the first place Stendhal was the first prominent man of letters in the nineteenth century to take up the genre which had remained in abeyance ever since Diderot inaugurated it with such brilliance in the late eighteenth century. And even though Stendhal somewhat unjustly associates Diderot's name with artists like Pierre and Vanloo, and 'other heroes of Diderot's Salons', he was evidently aware of his great predecessor's example and frequently recalls his belligerent manner, his tendency to digress and his general disrespect for established reputations. Secondly, the exhibition which opened at the Musée Royal on

25 August 1824 marked the first real manifestation of the French Romantics in painting, and saw the confrontation of the two great rivals, Ingres and Delacroix, the former represented by the *Vow of Louis XIII* (Plate 12), the second by the *Massacre at Chios* (Plate 13). As a theoretical champion of Romanticism we should expect Stendhal to have voted wholeheartedly for Delacroix. But in fact neither of these two pictures entirely satisfied him, and in general his attitude to what was later to emerge as the more advanced tendencies in French art remains moderate and cautious. Nominally he declares himself the advocate of genius and originality, of 'young painters with passionate souls and candid minds'; but in contrast to Baudelaire's subsequent idolization of Delacroix, Stendhal is wary of hero-worship, and none of the exhibiting artists entirely met his demand for a new Raphael. His criticism is nearly always a mixture of praise and blame, and for this reason he perhaps gives a more balanced view of the artistic scene in 1824 than Baudelaire does in 1846 or 1859. Unlike Baudelaire, he never lays claim to especially privileged insights into painting, but is content with his job as a routine journalist with views which usually coincide with those of the public at large.

The didactic purpose of the *Salon of 1824* is the same as that of the other criticism: to put an end to the imitation of outmoded prototypes. In *Racine et Shakespeare* Stendhal's attack was directed against the Racinian progeny in drama, whereas here it is against the followers of David, the authors of vast, belated classical compositions such as Cogniet and Abel de Pujol. Stendhal is careful to distinguish between David and his offspring. For David himself he had almost unqualified admiration, and rightly saw him as the greatest innovator of the eighteenth century, the 'bold genius' he acknowledged in *Racine et Shakespeare*, who once and for all banished Rococo insipidity from French art, and created a stoical ideal which clearly held a strong appeal for Stendhal. The one unfortunate lapse in David's *œuvre* was, in Stendhal's eyes, the *Sabine Women* (Plate 8), the picture in which the painter had striven after an archaic Greek purity and linear rigidity. It was this particular aspect of David which attracted a substantial following among his pupils. These were still exhibiting in great numbers in the 1820s, and Stendhal consistently deplored the proliferation of naked, muscular heroes gesticulating on canvases the size of a wall. He objects to

this kind of art, first on the grounds of simple common sense and observation. 'I have witnessed two or three heroic deeds in my time, and was struck by their appearance of simplicity.' (For the same reason, perhaps, Stendhal's own heroes prefer to avoid all histrionics: Julien Sorel accepts his death with a calm dignity.) Stendhal's quarrel with David's followers was also that they seemed to him to have raised their master's precepts to the level of an official dogma, and constituted a new classicism hostile to all innovation. Where David used Antiquity only as a guide to study, the more fanatical of his followers looked to it as the exclusive canon of perfection. As a result, French art had deserted the qualities of tone and colour specific to painting, to imitate the hard, linear character of sculpture.

Stendhal's rejection of all artificially imposed norms, whether by individuals or academies, is related to another wider aesthetic issue: that of Idealism versus Realism, corresponding to the schism that had already divided painters into Classics and Romantics, or the Homerics and the Shakespearians, as they were christened by Delécluze in the *Journal des Débats*. The Davidian artists, and such landscape painters as Bertin and Turpin de Crissé (Plates 15 and 16), belonged fairly and squarely to the classical camp, defended by Delécluze, Kératry and others. Ingres's position was indeterminate, for he was praised by the conservative critics, though also claimed by the Romantics as one of theirs, while Delacroix, Sigalon and Scheffer were firmly annexed to the Romantic cause, whose most outstanding spokesman was Thiers in *Le Globe* and *Le Constitutionnel*.[23] On this matter Stendhal's allegiance is not clear-cut, and he falls somewhere mid-way between the two schools. On the one hand strongly opposed to the classical Ideal as defined by Quatremère de Quincy, on the other he seems reluctant to go along with an all-out Realism. For this reason he cannot give any of the main innovators, Delacroix or Scheffer, his wholehearted approval. The problem was already stated by Stendhal, as Jean Prévost notes,[24] in an early book of thoughts and maxims, *Filosofia Nova*: how to idealize without sacrificing the truth? He returns to it again much later in his *Mémoires d'un Touriste*: 'How strong an element of truth should the fine arts admit? A capital question.' From the sections on portraiture in the *Histoire de la Peinture* it is clear that Stendhal accepted a measure of transposition and stylization as self-evident necessities. His own fictional

practice was to start from a given model (in *Le Rouge et le Noir* a newspaper report) and to combine it with a store of personal memories until the finished result bore only a distant resemblance to the original. Stendhal sees the novel as a heightened and intensified version of reality, but to achieve this effect the writer must avoid description for its own sake. The chief culprit in this respect for him was Scott, and the equivalent of Scott in painting is the Lyonnais troubadour-style artist Richard, in whose *Louis de la Trémouille* (Plate 30) Stendhal detects a similar archaeological pedantry. The simplification of forms and sacrifice of redundant detail is most imperative of all in sculpture, and here the supreme artist was Canova (Plate 34), whom Stendhal constantly admired for his skilful adaptation of classical beauty to suit nineteenth-century taste. In painting, none of the artists of 1824 achieved the balance Stendhal sought between formal perfection and the specific nature of appearances. He complains, for example, that Sigalon, in his *Narcissus* (Plate 32), has made his slave a miserable wretch instead of giving us a youth of Apollonian beauty, designed to extract the maximum pathos from the subject—as Girodet did in *Le Déluge* (Paris, Louvre). Similarly, Constable's *Hay Wain* (Plate 14) is too down-to-earth and particular for his French taste, for while he praises the verisimilitude ('the mirror of nature'), he criticizes it for its lack of ideal. On the other hand the classical landscape painter Turpin de Crissé idealizes too much, and Stendhal complains of the lack of truth. Translated into other terms, this is seen as a matter of the 'finished' and the 'unfinished' in painting. The Davidians and other painters in the classical style are too precise and mechanical, while the Romantics—Ary Scheffer, for instance, in his *Gaston de Foix* (Plate 32)—and the Englishman Lawrence (Plate 17) are negligent and slapdash. As a way out of this dilemma Stendhal assigns the highest rank to an artist of the *juste milieu*, Victor Schnetz (Plate 28).

It must be admitted that, viewed with the advantage of historical hindsight, Stendhal's judgements are often disappointing. After much intelligent theoretical discussion of Romanticism, the Romantic painter *par excellence* in his eyes turns out to be, not Delacroix, but Baudelaire's *bête noire*, Horace Vernet (Plate 33). Stendhal's reasoning here, at least, is perfectly consistent. By general acclaim Vernet was the most popular

painter at the exhibition, and popularity being proof that he was most in tune with modern times, Vernet is by definition the typical Romantic artist. Stendhal's somewhat grudging approval of Delacroix's *Massacre at Chios* stems partly from his personal dislike of the *mal du siècle* type of Romanticism, partly because he detected in it a travesty of one of his favourite pictures, Gros's *Plague-Stricken at Jaffa* (Plate 9); but principally because it seemed to him second-hand, painted by an artist uncommitted to his subject. He sensed that it lacked the immediacy of personal experience, and authenticity of this kind was always one of Stendhal's main criteria. Stendhal's failure to appreciate Delacroix and many others of the 1824 painters may also be due to his persistent nostalgia for the Napoleonic era in art: Gros's virile battle-pieces, the polished charm of Gérard's portraits and Prud'hon's voluptuous allegories.

In his general approach to painting Stendhal demanded the same kind of psychological realism that he looked for in literature and drama—'truth in the portrayal of the emotions', which he found exemplified in Prudhon's *Poverty-stricken family* (Plate 23). Human nature was always his first concern as a novelist and it is not surprising, therefore, that he showed more interest in figure painting than in pure landscape. His attitude to Constable indicates that he was deeply imbued with the French academic habit of regarding landscape as an inferior genre. *The Hay Wain* could only have been redeemed if it had represented something more spectacular, like the French Alps, instead of a stagnant corner of English countryside! Indeed Stendhal remains a partisan of *le grand goût* and his preferences are usually for art with human content of a moral, heroic, dramatic or pathetic kind. As a man of letters with only a short time to spend on pictures, he demanded above all intensity of emotion, a keen and immediate pleasure. Stendhal, like Diderot, judges paintings as if they were high moments from the theatre, and it is significant that in both writers there is a close relation between their art-criticism and their dramatic theory. The sort of paintings Stendhal admired, David in the *Oath of the Horatii* or the *Brutus*, could be conceived as scenes of arrested drama; similarly, when Stendhal condemns a picture, it is often condemned as bad acting (Girodet's *Atala*) or clumsy imitation of Talma (Cogniet's *Marius at Carthage*). Inappropriate gestures and expression is the chief flaw Stendhal

detects in the painters of 1824, not least in Ingres's *Vow of Louis XIII* (Plate 12), where the Virgin seems to him tight-lipped and sullen after the voluptuous Madonnas of Raphael and Correggio.

The last and by far the most voluminous body of writing in which Stendhal discusses the fine arts (among many other topics) is the travel literature: *Rome, Naples et Florence*; *Promenades dans Rome*; *Voyage dans le Midi de la France*; and the *Mémoires d'un Touriste*. Although of uneven quality, these works deserve the attention of anyone who wishes to study Stendhal's complex artistic personality as a whole. They are also well worth reading as specimens of a major nineteenth-century genre, in which writers showed themselves fully awake to the importance of geography and a sense of locality: art in relation to its environment. This was the kind of writing in which Stendhal felt most at ease, and it provided him with a natural relaxation after a hard day's sightseeing or travelling. We find a curious hotchpotch of personal reflections, anecdote, description, politics, history and erudition of all kinds, much of which provided him with a store of raw material when it came to the composition of his novels. Travel writing was also an obvious form of expression for the man whom Paul Bourget saw as the first of the European cosmopolitans, who styled himself 'Arrigo Beyle Milanese' to demonstrate his sympathy with Italy in preference to his native country. This archetypal 'déraciné' was an incorrigible traveller, for the sight of breathtaking scenery, fine works of art and monuments provided the only effective cure for the boredom and loneliness which periodically afflicted him. Travel literature had been widely practised in the eighteenth century, not only by professional artists like Cochin in his *Voyage en Italie* of 1769, but also by aristocratic men of letters like Montesquieu and the Président de Brosses with sufficient leisure to study and describe the works of art they saw in the course of their journey. Stendhal was well versed in the previous literature, as we can see from his letters to Pauline, but he retained a special predilection for de Brosses, the President of the Burgundian Parlement at Dijon, who left an account of his travels in a series of letters written to various friends in his home town, entitled *Lettres familières écrites d'Italie en 1739 et 1740*. This cheerful extrovert and epicurean, who appears to have taken his official duties lightly, was clearly a man after Stendhal's own heart. In the

Histoire de la Peinture Stendhal wrote, 'I cannot find a single depressing thought in de Brosses', and on several occasions he expressed his admiration for the witty, spicy qualities of the President's prose. De Brosses was, moreover, a connoisseur of the first order with tastes in painting which coincide remarkably with Stendhal's own; they agree in rating the Florentine school below the Bolognese and in their unbounded love of Correggio. This eighteenth-century traveller and man of taste became Stendhal's chosen model in the *Promenades dans Rome*, where, instead of conforming to the usual routine of describing works of art according to chronology or location, he follows de Brosses's example of setting out in the morning wherever the mood took him.

Of the travel books, the first to be written, *Rome, Naples et Florence*, is the most light-hearted in mood, filled with accounts of visits to the theatre and Opera and of encounters with such celebrities as Byron and Canova. But the book has its more serious side in passages where Stendhal considers topics like the influence of politics and government on the cultural health of a nation—another of Mme de Staël's favourite subjects. On balance Stendhal concludes that the current artistic stagnation of Italy (with the notable exception of Canova) was due to the effects of long periods of despotism. Yet, as it was put by Harry Levin, 'good government, which he supported in principle, failed to capture his imagination', and Stendhal knew that Molière's plays could never have been written in a democracy, or even a constitutional monarchy. Hence the title of one of his essays: 'Comedy is impossible in 1836.' The reign of Louis-Philippe, the background to *Lucien Leuwen*, was in some respects characterized by better administration than France had ever known before, but the whole country was suffering from chronic inertia. This, at any rate, is the impression Stendhal conveys in the *Mémoires d'un Touriste*. This is the most serious and least spontaneous of his books, with long discussions of such matters as political economy, geography, the development of the railways and the need for road improvements. In fact it reads in places more like the report of a town-planner or civil engineer. At the same time it reveals Stendhal to have been an assiduous sightseer and visitor of museums, with an interest in the artistic scene of the French provinces. At Lyon he devoted a substantial account to a visit to the Palais Saint-Pierre, where he

admired pictures by Guercino, Veronese and, especially, Rubens's *St Dominic and St Francis*. His judgement on the Lyonnais artists was only to be expected: 'The school's style is hard, dry, and frigid, charmless and about as mannered as it could possibly be.' Stendhal's main fear on visits to museums was of being accosted by some talkative bore, or worse still, as happened to him at Lyon, a bore who preferred Mignard to Michelangelo. Perhaps, after all, tastes were only a matter of preference, of whether a man liked peas or asparagus. In Avignon Stendhal visited the Musée Calvet, and at Nantes he was particularly struck by the 'abject and terrifying truthfulness' of the *Hurdy-Gurdy Player*, a picture then thought to be Spanish, but now attributed to Georges de la Tour. There are many other interesting judgements on painting in store for the reader with the necessary patience to work through a lot of other matter.

All these travel books suggest that Stendhal had a natural understanding of architecture, perhaps more than of painting. As an amateur archaeologist, he made a point of visiting every monument wherever he happened to be, and his descriptions of buildings (notably of St Peter's, Rome, in the *Promenades*) show concern for precise fact and exact measurement. The highlight of his journey in France was marked by the Roman antiquities of Autun, Vienne, Orange and Arles. Stendhal left a memorable description of the Pont du Gard, which he admired as a triumph of functional engineering. Some of the best qualities of Roman building had been assimilated by Romanesque architecture, but for the Gothic style Stendhal had little respect. 'We know that for cold, conceited people beauty is commensurate with complexity and effort. Gothic architecture makes a desperate attempt to look daring.' Stendhal's real objection to Gothic, however, was not aesthetic but political, for he suspected that the Romantic cult of medievalism had been deliberately fostered by writers like Chateaubriand in *Le Génie du Christianisme* to prepare for a restoration of the monarchy. He mocked the craze for antiquities of his contemporaries, but at the same time made extensive use of information from works such as *L'Essai sur l'architecture du moyen-âge* by Arcisse de Caumont, and especially from the *Essais sur l'architecture religieuse* by his friend Mérimée, who at that time was Inspector General of Historic Monuments. The debt to Mérimée is apparent in Stendhal's derivation of Gothic architecture from ribbed

vaults and pointed arches, which denotes a more scientific spirit than Chateaubriand's poetic but inaccurate notion that medieval architects were inspired by an attempt to create the effect of long vistas of trees in a forest.

Finally we come to the relationship between the fine arts and Stendhal's creative writing. At first sight the connection seems to be slender, and painting seems to have little to do with the novels. The allusions to pictures are infrequent in comparison with later writers like Balzac or Proust, and in contrast to Flaubert, Stendhal's style is abstract and essentially non-visual. There is a minimum of description, and consequently few of the purple passages in which so many nineteenth-century writers tried to rival the colour and texture of the painter's palette. Whenever Stendhal does wish to express emotion in front of a landscape, as in the passage on Lake Como in *La Chartreuse de Parme*, his writing takes on literary overtones, echoes from Lamartine and Rousseau. He characterizes the scene not in pictorial, but in moral terms, using conventional epithets like 'sublime', 'exquisite', 'ravishing', in a manner reminiscent of one of his favourite books, Fénelon's *Télémaque*. Nevertheless, as we can see from the early *Filosofia Nova*, painting played a by no means negligible part in the composition of the novels. As a student of human nature, with an interest in psychology and action rather than the physical setting, it is not surprising that Stendhal should have looked to figure painting for inspiration. His model here was Guérin, whom he particularly admired for the stark simplicity of his composition in paintings like the *Marcus Sextus* and *Phèdre*. He thought that this kind of *mise en scène*, with one or two prominent characters and a few bystanders, was an ideal which any aspiring dramatist or writer would do well to emulate. In practice Stendhal never kept to this austere plan, and minor characters of all kinds—actors, singers, priests, scoundrels and buffoons—proliferate in his novels as in a Shakespeare play. But in at least one scene of *Le Rouge et le Noir* Stendhal remembered Guérin's example, since Chapter IX, in which Julien makes his first assault on Mme de Rênal's virtue, bears the sub-title: 'M. Guérin's Dido, a charming sketch.' The enactment of the entire scene, with Julien in front of the reclining Mme de Rênal, and Mme Derville in the background, was obviously suggested by the disposition of the three main figures in Guérin's sketch (Plate 10).

There is other evidence in *La Chartreuse de Parme* that Stendhal used pictures to help him visualize characters, since the two heroines, Clélia Conti and the Duchess Sanseverina, are both defined after pictorial proto-types. 'Clélia Conti was still a young woman, a shade too slim, who might have been compared to the beautiful figures of Guido Reni. We will not disguise the fact that, according to Greek notions of beauty, her face might have been criticized for having features rather too strongly marked; her lips, for instance, though perfectly charming, were slightly too thick.' Clélia is an embodiment of the modern ideal, in contrast to the more stereotyped beauty of the Duchess, 'whose truly Lombard head recalled the voluptuous smile and the tender melancholy of Leonardo da Vinci's lovely pictures of Herodias.' And in the eyes of Canon Borda, one of the Duchess's unlucky suitors, the more fortunate Fabrice seems to be endowed with all the charm and grace of a Correggio. Indeed Correggio, although rarely mentioned by name, is the hidden inspiration behind the whole of *La Chartreuse de Parme*, and indeed Stendhal revealed that he had con-ceived the novel in the atmosphere and tonality of Correggio.[25]

In *Le Rouge et le Noir*, on the other hand, Stendhal had the Bolognese painters at the back of his mind. Jean Seznec has shown that the subject of Guercino's *St William of Aquitaine taking monastic orders* (Plate 6) prob-ably gave Stendhal the idea for the episode during the King's visit to Verrières, when Julien Sorel quickly exchanges the military costume he wore in the guard of honour for a surplice, in order to assist the priest in charge of the ceremony at Bray-le-Haut.[26] Significantly Julien fails to notice that his spurs are still showing, a detail also to be found in Guercino's picture. The link between Guercino is all the more convincing since Stendhal mentions this same picture (although with an incorrect title) in another context. When Julien goes to the seminary at Besançon, his alertness and intelligence make him unpopular with his fellow seminarists and he goes to great pains to acquire that expression of studied piety, 'ready to believe anything and suffer anything, so often found in Italian convents, and of which, for us laymen, Guercino left such perfect examples in his altar-pieces.' The originality of the Bolognese painters was to have brought the great religious events down to an earthy, human level; similarly the climax of *Le Rouge et le Noir* is a crime of passion. Contrasted with the

ethereal atmosphere of *La Chartreuse de Parme*, with its imaginary court of Parma, *Le Rouge et le Noir* is in many ways a forerunner of the Realist novel as it was soon to be practised by Balzac and Flaubert. In the same sense that Stendhal described Constable's landscape as 'truthful as a mirror', he defined the novel as a mirror of life (with the proviso that the writer cannot be held responsible for whatever the mirror happens to reflect). But in his own fiction, as well as in painting, Stendhal could never whole-heartedly embrace complete Realism, which would have meant the inclusion of too much mediocrity and ugliness for his liking. Nevertheless, in *Le Rouge et le Noir*, he goes some way towards the depiction of an ordinary, dull French provincial milieu which Flaubert carried to completion in *Madame Bovary*. The novel is firmly located in time and place, and its contemporaneity is accentuated by topical references to newspapers and events like the Battle of Hernani. The influence of Stendhal's travel literature can be felt in the opening pages, where he describes the setting of Verrières and the Jura mountains in the deliberately perfunctory, impersonal manner of a Baedeker. For the place is anything but inspiring, with its saw-mills and terraced walls, dominated by the arrogant presence of M. de Rênal's mansion. Stendhal has contrived everything to remind the reader of husbandry, property and self-interest, instead of the natural scenic beauty. As in Flaubert, there is the same unflattering portrayal of provincial life, with strongly caricatured portraits of M. de Rênal, the Mayor, whom Stendhal manages to dismiss with a few strokes of the pen, and of the hero's father, M. Sorel, the carpenter, a wily peasant and hard as nails, who sees his offspring only as a potential source of income. This is the claustrophobic setting against which Julien reacts so violently. Stendhal quickly establishes the environment in order to throw his hero into relief, and to make his subsequent behaviour understandable if not commendable.

Beauty, in *De l'Amour*, was defined as the promise of happiness, and in this sense too Stendhal's fiction can be seen as an extension of his writing on the fine arts. For the primary motivation of his heroes' behaviour is the same pursuit of happiness, with the difference that they look for it in action and adventure, whereas painting, books and music procure it in the form of contemplation. One of the most valuable lessons Stendhal learnt from the fine arts was that the capacity for spontaneous delight in beauty—

whether in art, landscape or people—is a measure of a person's disinterestedness. The unsympathetic characters in his novels, the Marquis del Dongo or M. de Rênal, are excluded from happiness because they are blind to everything outside their own immediate profit, whereas the heroes and heroines are constantly subject to irrational enthusiasms and states of exaltation. Ready to sacrifice everything for a few moments' ecstasy, they frequently act against their own interest: if Fabrice had been more cool and rational, he would never have gone to fight for Napoleon at Waterloo. This kind of passion was synonymous, for Stendhal, with the artistic temperament; indeed, both Fabrice and Julien have many of the qualities of potential artists. At the sound of the cathedral bells on the day of the procession at Besançon, instead of thinking of such material considerations as the bellringers' wages, Julien is transported with delight. He realizes that he is too much of an aesthete to make a good prelate, and Stendhal comments sardonically: 'Souls which can be deeply moved like this are at best good only to become artists.' These states of rhapsodic exaltation which his heroes experience are, as Marcel Proust noted, frequently produced by places of high altitude;[27] we think of Julien up in the Jura mountains where he catches sight of the eagle, the symbol of his own Napoleonic ambitions, or Fabrice high in the belfry of the village church at Grianta, overlooking Lake Como. There Fabrice enjoys a few moments of perfect bliss. He resolves to be true to his better self and not to feign love for his aunt for the sake of self-advancement, but good intentions of this kind are short-lived and soon 'the thought of privilege had blighted that delicate plant known as happiness.' Stendhal allows his heroes only a moment's respite for meditation, and quickly plunges them back into the intrigue. The ultimate symbol of self-sufficiency and detachment is the Farnese tower of the prison at Parma, in which Fabrice, incarcerated for killing the actor Giletti, experiences belated happiness in his love for the prison governor's daughter, Clélia Conti. Thus Stendhal shows how the kind of superior beings he admired manage to defy the laws of gravity, and to rise above their physical environment. Fabrice attains a sense of liberation from the petty vexations of everyday life and, totally absorbed in love, he stands both literally and metaphorically head and shoulders above the other characters.

The positive virtues of Stendhal's writing on the fine arts ought to be clear enough from the following selection for a lengthy appraisal to be unnecessary. As an art-critic, he may not stand in the same rank as Baudelaire, the Goncourts, or even Gautier, all of whom had a more natural feeling for pictures. But, unlike the later nineteenth-century art-for-art's-sakers, Stendhal was never tempted to make a cult of art, or to detach it from other human activities. His own intellectual curiosity, a wide knowledge of European literature, and interests in many different areas of study all taught him that works of art are not produced in a void, and that painters and writers are subject to the same prevalent influences as other men. While not a rigid determinist like Taine, Stendhal recognized art to be the product of a complex set of factors, all of which must be borne in mind in attempts at aesthetic analysis. For a variety of reasons, cultural history has become unfashionable today, and art-historians and literary specialists tend to treat the objects of their study as unrelated phenomena. Stendhal provides a salutory corrective to this kind of intellectual compartmentalization, and today would certainly have been a strong advocate of interdisciplinary studies. The other most precious quality in Stendhal is constant emphasis on aesthetic pleasure as the only possible basis for a proper understanding of art. He always remained that typically eighteenth-century combination of ideologist and man of sensibility. Although an élitist in the sense that he wrote for the 'happy few', he believed that most people, given the appropriate initiation, are potentially capable of enjoying art, if only they have the courage to follow their own inclinations, and refuse to let themselves be browbeaten by accepted opinions. For Stendhal, the first essential in aesthetic enjoyment is an attitude of open-mindedness. The next stage is one of application and self-cultivation, and in this Stendhal set an example, for as we can see from his letters and *Journal*, he worked consistently towards the development of his own natural gifts. His own pre-eminence as a writer was the result of long years of training, both of his stylistic ability and of his mental faculties in general. Every individual is theoretically capable of a similar effort, for Stendhal is one of the few nineteenth-century writers who retained an optimistic belief in the value of art as a means towards human perfectibility.

2 L'Histoire de la Peinture en Italie

INTRODUCTION

THE PAPACY

In the Middle Ages, as today, all rights were created by force; but today power seeks to give its actions the semblance of justice. A thousand years ago the bare idea of justice scarcely existed in the mind of the powerful baron who occasionally turned to reflection during the long period of confinement to his castle in the winter. The common man, reduced to his animal state, thought of nothing every day except providing the necessary food for his own existence. Amongst these degraded savages, the popes, whose power rested only on a few ideas, thus had the most difficult role to play in the world. Since you either had to be clever or perish, necessity created talent. In this respect several of the popes in the Middle Ages were extraordinary men.

It is obvious that there was no question of religion here, still less of morality. Without physical violence, they managed to rule over wild animals who only understood the rule of force; hence their greatness.

In order to be rich and powerful, they had merely to prove the existence of hell, that certain sins lead there and that they had the power of absolution. All the rest of religion was designed to reinforce these few truths. . . .

Every year Italy saw one of its towns subjugated by a despot or another despot driven beyond its walls. Incipient republicanism alternating with weak despots paying court to the men of wealth, this was the condition of all the cities during the two or three centuries before the emergence of the arts. It creates a strange pattern of civilization. Excited by idleness, wealth and the climate, the passions of the rich can only be restrained by public opinion or by religion. But the first of these two bonds did not yet exist, while the second was nullified by means of indulgences and hired confessors. It would be useless to attempt to visualize the tumultuous passions of those Italian souls in the chill light of our own experience. The roaring lion has been snatched from his forests and tamed into domestic servility. To find him in all his pride you must go deep into the Calabrian Mountains.

The tense nerves of the Mediterranean races give them a vivid

conception of the torments of hell. There is no limit to their generosity towards the things or people they hold sacred.

This is the third cause of the extraordinary brilliance of the arts in Italy. It needed a rich, passionate and deeply religious nation. A concatenation of unique accidents produced this nation, and it was endowed with the ability to derive the keenest pleasure from a few colours laid on a canvas. . . .

MEMOIRS OF EVERYDAY LIFE

Shall we now come down from the summits of history to the details of private life? First of all you must abandon all those sensible and dispassionate ideas about social utility which fill the Englishman's conversation for three quarters of his day. People did not gratify their vanities in subtleties; everyone wanted pleasure. Theories about life were not very advanced, and the only food for thought of this sombre, melancholic nation was passion and its dire, bloody results.

Open the confessions of Benvenuto Cellini, a straightforward book by the Saint-Simon of that time. It is little known because its simple language and profound sense offend long-winded writers. It has, however, some delightful passages. For instance, the beginning of his relationship with a great Roman lady, Porzia Chigi; for charm and exquisite spontaneity it is comparable to the story of that young shop-girl Rousseau found in Turin, Madame Basile.[1]

Boccaccio's *Decameron* is familiar. Its style copied from Cicero is tedious, but he paints a true picture of the customs of his day. Machiavelli's *Mandragola* is like a light illuminating the far distance; all this man needed to be a Molière was a rather more lively wit.

Open any collection of anecdotes from the sixteenth century at random. . . .

Casimo I ruled in Florence a short time after the great painters and was considered the luckiest prince of his time. Today people would pity his misfortune. On 14 April 1542 he had a daughter called Maria, who, as she grew older, acquired that exceptional beauty which the Medicis so conspicuously displayed. She was loved all too well by one of her father's pages, the young Malatesti da Rimini. An old Spaniard, Mediam, the man

in charge of the princess, surprised them one morning in the posture of the pretty group of *Love and Psyche*.[2]

The beautiful Maria died poisoned, while Malatesti managed to escape from a narrow prison twelve days or a fortnight later. He had already reached the island of Candia where his father was in charge of the Venetian army, when he fell victim to an assassin. Such was honour in those days, a cruel notion which replaced republican *virtù* and was no more than a base mixture of vanity and courage. . . .

It was in that passionate century when souls could yield freely to the highest pitch of emotion that so many great painters emerged. It is remarkable to think that they could all have been known by a single man. If he had been born the same year as Titian, that is in 1477, he could have spent forty years of his life with Leonardo da Vinci and Raphael, who died in 1519 and 1520 respectively. He might have spent many years with the divine Correggio, who only died in 1534 and with Michelangelo whose career lasted until 1563.

This fortunate art-lover would have been thirty-four at the death of Giorgione. He would have known Tintoretto, Bassano, Paolo Veronese, Garofalo, Giulio Romano, Fra Bartolommeo (died 1517), and the agreeable Andrea del Sarto, who lived until 1530; in short, all the great painters except those of the Bolognese school, which came a century later.

When nature was so fruitful during this short space of forty-two years from 1452 until 1494, when these great men were born, why has she been so dreadfully barren ever since? This, it seems, is something neither you nor I will ever know. . . .

MONARCHY AND THE FREEDOM OF THE ARTS

Although the painter's brush cannot speak, government by monarchy, even when the King is an angel of benevolence, is always an obstacle to the creation of masterpieces, not because it prohibits certain subjects but because it breaks an artist's soul.

It is less hostile to sculpture, an art which hardly allows for expression and seeks only beauty. I should never wish to deny that this form of government can be very just in respect of property and the freedom of its

subjects. What I say is that the habits it imposes on nations crush their morale. . . .

These ministers [in a monarchy] may be the most honest men in the world. But the desire to please them creates a servile mentality, has the disastrous result of pettiness and drives away all originality; for in a monarchy the man who is different from other people insults them, and then they revenge themselves by mockery. Henceforward there are no more true artists, no more Michelangelos, Guidos or Giorgiones. You have only to look at the activities in a small French town, when a prince of the blood is about to pass through, and the anxiety with which an unfortunate young man intrigues in order to gain a place in the mounted guard of honour. He finally attains his ambition not by talent, but by the lack of it; because he isn't against the authorities, and because the old lady who he plays cards with has some influence with the mayor's confessor. From that moment on he is ruined. . . .

To live at court is a misfortune for artists. Moreover they have a superior who has to be satisfied.

If Lebrun is the King's head painter all artists will copy Lebrun. But if, by some remote chance, some unlucky genius is insolent enough not to follow this style, the head artist will be careful not to encourage a talent which might, by its originality, put his royal master off his own. The leading painter may be a man of integrity, but he will not appreciate another kind of talent. Thus painting will always be mediocre in absolute monarchies. Poussin happened to be born in one and he went to die in Rome. . . .*

CHAPTER XV

ON FRENCH TASTE IN THE ARTS

The cause of bad taste among the French is infatuation. This in its turn stems from an even more unfortunate trait, namely our total lack of

* The arts must be linked to a mode of feeling and not to a system. Thus the democratic Assembly, not the Institute, is the only good judge of competitions.

character. We must make a distinction here between character and ostentation, and try to see why our generals were admired throughout Europe while our senators were its laughing-stock.

Did the Frenchman of 1770 ever really have sufficiently distorted sight to find Boucher's colours true to life? Surely not—that is impossible. But we have too much *amour propre* even to dare to be ourselves. The same man who can face pistol-shots without turning a hair suddenly takes on a ridiculously apprehensive expression when asked to begin a conversation about the play he has just seen. Everything is either *divine* or *detestable*, and when people are tired of the one word they use the other. . . .

Under Louis XIV we were religious; then Voltaire came and found his fame ready-made by ridiculing the priests. Fortunately he made excellent jokes and we still laugh at them.

After the crimes of the Terror, it did not need much mental effort to guess that public opinion demanded a different impulse, which made the people read *Le Génie du Christianisme*. . . .

In France admiration is impure by nature. To criticize the popular favourites would be stupid, because in order to defend a new opinion you are forced to uphold something of no importance by tedious argument. And panegyric, which is rather a silly game, happens to be endemic in the character of the wittiest nation in Europe.

CHAPTER XX

MASACCIO AND THE BEGINNING OF EXPRESSIVE ART

This man is a genius who marks an epoch in the history of art. He first learnt his style from the work of the sculptors Ghiberti and Donatello. Brunelleschi had revealed perspective to him. Then he went to Rome and probably studied the Antique.

Masaccio opened up a new path to painting. You only have to see the fine frescoes in the Carmelite Church,[3] which fortunately escaped the fire in 1771.

The foreshortening is admirable, and the attitudes of the figures show a

variety and accomplishment which even Paolo Uccello did not attain. The nude parts are treated simply but with great artistry. Finally, the highest praise that can honestly be bestowed on Masaccio is that his heads have something in common with Raphael's. Like the painter of Urbino he characterizes each figure in the composition with a different expression. That figure which has so often been praised in the *Baptism of Saint Peter*, a man who has just undressed trembling with cold, remained unrivalled until the century of Raphael. In other words Leonardo da Vinci, Fra Bartolommeo and Andrea del Sarto failed to equal it.

This point marks the beginning of expression.

All men, intelligent or stupid, passionate or lethargic, agree that man is worth nothing except by virtue of his heart and his mind. In order to function, the human machine needs blood and bones, but we pay hardly any attention to these material factors if we want to go straight to the great aim of life, its ultimate goal—that is, to think and to feel.

In comparison with expression, the history of draughtsmanship, colour and chiaroscuro and the various elements of painting are only its material conditions.

Expression is everything in art.

A picture without expression is merely an image made to entertain the eye for a moment. Of course painters must have mastered colour, drawing, perspective and so on; otherwise they aren't painters. But to stop at these secondary forms of perfection is to mistake the means for the goal, to fail in the artist's vocation. . . .

Through expression painting can enter into the noblest qualities in the heart of great men. *Napoleon touching the plague-stricken at Jaffa* [Plate 9]. *

Draughtsmanship earns the admiration of pedants.

Colour attracts the big English art dealers.

However, great painters should not be criticized too lightly for lack of

* In case people tell me that I don't know what I am talking about in art, I shall tell them that I stick closely to my own ideas and that I have lived through these years. I only quote this as a picture, and wouldn't state that he didn't have them poisoned afterwards.

expression. I have seen five or six great actions during my life and what struck me about heroes was that they don't give themselves airs. . . .

CHAPTER XXII

DEFINITIONS: THE PROBLEM OF STYLE

Let us imagine how several painters might treat the same subject: for example, the Adoration of the Magi.

A picture by Michelangelo will bear the mark of power and terror. The kings will be men worthy of their rank and will seem moved by the child as they kneel before him. With pretty, harmonious colours the picture would lose its effect, since the true harmony of the subject is a harsh one. When Haydn wanted to portray the first man driven out of Paradise, he did not choose the same harmonies as the agreeable Boccherini as he charms away the night with his tender strains.

Raphael will make us less conscious of the majesty of the kings. Instead all our attention will be drawn to the celestial purity of Mary and the expression of her son's face. The action will have lost its character of Hebrew ferocity. The spectator will be vaguely aware of God as a loving father.

If the picture is by Leonardo da Vinci, nobility will be even more perceptible than in Raphael. Our attention will not be diverted by strength and an ardent sensibility. People who cannot respond to majesty will be delighted by the kings' noble expression. Heavy with sombre half-tones, the picture will seem to exhale melancholy.

The same picture by Correggio will be a delight for the eye. Its qualities of divinity, majesty, and nobility will not strike the heart immediately. But the spectator will be incapable of taking his eyes off the picture and his soul will be happy. In this way he will grow aware of the presence of the Redeemer.

As for the material element in style, we shall see each of the ten or twelve great painters use different means.

The moral effect of a composition can be enhanced by the choice of colour, brushwork, distribution of shadow, certain accessories etc. Everyone

knows that a woman waiting for her lover and a woman waiting for her confessor do not wear the same hat.

Every great artist sought the means of conveying to the human heart the *particular impression* which seemed to him to be the ultimate aim of painting.

It would be absurd to expect connoisseurs to know the moral aim of art. On the other hand they are brilliant at distinguishing the broken finish of a Bassano from the melting colours of a Correggio. They have learnt that Bassano is recognizable by his bright greens, that he cannot draw feet and that he repeated a dozen familiar subjects throughout his lifetime. They know that Correggio attempts graceful foreshortening and can recognize the gentle expression of his faces, the adorable voluptousness in his eyes and the six inches of crystal which seems to coat all his pictures. . . .

There is nothing difficult in all this except how to put on a suitably knowing air. It is only one form of expertise like another, which should not deter anybody. To be successful at it you need neither genius nor a soul. . . .

Every artist's style, if he has a style at all, can be recognized in his draughtsmanship, the contours of his muscles, his shadows and drapery, and rendering of light and local colour, for each of these has its own special character. The true artist will differentiate the green of a tree which overhangs the lake where Leda is playing with the swan [Plate 5] from the green of a dark forest where assassins are lying in wait to murder the traveller. . . .*

Yellow and green are gay colours; blue is sad; red projects objects into the forefront; yellow attracts and retains shafts of light; azure blue is sombre and best suited to create an aura of mystery.

All the great artists use yellow for their haloes (including Correggio).†

If you stand in the Louvre between the *Transfiguration* [by Raphael] and the *Communion of St Jerome* [Plate 7], you will find something restful to the eye in Domenichino's picture: this is chiaroscuro. . . .

* Titian: *Martyrdom of St Peter*. [Stendhal is referring either to the picture formerly in SS. Giovanni e Paolo, destroyed in 1857, or to the version, now lost, once in the possession of Pope Pius V. Both pictures were engraved.]

† You must remember the amazing effect of the *St George* at Dresden.

CHAPTER XXX

THE GENERAL STATE OF MIND

Summary of the evolution of art in Tuscany around 1500. . . . Since artists had learnt how to imitate Nature exactly, much progress had been made, especially in their facial expressions which, even today, are surprisingly lively. But painters aspired to nothing beyond accurate reflection of reality; they were rarely selective.

Whoever could have conceived of an *ideal beauty*?

The rather vague notion we have of this term is crystal clear if we compare it with the fifteenth century's idea of it. When we read the works of criticism of that time we constantly find them call *beautiful* what is accurately imitated. Whenever people wanted to honour a painter in those days they called him the ape of Nature.

As soon as the conversation in a Paris drawing-room comes round to the subject of beauty, the examples of Apollo and Venus fly to everybody's lips. This comparison is so commonplace that it has even become a stock-in-trade for the popular song. How depressing for someone of Apollo's sublime majesty to be found in such a quarter! It shows, however, that even ordinary people know that a good statue must look like Apollo. And even if this idea is not absolutely correct, it is about as near to the truth as the ordinary man ever can be.

In good society people very aptly quote the heads of Niobe's family, Raphael's Madonnas, Guido Reni's Sibyls, and some people even mention Greek medallions. Better examples could not be found. But it ought to be pointed out that nobody ever discusses any ideal beauty other than the ideal of *contours*. The term seems only to apply to sculpture. People admire Titian's *St Peter*, but nobody thinks that colour can have its ideal beauty too. They go into ecstasies over Correggio's *Night*[4] but never say: 'This is the ideal beauty of chiaroscuro.' In respect to these two important elements in painting, which are far more intrinsic to the art than beauty of outline, we are no more advanced than the Italians of 1500. We sense their appeal but fail to discover their cause.*

* The aim of the Ideal is to make the imitation more intelligible than Nature by the elimination of detail.

It is quite obvious that Ghirlandajo and his pupils lacked the assistance of public opinion as enlightened as ours today.

It is also clear that, as far as the technical aspects of art were concerned, there was still progress to be made by filling out the contours, creating more harmonious colours, more accurate aerial perspective, greater variety of composition, and above all ease of brushwork, which always seems laborious in the painters discussed up to now. For such is the strangeness of the human heart, that for works of art to give the utmost pleasure, they must appear to have been created painlessly. We enjoy the charm of his picture at the same time as we enter into the artist's mind. As soon as effort is apparent, the magical sensation vanishes. Apelles used to say: 'If some people think I am slightly better than Protogenes, it is only because he cannot leave his work alone.'

A little conspicuous negligence adds to a picture's charm. The Florentine painters would have regarded it as a crime. . . .

ON THE DIFFERENCE BETWEEN PAINTING AND LITERATURE

In order to describe a person like the Virgin in the *Madonna alla Seggiola* [Plate 4] words need a long succession of events; painting can place her before our heart in the twinkling of an eye. Whenever poetry enumerates it fails to make a deep enough impression on our heart to make us complete the picture.

The privilege of painting is that it speaks to those sensitive souls who have not penetrated the labyrinth of the human heart; to the people of the fifteenth century, whom it can address in pure language unadulterated by usage and to whom it can give a sensuous pleasure. For there can be no better prelude to logical argument than sensuous pleasure; hence the great advantage of comedy. . . .

Logic is less essential to painting than to poetry. Certain emotions must by analysed with mathematical precision; but you must experience these emotions. Anyone who cannot sense that melancholy is basic to Gothic architecture and joy to Greek architecture should study algebra. . . .

If Michelangelo had only read thirty pages of Tracy's *Logique*,[5] what

extremes of terror he could have struck into the ordinary man, how he might have inspired great hearts with sublime feelings! . . .

CHAPTER XXXIV

THE ARTIST

Every artist must see Nature in his own way. What is more absurd than to borrow the vision of another man, often of totally different character? What would Caravaggio have become if he had studied Correggio, or Andrea del Sarto, if he had copied Michelangelo? My philosophy is a stern one, and so it must be. It is to expect, in other words, all artists to be superior men. The humble truth is that, up to a certain stage, the pupil perceives nothing in Nature. First of all his hand must learn to obey, then to recognize in Nature the elements his master has extracted. Once the blindfold is off, if he is at all gifted, he will learn to notice the things which he in his turn must represent to give pleasure to men with souls like his own. The great problem here is that he must *have* a soul.

The mass of honourable but mediocre pictures have been left to us by intelligent and talented men whose misfortune it was never to have known sadness. The character of a Duclos[6] is not unusual in the history of art. What did Annibale and Ludovico Carracci lack to rival Raphael and Correggio? What do so many men lack to become good second-rate painters?

You do not need any sensibility to be a great general or a distinguished legislator. But in the Fine Arts (so called because they give pleasure by means of beauty) you need a soul, even to portray the most dispassionate things.

What could be apparently less interesting than this observation: swallows make their nests in places with remarkably pure air?

And yet nothing could speak to man more graphically of his misfortunes, or cast him into darker and more profound meditation than these words:

> This guest of summer,
> The temple-haunting martlet, does approve,
> By his lov'd mansionry that the heaven's breath
> Smells wooingly here . . .
> Where they most breed and haunt, I have observ'd,
> The air is delicate.
>
> *Macbeth*, I. vi

This is the art of bringing passionate life in details, the supreme achievement of sublime spirits which the vulgar will never be made to feel. He will never see any more in Banquo's remark than an observation of natural history, and an inaccurate one if he dared say so. . . .

All men who take some interest in life and have keenly felt the despotic hold of beauty might have become artists. Whenever passion left them some peace of mind they might have portrayed it, and thus filled a terrible feeling of emptiness by the pleasure of work. But the potential sculptor lacks skill in carving marble, the man who might have been an artist cannot draw, and the poet cannot write verse. Meanwhile, beside them soulless craftsmen excel at these techniques. What a poet *Mademoiselle de Lespinasse* would have made if she had written verse like *Colardeau*![7]

In the fifteenth century people felt things more keenly. Life was not stifled by etiquette, and the Old Masters were not always on hand to be copied. Stupidity among men of letters had no other disguise than to imitate Petrarch. Violent passions had not yet been extinguished by excessive politeness. Everything was less professional and more spontaneous. Great men always associated the woman they loved with the success of their art. A few people will understand Raphael's happiness as he painted the sublime *Saint Cecilia* from La Fornarina. . . .*

THE ARTIST AND LOVE

I do not deny that it is possible to be a passionate lover and a very bad painter. But Mozart did not have the soul of a man like Washington.

* The happy few. In 1817, among that section of the public less than thirty-five years old and with an annual income of more than 100 Louis and less than 20,000 Francs.

Isn't the easiest form of distraction for the unhappy lover the recollection of his passion? The rest is the art of moving hearts, an art which he has strongly experienced.

The artist's work in these conditions is merely to recall in their correct sequence the cruel cherished thoughts which constantly afflict him. By a deep-rooted psychological habit, self-esteem usually intervenes and suppresses them. But now the soul feels no more inhibitions, and finds a new pleasure in the recollection of past emotion. Gradually aesthetic sensations merge with the sensations offered by life. Henceforward the painter is on the right track. It only remains to see whether he was endowed with creative power. . . .

'But', some Duclos will say to me, 'you see love everywhere.'

I shall say to him: 'I have travelled the length of Europe, from Naples to Moscow, with all her most original historians in my coach.'

Love is the only remaining form of activity as soon as people are bored in the Forum, or no longer have to go out armed. Whatever people say, the climate of Naples makes people feel the subtleties of love very differently from the way it is experienced among the mists of Middelburg. When Rubens wanted to create beauty he was forced to make a display of the sort of charms which have no more than an exotic value in Italy.

In this hot, idle climate people are in love until the age of fifty and become desperate when jilted. Even the judges are agreeable and unpedantic.

The establishment of regular government in Italy around 1450 thrust a vast amount of leisure on society, and if idleness seems hard to bear at first, after a while it becomes intolerable. . . .

STENDHAL'S IDEAL READER

If I am read at all, I hope it will be by some sensitive soul who will open my book to know the life of the man Raphael, who painted the *Madonna alla Seggiola*, or of Correggio, who created the head in the *Madonna alla Scodella*.[8]

This unique reader (I should expect him to be unique in every way) will buy some engravings and gradually learn to enjoy more and more paintings.

The young man kneeling in a green tunic in Raphael's *Assumption* or the Benedictine monk fingering the keyboard in Giorgione's *Concert* will become dear to him. In this last picture he will see what fools tender souls can be, like Werther talking of passion to the frigid Albert. My dear, unknown reader (dear only because I don't know you), you may yield to the fine arts with all confidence. For study which may seem dry at first will bring you strong consolation in the depths of your sorrows.

Little by little the reader will learn to distinguish the different schools and recognize the masters. This knowledge will increase and bring him new pleasures. He would never have believed that thought could produce feeling. Nor did I; and I was very surprised when I took up the study of painting out of boredom and found that it was like balm to unbearable suffering. . . .

CHAPTER XLV

LEONARDO AT SANTA MARIA DELLE GRAZIE, MILAN

You must know this picture [*The Last Supper*]; it is the original from which Morghen[9] did his fine engraving.

The painter had to represent that poignant moment when Jesus, seen simply as a young philosopher surrounded by his followers on the eve of his death, says to them with deep emotion: 'Verily I say unto you, that one of you shall betray me.' Such a loving heart must have been profoundly moved at the thought that among his twelve chosen friends—with whom he had taken refuge to escape an unjust persecution, and whom he wished to see assembled that day at a fraternal meal as a symbol of the union of hearts and universal love he wanted to bring about on earth—there was a traitor about to hand him over to his enemies in return for a sum of money. To be expressed in painting, such sublime and moving grief demanded the simplest disposition of the figures, in order to fix the whole of our attention on the words uttered by Jesus at this moment. The expressions of the disciples had to be of great beauty and their gestures exceptionally noble to make it clear that Jesus' suffering was not due to a

base fear of death. An ordinary man would not have wasted time on dangerous pity; he would have stabbed Judas, or at least taken flight with the faithful disciples.

Leonardo da Vinci sensed the heavenly purity and profound sensibility which mark the action of Jesus. Racked by the detestable indignity of an act of such treachery, appalled at the sight of such human wickedness, he turns away from life in disgust, preferring to abandon himself to the divine sadness which overwhelms his soul, rather than attempt to save an unhappy life constantly surrounded by such thankless men. Jesus watches the collapse of his system of universal love. 'I was wrong,' he said, 'I judged men after my own heart'. His emotion is so strong that, as he pronounces to the disciples these sad words, 'One of you shall betray me', he dares not look one of them in the face. . . .

But we sense that all the men surrounding Jesus are only disciples, and the eye, after surveying the various characters, soon returns to their sublime master.

Such dignity in suffering is truly heart-rending. Our hearts are brought back to the sight of one of the great misfortunes of humanity, the betrayal of friendship. In order to relieve the feeling of claustrophobia, an impression of open air was needed. So the artist painted the open door and two windows at the far end of the room. The eye finds repose as it perceives a peaceful landscape in the distance. A longing of the heart is satisfied by this calm silence, which reigned on Mount Sion, where Jesus used to assemble his disciples. The evening light with its dying beams falling over the landscape inparts to it a tinge of sadness in harmony with the state of the action. He knows that this will be the last evening the Friend of Man will pass on earth. The next day at sunset he will no longer be alive. . . .

CHAPTER LIV

ON HISTORICAL TRUTH

A criticism has been made of Leonardo. It is a fact that Christ and the apostles took their meals lying on couches and not sitting at a table as we

do today. But Leonardo is a great artist precisely because he did not display his knowledge. It is the same with historical truth in tragedy. If you take from history customs which are unfamiliar to the ordinary playgoer he will stop in surprise. The theatrical effect is destroyed because it cannot quickly penetrate the heart via the mind.

A mirror should not draw attention to itself, it should show the reflected image with perfect clarity. . . .

We forgive Shakespeare for siting harbours in Bohemia because he depicts human emotions with a depth as remarkable as the geographical knowledge of MM. Dussault, Nodier, Martin[10] etc.

Even if the etiquette governing meals in the past had been more widely known in Leonardo's time he would still have ignored it. That great artist Poussin painted a picture of the *Last Supper* with the apostles seated on couches—a detail which the semi-learned applaud from the full height of their knowledge. But this is perhaps the first time you ever heard of that picture, in which the figures are very awkwardly foreshortened. The surprised onlooker merely makes some remark about the painter's ingenuity and moves on. If we could see Christ's Last Supper with all the accurate details concerning Jewish ritual we should be surprised but hardly moved. The great painters were intelligent enough to spare us the absurd, primitive customs of our barbarian ancestors when they had abandoned warfare and decided to adopt the Ossian of this small Hebrew tribe as their Bible.

CHAPTER LXVI

WE KNOW WHAT WE LIKE

It is possible to become an artist by learning the rules from books and not from the heart. That such books of rules exist is the misfortune of our age. For precepts of this kind mark the limits of the talent of our artists. Lame rules cannot keep up with the impetus of genius.

Moreover, since rules are based on the sum total of all men's taste, they are by nature opposed to the encouragement of original talent. Hence the

quantity of pictures which cause young art-lovers so much embarrassment at exhibitions. They are at a loss how to criticize; to criticize would be creative.

To crown the iniquity, these artist–parrots impose their oracles on others as if they had derived them first-hand from Nature.

A hundred thousand Frenchmen have been taught literature by *La Harpe*[11] and had their judgement ruined in the process. In addition he has stifled two or three men of genius (notably in the provinces).

Like the Vismara, an Indian butterfly, true talent takes its colouring from the plant it feeds on. I, who always enjoy the same stories, opinions and natural scenery, how could I fail to delight in my own talent, which nourishes me with everything I most love?

AESTHETIC PREFERENCES

What an excellent subject for comedy: the La Harpes and all the other people of taste in France dictating to nations from the height of their pulpits, boldly pronouncing scornful judgement on men's different preferences, when in fact they are quite ignorant of the first principles of anthropology! Hence the inanity of the arguments about Racine and Shakespeare, Rubens and Raphael. All we can do is to ascertain, after scholarly research, whether the majority follow the banner of the author of *Macbeth* or the author of *Iphigénie*. If our scholar had Montesquieu's intelligence he might say: 'Racine's admirers are the product of monarchy and a temperate climate, while Shakespearian enthusiasts are created by turbulent freedom and extreme climates.' But even if Racine appealed only to a single man, and the rest of the world voted for the author of *Othello*, the rest of the world would be fools if they said to him through the mouthpiece of some conceited little pedant: 'Be careful, my friend, you are mistaken, you have lapsed into bad taste. You prefer peas to asparagus, while *I* prefer asparagus to peas.'

Freed of all extraneous judgements, and reduced to pure sensation, aesthetic preferences permit no reply.

Good books on the arts are not collections of judgements in the manner of La Harpe, but books which illuminate the depths of the human heart,

revealing beauties to me which I was pre-disposed to love but, for lack of initiation, could not understand.

ECLECTICISM

We Parisians, chilled as we are far more by the fear of ridicule than the Seine mists, when we meet an artist in society who shows indulgence for another artist of opposite tendencies, we say: 'What a very sensible man!' But a certain kind of common sense no more goes together with enthusiasm than ice and the sun, freedom and a war-hero, Hume and Tasso.

The true artist with an energetic and active heart is essentially intolerant. Given power he would be the most terrible tyrant. Although I am no artist, if I had supreme power I am not sure that I wouldn't have the *Galerie du Luxembourg* razed to the ground, since it corrupts the taste of so many Frenchmen.

CHAPTER LXVII

ON THE CLASSICAL IDEAL OF BEAUTY

Classical beauty was discovered only gradually. Images of the gods were originally simply blocks of stone, which were later carved to present a crude shape vaguely recalling the human body. Then came the statues of the Egyptians, and finally the *Apollo Belvedere* [Plate 1].

But how was this gap bridged? This is where we must fall back on the evidence of pure reason.

CHAPTER LXX

WHERE ARE THE ANCIENT GREEKS TO BE FOUND?

Not in the dark corner of some vast library, bent over desks laden with piles of dusty manuscripts, but in the North American forests out hunting

with the savages of the Wabash. The climate there is not so pleasant, but that is where the Achilles and Hercules are today.

CHAPTER LXXI

PUBLIC OPINION AMONG SAVAGES

The first mark of distinction among savages is strength. The second is youthfulness because it promises a long exercise of strength. These are the qualities they extol in their songs, and if certain conditions (too complex to be analysed here) had made it possible for the arts to flourish among them, there is no doubt that once their artists had learnt how to imitate Nature their first statues of the gods would have been portraits of the strongest and most handsome young warriors in the tribe. Feminine opinion would decide which men the artist ought to take as his model.

For at the root of the feeling for beauty there is perhaps a certain amount of instinct, as in maternal love.

Instinct has been denied by some people. You have only to watch little birds and see how they immediately start pecking the corn at their feet as soon as they are hatched.

CHAPTER LXXIII

THE QUALITIES OF THE GODS

To be accurate, it must be said that at first the distress of primitive peoples is such that they have no time to pay attention to feelings of terror, and have no conception of the gods. Then they think of powers of good and evil; but they offer prayers only to the powers of evil, for what have they to fear from the good? Finally comes the notion of a higher divinity, and this is where I begin.

Now, for logical people, what is the most welcome quality in a god?

Justice. In the eyes of a people, justice is the practical exercise of the well-known maxim: 'Let the supreme law be the general salvation.'

If you are faced with the choice of sacrificing a hundred old men unable to withstand hunger and two weeks' march across country with no food, and of leading the tribe into a fertile region—failing which everyone will die of hunger in the forest; there can be no hesitation, the old men must be sacrificed. They themselves know they must die and they frequently ask their children to kill them. The sort of justice which prescribes such acts of sacrifice cannot have a cheerful expression. The main characteristic of these statues will therefore be a look of deep seriousness and intense watchfulness.

CHAPTER LXXIV

THE GODS LOSE THEIR MENACING EXPRESSION

I have traced the origin of the arts back to the cultivation of the land. As the tribe gradually loses its fear of starvation, the savage will take some rest, since he is no longer compelled to exercise his strength every day in order to survive. To while away the boredom produced by leisure and the absence of physical exhaustion, men will immediately turn to song, religion, and the arts associated with religion. They will become critical of what they admired a hundred years earlier. True strength does not express itself in anger; for anger supposes the effort to overcome an unforeseen obstacle. But for real wisdom nothing is unforeseen. Extreme strength never involves effort.

Thus the gods lose that menacing look expressing an angry disposition, which the warrior finds effective in striking fear into his enemy. Since the god already suggests strength by his accentuated muscles and the thunderbolt under his arm, it is unnecessary to emphasize this by a threatening appearance. Imagine a man recognized by the rest of his tribe as by far the strongest, and ask yourself: 'What would be the best expression for him to assume?' One of benevolence. Added to wisdom and strength, the god will bear the mark of an untroubled serenity. Here we are already face to face

with the Greeks' *Jupiter Mansuetus*, that sublime head eternally admired by artists. Notice that its neck is very broad and muscular, one of the main signs of strength. It has a strongly pronounced brow, which denotes wisdom.

CHAPTER LXXVI

ODDLY ENOUGH, NATURE MUST NOT BE COPIED EXACTLY

Our primitive races begin to use their brains as soon as they have some leisure, and they notice in their strongest warriors that physical exertion involves a certain deterioration of the parts of the body. The native of the Wabash who walks barefoot as a child and even later only wears makeshift shoes has feet protected by a kind of horny skin, allowing him to stride through thorns and brambles. His calves are badly scarred . . . as a result of this harsh life, countless accidents, falls, wounds, pains caused by the cold nights have added their own individual blemishes to the usual imperfections produced by strenuous physical exercise. It is easy to avoid showing the signs of such blemishes in images of the gods.

CHAPTER LXXXIII

IDEAL BEAUTY

Classical beauty therefore is the expression of a useful quality. Because, to be of the greatest possible use, a quality must be combined with all other physical advantages. Since all passions disrupt habit, they are prejudicial to beauty. . . .

CHAPTER LXXXIV

ON THE FRIGIDITY OF THE ANTIQUE

Art must command our attention. When the spectator is paying reasonable attention, the author who says three words in a certain time will have the advantage over the man who says twenty. In his case the spectator is creative; but the dull man will find him arid.

Many bas-reliefs in classical Antiquity were inscriptions.

Whenever a figure becomes a hieroglyph it tends to be more remote from reality, but more easily legible as a symbol.[12]

The elimination of detail in classical sculpture makes the various parts of the body seem larger; at the same time giving it an apparent rigidity and nobility. The earliest Greek sculpture is characterized by a calm style and great simplicity of design. It is recorded that, at the apogee of Greek civilization, Pericles wanted all statues to preserve that primitive simplicity which seemed to him evocative of the notion of greatness.

CHAPTER LXXXV

THE TORSO IS MORE IMPRESSIVE THAN THE LAOCOÖN

I shall not go into detail. Why in my view is the *Torso*,[13] which slightly attenuates Herculean strength by the elegance we associate with the divine, why is this figure of a more sublime style than the *Laocoön?*

If the reader likes my ideas he will see what I mean [Plate 2]. You need only feel. The man of passion who yields to the effect of the fine arts will find everything in his own heart.

CHAPTER LXXXVII

SCULPTURE AS A MEDIUM

That eternal obstacle of the graphic arts, movement, is what tells me that

a living thigh is hidden beneath this drapery with its thick, shapeless folds. But only light, unsymmetrical draperies are permitted in sculpture.

Sculpture as a medium is limited to expressing physical appearances through the muscles. Thus full-size statues can only represent permanent characteristics or emotions which have become habitual. Forms can be slightly modified by emotions.

Sculpture cannot represent anything sudden.

Sculpture only admits subjects in which the entire body is fully represented; since, because the body must be naked, it claims a share of our attention. For the sculptor, Tancred in a rage, fighting the perfidious enemy who has just set fire to the Christians' tower, and Tancred a quarter of an hour later in the most terrible plight imaginable, are only one and the same man. All he can do is to create two busts; how can he show Tancred's shoulders as he leans towards Clorinda to baptize her?[14] These shoulders must be visible and yet refuse to lend themselves to treatment in sculpture; they would look merely lifeless. Painting is more fortunate, since it can simply hide them in armour and lose none of its effect.

Painting is superior to sculpture even in the two expressive busts; for what is the most moving bust seen from behind? On the other hand, in a bust in which *character* predominates, everything is expressive, and even Raphael cannot rival the *Jupiter Mansuetus*. This is because the sculptor can make each form convey a far greater number of ideas than the painter.

Consequently, when the sculptor follows the example of the brilliant heretic Bernini, and attempts to rival painting by contrasted groups, he makes the same kind of mistake as when he paints marble flesh colour. Reality has a charm which sanctifies everything and constantly gives us new lessons in the great art of happiness. A true story can evoke the most tender sympathy, but when it is invented it is merely commonplace. Absurdity, however, ensures that the limits of the arts are respected.

Art-lovers frequently compare Livy's *Coriolanus* with the version by Poussin.[15] History relates how Veturia and the Roman women described Rome to Coriolanus as a scene of desolation and weeping, in order to move the hero's heart over his country's plight. They finish their speeches with this moving picture.

Poussin represented it by a *visible* female figure carrying the symbols of

Rome. This figure is being pointed out to Coriolanus by some Roman women and serves to complete the composition.

This sort of mistake is called by men of letters the *poetic beauty* of a picture. Livy's image of grief-stricken Rome is overwhelming; Poussin's is merely ridiculous. This great painter failed to see that poetry has to describe Angelica's cheeks as a bed of lilies and roses only because it cannot portray the beauty of flesh.

Shakespeare would have said to Poussin: 'Can't you remember that we are organically incapable of understanding with our hearts and minds at the same time? As soon as a picture shows me fictitious characters next to real ones it no longer moves me, and becomes only a more or less interesting enigma.'

The poet leaves to each reader's imagination the job of adding in the physical dimensions of his characters.

CHAPTER LXXXIX

A SCULPTOR

I shall not abandon my Greeks because they have become happy. Love was encouraged by the warm climate in their country, and religion did not freeze it but favoured it. The example of the gods invited mortals to enjoy voluptuous pleasures. The Isthmian games were inaugurated and prizes were awarded to beauty by the assembled Greek nation.

The artist was carried by public opinion before sterner judges, more ardent admirers and more awe-inspiring rivals. In his heart a thirst for glory was kindled as strong as the human body can endure. He quickly forgot the time when he desired fame to bring him the attentions of the most beautiful women, esteem, wealth and happiness in life.

Far from pursuing these coarser pleasures, he learnt to despise them; they would have sapped his moral faculties and his ability to feel and create the sublime. Health, life, he sacrificed everything to that thirst for immortal fame. For him real life was only the scaffolding on which to raise his glory. He lived only for the future.

Shy and lonely, he avoided human company and barely ate enough food to keep alive. If he was born in a hot climate, such efforts were rewarded by ecstatic visions; he created masterpieces and died half-mad in the middle of his career.* And it is such a man whom our unjust society would have wise, moderate and cautious. Would a cautious man sacrifice his life to please people like you, with all your wisdom of mediocrity?

After all, the philosopher asks, how should life be valued? By a long succession of colourless days, or by the quantity and intensity of pleasure?

CHAPTER XC

THE PROBLEMS OF PAINTING AND DRAMA

The epic poet can manage with a lively imagination and a talent for versification. Deep understanding of beauty is enough for the sculptor. But the art of the painter and the dramatic poet is determined by one special factor.

Emotion cannot be seen with the human eye, whereas fire and funeral processions can.[16] Only their effects are visible. Werther kills himself out of love. M. Muzart comes into Werther's room and discovers the handsome young man lying on his bed; but how can he see the process which drove Werther to suicide?

This can only be found in one's own heart. Men who have never known the madness of love can have no more idea of the fatal agony which can break a passionate heart than people had of the moon before they had seen it through Herschel's telescope. Nothing can describe the impression of that snow which looks as if it had been trodden by a round-footed animal.

To be effective, painting and drama must be able to convey the impression of that snow to people who have never seen it.

The method used by our modern Alexandrine poets to describe this strange sight is to copy the original picture from Racine. Even more

* I regret to say so, but you must be chaste in order to appreciate classical beauty. The calm appearance of sculpture can only be attained by the man capable of painting passion in all its violence.

absurd than their tragedies is the way these men maintain in their prefaces, biographies etc. that Racine was too sensible ever to be a victim of passion, and that he found the emotions of Oreste and Phèdre by reading Euripides.

How can you describe passion if you have not experienced it? And how can the artist who feels it beating in his heart spare the time to acquire talent?

CHAPTER XCII

TEMPERAMENT: SIX TYPES OF MEN

The possible combinations of temperament are endless. But, for his own guidance, the artist will distinguish the six most pronounced temperaments to which all others can be related: the sanguine, the bilious, the phlegmatic, the melancholic, the nervous and the athletic.

This concept is less useful for individuals than for nations.*

CHAPTER XCIII

NOTE ON PHYSIOLOGY

In politics or in the arts you cannot reach sublime heights without a knowledge of man, and you must have the courage to begin at the beginning, with *physiology*.

* I ought to have included here a copy of Lavater's caricatures of the four temperaments, or made engravings of the drawings I had done for me on my travels of people who seemed to have temperaments of a particularly marked kind. But patience is not my virtue.

CHAPTER XCIV

THE BILIOUS TEMPERAMENT: MICHELANGELO

Violent sensations, sudden, impetuous movements, and sensations as quick and volatile as in the sanguine man; but since each sensation is so much stronger, they become still more dominant while they last. The consuming passion in the bilious man generates even more absolute, more exclusive and more changeable ideas and emotions.

This temperament plunges him into a constant state of anxiety. The easy well-being of the sanguine man is quite foreign to him, and he can find rest only in violent activity. Only in extreme moments when danger or difficulty claim all his powers and he is fully conscious of them every minute, only then can this man enjoy life. The bilious man is driven on to greatness by his physical constitution. . . .

Giulio Romano and Michelangelo painted bilious characters exclusively. Guido Reni, on the other hand, attained a celestial beauty by portraying only sanguine people; hence the innocuous quality of his art. This is surprising in Italy, where painters lived among a bilious nation.

CHAPTER XCV

I shall be accused of giving too much importance to temperament. I agree that there are other external symptoms in life, equally striking and unmistakable. But all these symptoms involve movement; important though they are for music and pantomime, they are of no use to the graphic arts, which remain silent and almost motionless. . . . A clever watchmaker can judge the time by looking at the mechanism of a clock. The painter must use form to reveal a person's character as it is determined by his physical constitution.

CHAPTER XCVIII

THE ATHLETIC AND NERVOUS TEMPERAMENTS

In a puny little body, Voltaire had that brilliant mind typical of the eighteenth century. For us he is therefore typical of the nervous temperament. . . .

Now I ask the reader to call to mind the strongest men he has known. Didn't their strength go together with heart-breakingly slow reactions to moral impressions? Could such heavy bodies be expected to perform noble deeds?

Even among the Ancients, who prized strength so highly, and rightly so, the prototype of all athletes, Hercules, was more famous for courage than intelligence. *

CHAPTER XCI

THE INFLUENCE OF CLIMATES

Climate and temperament determine the strength of the [creative] impulse; upbringing and custom determine the direction in which it is channelled.

CHAPTER C

Temperaments, in the long run, are the product of climate. The Dutch sailor who settles in Naples may acquire a bilious temperament, but in his son or grandson it will have become hereditary.

A sanguine nation is produced by a gentle atmosphere, light rainfall,

* Because the Italian painters (Guercino, for instance) had not noticed this fact they made their saints too strong and made them look like surly labourers.

and moderate temperatures. It is obviously absurd to speak of French gaiety among the mists of Picardy or the dreary chalk plains of Champagne. . . .

Mild temperatures combined with all other favourable conditions, but subject to frequent sudden changes, make that combination of temperaments very common in a nation which can be described the *sanguine-bilious*. This is the French temperament, and I don't think it is French vanity which makes this seem to me the happiest one. The greatest obstacle to happiness among the French, I think, is *envy*, but provided they have the firmness to defend their constitution of 1814, this gloomy feeling will disappear in our children.

CHAPTER CI

HOW CAN WE IMPROVE ON RAPHAEL?

In scenes of pathos produced by the passions, the great painter of modern times, if ever he emerges, will give each of his figures the ideal beauty derived from the temperament most likely to feel the full effects of those passions.

It will not be left to chance to decide whether Werther should have a sanguine or a melancholic temperament, and Lovelace a phlegmatic or bilious one. The good curate Primrose and the pleasant Cassio will not have bilious temperaments, but rather the Jew Shylock, the sombre Iago, Lady Macbeth and Richard III. The sweet, pure Imogen will be slightly phlegmatic.

The *Apollo Belvedere* [Plate 1] was created on these principles. But every time the artist wants to show a handsome young god, will he merely produce sterile copies of the Apollo? No, he will match the type of beauty to the action. Apollo delivering the earth from the serpent Python will be strong, but when paying court to Daphne he will have gentler features.

CHAPTER CII

SELF-INTEREST AND FEELING

As far as the ordinary human beings are concerned who form the subject-matter of painting (as the gods do of sculpture), the artist observes that a man's character is his usual way of looking for happiness. But moral habits and their physical expression are changed by passion. A passion is a new aim in life, a new way to happiness which makes us forget all others and renounce habit. When he represents passion, to what extent ought the artist to modify beauty or change his predominantly utilitarian view of character? To what point can man forget his immediate interest and yield to the delight of spontaneous feeling? This question must be put to artists like Raphael, Poussin and Domenichino, since the only answer can be to take up the paint-brush. At this stage discussion usually trails off into *obscurity*, the besetting sin of all art-criticism.

CHAPTER CIV

WHO IS RIGHT?

[Stendhal shows how aesthetic preferences are a matter of mood and the moment: there can be no choice between Mozart or Cimarosa, or works like a Raphael Madonna and the head of Apollo.]

Once great artists have reached these heights who will dare to decide between them? That would be to prefer yesterday's love to tomorrow's love, and passionate hearts know all too well that pure love leaves no memories.

When we come down from this empyrean air to the level of our usual mediocrity we can only judge art by its effects, and admiration leaves no traces.

The general rule rightly says that we judge the strength of a passion by the one we sacrifice to it. But everything in this question is variable, even the most permanent of man's attachments, the love of life.

If admiration leaves no memories behind, and if no human being can feel the beauty of those divine works in a single day, who will step forward and decide between Canova's *Pâris*[17] and Michelangelo's *Moses?*

CHAPTER CV

ADMIRATION

The author of this history will not disclose his own opinion, which is probably only the product of his particular temperament. Sanguine and melancholic temperaments will perhaps prefer the *Pâris*. Bilious ones will be delighted with the terrifying expression of *Moses*; even the phlegmatic will feel slightly moved.

CHAPTER CVI

HAVING THE COURAGE OF OUR OWN OPINIONS

For the majority of readers, all this has about as much interest as for a man blind from birth. When men visit the Museum with women, as they enter the Galerie d'Apollon, they look for something pretty; or if they are with a friend, they try to remember some intellectual notion or learned phrase by Winckelmann. Even the provincial has to express his admiration out loud and quotes from Dupaty's Travels.[18] Nobody has come to look. Even among genuine art-lovers, which of them has the modesty to walk with his eyes lowered to the floor straight up to the picture he has come to see? They might do better to invoke the shade of Lichtenberg *[19] and ask him for a witticism on each picture. What possible interest can I take in their heated discussions on the respective merits of the two claimants to the Chinese Empire?

* Chamfort's wit in a German professor who has written on the adorable Hogarth.

CHAPTER CVIII

THE ART OF LOOKING

To take pleasure in the *Apollo* you must look at it in the same way as at a fast skater on the lake at La Villette. You admire his skill and you laugh when he falls. The sculptor's job, it seems, was to please everyone. If he cannot win the attention of a well-educated man not too preoccupied by unhappiness or too much pleasure, it is his own fault. This person should not blame himself for his lack of response, and, above all, should not try to force admiration. That would be enough to put him off the arts for good.

He should wait. In a year or two, when he comes into the Museum one day by chance, he will be surprised to find his eyes fall on the *Apollo* with pleasure and discover great beauty in it. Each line seems to speak in a voice which exalts and delights his heart. He leaves in a rapture and preserves a long memory of his visit.

If those expressions of pleasure, delight and happiness which I hear every day as I walk down the galleries were sincere, this place would be besieged by more people than the door of a ministry. There would be crowds as large as at exhibitions on Fridays. Every man of the world has enough knowledge to appreciate the shape of a pretty woman, and yet we refuse to acquire the elementary but indispensable knowledge to look at pictures. As a result the Museum of Paris is deserted. . . .

CHAPTER VIII

ON STYLE IN PORTRAITURE

[A fictitious conversation between Stendhal and a casual acquaintance on the respective merits of classical and modern sculpture. Stendhal explains how the former achieves its effect by simplification and stylization, and deliberately avoids too much naturalistic detail because 'sculpture draws too much attention to the object it intends to represent'. The following chapter is a continuation of the discussion.]

CHAPTER CIX

HOW AN ACTIVE LIFE IS INCOMPATIBLE WITH LOVE OF THE ARTS

Here we are again in front of the *Apollo*. At first I am greeted with a minor volley of erudition. I notice that my friend, obviously impressed by my chatter yesterday, has ordered Winckelmann and Lessing from his bookshop.

'Let's forget about the learned Winckelmann.'

'Quite right,' he replies laughingly, 'because he fails to answer an objection which is causing me a lot of worry. The greatest artist must avoid details; but then we have art reverting to its infancy in its search for perfection. The earliest sculptors did not show detail either. The difference between them and modern sculptors is that in their case, as they created the arms and legs of their statues all of a piece, it was not they who avoided detail but detail which avoided them. Note that you must have mastered something before you select. The sculptor of *Antinous*[20] kept certain details and developed them further. In particular he has accentuated their physical characteristics and given them greater clarity of expression. Take that other portrait, Canova's *Statue of Napoleon*, and look at the leg and especially the foot. I am deliberately taking the least noble parts, and yet how noble these are! From whatever distance you see the statue, you can not only distinguish each part of the body but also tell that it is a hero's body. The broad outlines of his leg have the same appearance and degree of curvature as his arm.

'It is quite true that all this is meaningless and non-existent for the crowd of men absorbed in the coarse interests of active life, for whom the temple of art is locked with a triple bolt. If they ever came across a fragment of the *Borghese Gladiator*,[21] which you see here, in a corner of Rome, and a piece of the Apollo, they would notice in the Gladiator a heap of well-carved muscles and much prefer it to the god of daylight. Let us ignore these philistines.'

I then explained to my acquaintance how I derive classical beauty from the primitive Greeks, to which he made some fascinating objections. To meet them, we began to compare in detail each part of the Gladiator with

the corresponding part of the Apollo. We always recognized the same device: the Greek sculptor, in creating a god, eliminated the details which might have suggested an ordinary human being.

Standing to the left of the Apollo, opposite the window, so that the left arm was covering the neck, we noticed how the contour on the daylight side was formed by five wavy lines. The contour of the Gladiator, on the other hand, we always found to consist of a much greater number of lines; and these lines crossed at far smaller angles than the Apollo's contours. . . .

'Let's go and look at the pictures,' said my friend. 'Do you think the artist should apply the same principle to colour and chiaroscuro as we have to lines?'

We went upstairs and by chance entered the Galerie d'Apollon, where we noticed Raphael's *Calumny of Apelles*,[22] and some studies in red pencil of La Fornarina for Madonnas. I said, 'Look how great artists almost attain ideal form simply in light pencil sketches. There are barely four strokes to this drawing, and yet each one fills an essential outline. Next to this look at the drawings of all those artist–craftsmen. They begin with the details, and that is why they delight the philistine, who only notices the pretty little things in art.'

CHAPTER CX

A VERY STRONG OBJECTION

I came across my acquaintance again.

'Ah', he said, 'I have found an objection which completely ruins your theory. Isn't there a difference between beauty* and a *distinguished appearance*? Every day we see young men of twenty arriving from the provinces with the freshest complexions and the picture of health. But another young man who arrived ten years ago lost those vivid colours and that robust look after a few months of Parisian life. The newcomer is

* Beauty is the expression of a certain habitual way of seeking happiness; passions are the fortuitous way. My friend is not the same man at a ball in Paris as he is in the American Forests.

unquestionably more handsome, and yet we pity him because the other man outshines him. Can it be, then, that the kind of beauty which you explained to me is not considered beautiful everywhere? Is your beauty a queen unsure of her own empire?' 'I will confess to you, that it is the very strength of your objection which makes me certain of this theory of the origin of classical beauty.'

CHAPTER CXI

THE MODERN IDEAL OF BEAUTY

It cannot be denied that the Greeks discovered beauty at the time they were emerging from primitivism. No historian tells us that beauty fell out of the blue. Nor can we believe that it was invented by the arguments of their philosophers, since they are too absurd. But not even the German scholars most hostile to my theory will deny that, like the finest fifteenth-century pictures, it is the unexpected fruit of an entire civilization.

The real problem here is to show beauty to be the expression of *purpose*.

I did not claim that I shall prove this. I simply ask you to test this notion in your own soul and say whether this is not what beauty is.

To do this, I repeat, you must have a soul. And, in front of classical art, you must have felt spontaneous pleasure and not the pleasure of self-esteem.

I can't prove to someone that he has cramp, since he only has to deny it to show me wrong. I am not studying tangible objects but the most deep-rooted human feelings.

All I can do is to pose the limits of the question. Do statues express something? Yes, since we look at them without feeling boredom. Do they express something harmful? No, since they give us pleasure. Some candid, young people may say: 'Yes, the *Pallas* frightens me.' But once they have got over their surprise at the enormous size of the *Jupiter Mansuetus*, they will find it reassuring. . . .

As for the so-called *air of distinction*, I am afraid people would never

have thought of it without the idleness of court life, boredom, love, excessive luxury, a hereditary nobility and the delights of society.

Nothing like that existed in Greece, only a forum which generated work and a constant stream of emotions. You must either state that beauty has nothing to do with the imitation of Nature, or else agree that since Nature has changed there must be a difference between classical and modern beauty.

CHAPTER CXIII

GREEK AND MODERN NOTIONS OF COMPORTMENT

To behave recklessly in the streets of Athens would be the same as today for a young man of good social connections to be seen on a winter's day on the Terrasse des Feuillants arm-in-arm with a prostitute. Thoughtless behaviour suggests neither the strength necessary for battle nor the wisdom needed in council. Gaiety would have been regarded as madness in Athens in those days, as it still is in Constantinople today.

I want to come back to this word *grace*. No two things could be more different than the classical grace of the *Venus of the Capitol* and the modern grace of Correggio's *Mary Magdalen*. To understand that ten degrees of frost at Stockholm is very mild weather you have to have felt the usual rigours of the climate. Similarly you must know the harshness of the customs in classical Antiquity. But unfortunately knowledge dulls the mind and makes us forget how to read between the lines. We have not the slightest notion of classical Antiquity in France.

Grace today is incompatible with any suggestion of physical strength, and it must have a touch of recklessness which can be so appealing when spontaneous. In those days any hint of weakness which countered the idea of strength immediately dispelled all beauty.

CHAPTER CXV

CLASSICAL BEAUTY INCOMPATIBLE WITH MODERN FEELINGS

You must know the story of Herminia as she comes across the shepherds. It is one of the most heavenly scenes created by modern poetry, full of melancholy and sad recollection.

> Intanto Erminia infra l'ombrose piante
> D'antica selva dal cavallo è scorta;
> Nè più governa il fren la man tremante,
> E mezza quasi par tra viva e morta . . .
> Fuggì tutta la notte, e tutto il giorno
> Errò senza consiglio e senza guida . . .
> Giunse del bel Giordano a le chiare acque,
> E scese in riva al fiume, e qui si giacque . . .
> Ma'l sonno, che de' miseri mortali
> È col suo dolce obblio posa e quiete,
> Sopì co' sensi i suoi dolori, e l'ali
> Dispiegò sovra lei placide e chete . . .
> Non si destò finchè garrir gli augelli.
> Non sentì lieti e salutar gli albori . . .
> Apre i languidi lumi . . .
> Ma son, mentr'ella piange, i suoi lamenti
> Rotti da un chiaro suon ch'a lei ne viene,
> Che sembra, ed è di pastorali accenti
> Misto, e di boscarecce inculte avene.
> Risorge, e là s'indrizza a passi lenti,
> E vede un'uom canuto all'ombre amene
> Tesser fiscelle alla sua greggia accanto,
> Ed ascoltar di tre fanciulli il canto.
> Vedendo quivi comparir repente
> L'insolite arme, sbigottir costoro;
> Ma gli saluta Erminia, e dolcemente
> Gli affida, e gli occhi scopre e i bei crin d'oro.
> Seguite, dice, avventurosa gente.
>
> Tasso, *Gerusalemme Liberata* (CANTO VII)

At the moment when Herminia takes her helmet off and her fine hair falls in golden locks down onto her shoulders and the shepherds are undeceived, this charming face has to express frailty, unrequited love, longing for rest and an instinctive, spontaneous kindness.

If classical beauty is the expression of strength, reason and prudence, how will it manage to portray a scene which moves us precisely by the absence of these virtues?

CHAPTER CXVI

ON LOVE

Strength, reason and extreme caution, are these the qualities which produce love?

The noble qualities which appeal to us, tenderness, generosity free from self-seeking vanity, spontaneous emotion, willingness to abandon our hearts to a single thought, strength of character when supported by happy love and touching frailty when left to the feeble stay of human reason: none of all this can be found in classical sculpture.

The reason is that today love is almost always outside marriage; with the Greeks, never. Listen to modern husbands; they want security, not pleasure. In ancient Greece the public expressed the husband's point of view, but today it expresses the lover's. The Greek republic stood for security, happiness and the civic virtues and it sanctified domestic life. The best we can say today of marriage is silence, and it is a known fact that the marital virtues can only inspire love in an old bachelor or a cold young man devoured by ambition.

CHAPTER CXVIII

WE HAVE NO NEED OF THE CLASSICAL VIRTUES

Let us remember the qualities necessary to the sculptor in the forests of Thessaly.

They were, I remember, justice, prudence and goodness, all three in strong measure. Man demanded these virtues in his gods as he expected them in a friend. But such virtues are rather out of place in France. Not that I want to pose as a cynic, but if I *do* seem guilty of cynicism it is because I want to know why Guido Reni appeals to us more than Caravaggio. I shall express my own opinion, and say, with all apologies for now and the future, that all moralizing bores me and that I prefer La Fontaine's *Contes* to Jean-Jacques Rousseau's best sermons.

After this profession of faith, please allow me to depose the virtues of Antiquity, and to point out that we no longer need physical strength in a town with such an efficient police force as Paris. . . .

Even in England strength is going out of fashion, and when we find the prowess of the noble Lord *** praised in the newspapers, it is like reading a bad joke. Because great physical strength has one big disadvantage; the very strong man is usually very stupid. He is an athlete, with almost completely insensitive nerves. His entire existence is spent in hunting, drinking and sleeping.

I don't think you would like your friend to be a *Milon de Crotone*.[23] Would you like him any better with that energy of character and force of concentration which strike us in the *Pallas of Velletri*? No, for that head on living shoulders would frighten us.

No, with these classical virtues your friend would either be driven out of France, or else become a hermit and a misanthrope, tiresome and of very little use to the world. For the really absurd thing about Alceste is that he resists the influence of his government. He is the sort of man who tries to stem the Ocean with a garden wall. Philinte ought to have told him jokingly to cross the Channel instead.[24]

CHAPTER CXIX

THE MODERN IDEAL

If we had to define the ideal beauty, we might select the following qualities.

1. An extremely alert mind.

2. Features of great charm.
3. Eyes flashing with the spark of wit, not with the dark fire of passion. Emotions find their strongest expression in the eyes, which sculpture cannot convey. Modern eyes ought, therefore, to be very wide.
4. Great gaiety.
5. A store of sensibility.
6. A slim figure and, especially, the agile appearance of youth.

CHAPTER CXXIII

CLASSICAL BEAUTY IS SUITABLE FOR THE GODS

But, people will say, the modern ideal will never have the sublime character and look of grandeur which we admire in the most insignificant classical bas-relief.

Grandeur consists in the expression of strength, nobility and great courage.

Modern beauty will not have the look of strength, but of nobility—perhaps even greater nobility than classical art.

It will also reflect great courage, in so far as the strength of character is still compatible with charm. We admire courage, but we like it only to appear when required. This is what spoils court-life under military dictatorships, and slanderous tongues say that military courtiers are rather stupid. Catherine II agreed with this.

Charm is incompatible with strength; the human eye cannot see two sides of a sphere at the same time. The court of Louis XIV will long remain the model of all courts because the Duc de Saint-Simon was respected in civilian dress and because people enjoyed themselves there more than in town. . . .

The classical ideal of beauty will always reign supreme on Olympus, but we mortals shall only continue to love it as long as we have to exercise a divine function. If I had to choose a magistrate, I should want him to look like the *Jupiter Mansuetus*. If I had a man to present at court, I should wish him to have a face like Voltaire's.

CHAPTER CXXV

THE TWENTIETH-CENTURY REVOLUTION

Nothing stranger can ever have existed than a collection of twenty-eight million men speaking the same language and laughing at the same things. For how long will our true character in the arts lie buried under imitation? We, the greatest nation which ever existed (yes, even after 1815), we continue to imitate the small tribes of Greece when it could scarcely count two or three million inhabitants.

When shall I see a nation brought up solely on the knowledge of what is useful and what is harmful—without Jews, without Greeks, and without Romans?

Moreover this revolution has begun without our knowledge. We see ourselves as the faithful worshippers of the Ancients; but when it comes to human beauty, we are too intelligent to admit their system with all its consequences. In this as in other matters we have two beliefs and two religions. With the prodigious growth of ideas during the past two thousand years, the human mind has lost its ability to be consistent.

Today women rarely express any considered opinions about beauty; if they did, we should find an intelligent woman in great embarrassment. She admires the statue of Meleager[25] in the Museum, but if this same statue (so rightly admired by sculptors as a perfect model of male beauty) walked into her drawing-room with the same expression and the kind of mind suggested by it, it would look clumsy, even absurd.

The reason for this is that well-bred people no longer feel in the same way as they did in the Greeks' day. The true art-lovers, who educate the rest of a nation's feeling, are to be found among leisured people who, accustomed to luxury, have still retained a certain naturalness. What sort of emotions did those people have amongst the Greeks? And what do they have today?

With the Greeks, after an ardent patriotism there was an emotion which scarcely deserves the name of love. Today there is sometimes love, but always the semblance of it. I am well aware that people of intelligence today, even those with a soul, devote a lot of time to ambition, either for

public honours or for selfish satisfaction. I also know that they have few strong preferences, and that they spend their lives in amused indifference. Then the arts decline;* but from time to time indifference is banished by public events.†

Meanwhile public taste is controlled by love.

There is more of a tinge of nobility in the contemplative love of painting than in the surrender to music. Because in painting there is an ideal beauty which is far less perceptible in music. We immediately see the difference between an ordinary head and the head of Apollo; but a musical air gives us the same feelings, whether it is superior or not to the song 'Deh Signor!' by Paolino in *Le Mariage Secret*.[26] Music sweeps us along and we make no judgement. In painting pleasure is always preceded by a judgement.

When a man comes up to the *Madonna alla Seggiola* he exclaims: 'How beautiful!' Thus painting never entirely misses its aim, which sometimes happens in music.

In a museum the spectator is more alert, more perceptive and less dreamily melancholic than at the Comic Opera. A more painful effort is needed to return from the spell of music to what men call serious business than from painting.

The mists of the Seine are therefore less unfavourable to painting than to music.‡

* The reign of Louis XIV. † The Revolution.

‡ Music is the depiction of tender emotion; it is incapable of portraying total lack of feeling. Since music is an intrinsically tender art, it projects tenderness over everything; and it is precisely because of this illusoriness of the picture it presents of the world that music delights tender souls and displeases others so much.

Why does music bring such consolation to unhappiness? Because in a vague sort of way which spares our self-esteem, it inspires belief in a gentle pity. It transforms the sterile grief of misery into regretful sorrow; it shows men gentler than they really are, makes us shed tears and recalls past happiness, which the unhappy man thought impossible.

PARISIAN REFINEMENT OF TASTE

In France the sun is rather wan; the inhabitants are very intelligent and inclined to express their emotions with studied refinement. Simplicity is admired only when exemplified in a great man, but advanced civilization is daily curing us of this defect. All countries begin with simplicity; the quest for novelty then produces refinement, and finally brings us back to simplicity. That is the stage we have now reached, and in matters of feeling it is perhaps in Paris that the most subtle judges are to be found; but they always have a certain frigidity.

It is, then, in Paris that refined love has best been portrayed, where the meaning of a word, a look, or a mere glance is really understood. Watch Mademoiselle Mars playing Marivaux, and study her carefully, for there is nothing to match her.

In Athens people did not look for such refinement and subtlety. Physical beauty was the object of a universal cult. . . But the cult of beauty remained purely physical; love went no further than this, and Buffon would have found that many of the Greeks agreed with his ideas.

CHAPTER CXXVIII

WHAT WAS THE FINAL ACHIEVEMENT OF THE ANCIENTS?

Within the narrowest limits of perfection, they excelled at the easiest of the fine arts.

In the domain of beauty in general, they had saner ideas than we do today and were simple from simplicity and not, as we are, from sophistication.

The Ancients excelled in sculpture because they always had a sound constitution in that respect and we have a poor one.

Because the naked body is prohibited by our religion, sculpture is deprived of its object. All generous emotion has been banished by our God and sculpture has nothing left to represent.

CHAPTER CXXIX

DRAWING-ROOMS AND THE FORUM

Modern beauty is based on the general distinction between drawing-room life and life in the Forum.

If we ever met Socrates or Epictetus on the Champs-Elysées, we should shock them profoundly if we told them that today strength of character does not make for happiness in private life.

Léonidas, * who looks so impressive as he reads the inscription: 'Passer-by, go and say to Sparta . . .', might have been, in fact certainly was, an extremely insipid lover, friend and husband.

You must know how to be charming at a party, and the next day win a battle or die.

CHAPTER CXXXI

THE APTITUDE OF NATIONS FOR MODERN BEAUTY

In Italy the climate produces stronger passions, and since there is no capital city, governments have no hold on people's feelings. There is therefore greater originality and spontaneity. Everybody has the courage to be himself. But whatever little power the government *has*, it has obtained by cunning.

So the Italian has to be extremely suspicious. Whenever his profoundly bilious temperament allows him the easy happiness of the sanguine person, his government is there ready to prohibit it. In this country where all the elements of happiness have been combined by nature, no amount of fear and suspicion can be too great. Generosity, or trust in somebody or something, would be sheer madness. What an unfortunate circumstance for Europe, which could so easily be changed by giving Italy a King and a constitution! For Italy is the land with the greatest potentiality of great

* In the fine picture by M. David, Léonidas's expression is sublime, a most unusual thing for the French school.

men; her human growth is more abundant. She is the home of the impulse to greatness, but it is misdirected, and Camillas become Saint Dominics. . . .

For urbane people, for young aristocrats and old courtiers, Italy is intolerable. But the man who has been tossed about by revolutions, and has learnt to value men's true worth at his own expense will prefer Italy because:

1. Governments have not managed to spoil the climate.
2. In art they have only ruined tragedy and comedy. Music and the graphic arts have been protected by rulers, in so far as they sympathized with intellectual life.
3. Whenever you see an Englishman perform a fine deed, you can put it down to the influence of his government. When an Italian acts heroically it is despite his government. . . .

The modern ideal of beauty is therefore still impossible in Italy, and the qualities suggested by it would seem absurdly weak to an Italian. But he has too much genuine sensibility not to adore the modern ideal as soon as he sees it.

If ever the Germans, that sentimental, lethargic nation desperately trying to give itself a character but never succeeding, were to create a modern form of beauty they would bring to it rather more innocence but less intelligence.

The Spanish, who with such courage show such stupidity, will have artists in twenty years' time if they are granted a constitution. Then we shall see what their taste in art is like, for ever since Philip II they have been silent.

For such is the power of events and human weakness, that the *spirit of despotism*, which once abhorred the English Constitution, will have disseminated it throughout Europe and thereby changed the arts. The cork is held down by hundreds of little chains which prevent it from rising to the surface of the water.

CHAPTER CXXXII

THE FRENCHMEN OF YESTERDAY

We must tell our nephews that there was a vast difference between the Frenchman of 1770 and the Frenchman of 1811, the year which marked the apogee of our new social habits. In 1811 people were much closer to the classical ideal.

I shall pay tribute not to the revival of the arts, but to the convulsions which have shaken us for thirty years and as a result of which there is neither society nor community spirit left in France.

Tossed about by so many strange and often dangerous events, justice, goodness and strength have progressed, while the virtues peculiar to society are no longer valued. For where could they be valued? Everybody born after 1780 has fought in the wars and prizes physical strength not so much for the day of battle as for the endurance needed on campaigns.

Previously the necessary virtues were gaiety, charm, tact, discretion, a host of qualities which, united under the heading *savoir-vivre*, were highly appreciated in the salons of 1770. They demanded a certain initiation. Today we have reverted to the social graces which no despotism can banish from human intercourse. The young man of sixteen who can dance and say nothing is a model of perfection.

I notice that our respect for strength is not based on a favourite pastime, as it is in England. We have no fox-hunting, and Cardinal de Fleury's ministry,[27] with its thirty years' peace, would soon make us remote from classical beauty.

CHAPTER CXXXIII

WHAT WILL BECOME OF MODERN BEAUTY?

Unfortunately ever since people began to admire the classical ideal of beauty, no more great painters have appeared. The use to which it is put today will cure us of it. Why not? The Revolution cured us of freedom, and large towns have demanded that there should be no constitution.

In France there are poets who, in order to imitate Molière more closely, simply copy him out, and when they want to portray a suspicious person, for example, take the plot of *Tartuffe*, simply changing the names.

This general method also applies to painting.

Because painters have once learnt that the *Apollo* [Plate 1] is beautiful they always copy it in their young figures. For their adult male figures they use the *Belvedere Torso* [Plate 2]. But the painter is very careful never to put anything of his own soul into his picture, or he might become ridiculous. Amidst hymns of praise, art once again becomes a purely mechanical exercise as it was with the Egyptian artisans. Ours could be redeemed by colour, but this calls for some feeling and it is not an exact science like drawing.

If our great artists could predict history they would be appalled to see their place marked out by posterity between Vasari and Santi di Tito. These were to Michelangelo what our artists are to Antiquity. They made precisely the same criticism of Correggio as ours make of Canova.

The place is ready in France for another Raphael. Hearts are thirsting for his work. Look how they received the head of *Phèdre*.* What is more, people only admire contemporary exhibitions from a sense of duty, and when the unfortunate public is asked: 'Doesn't this look like classical Antiquity?' it is at a loss to reply. *The public is wrong*,[28] and quietly drifts away with a yawn.

CHAPTER CXLIV

THE LIFE OF MICHELANGELO

Certain academic philosophers will not fail to remark that nothing is easier for the fine arts to express than the feelings of the divinity. This is all the easier because we cannot possibly imagine the simplest feeling which God might have towards men. If anyone maintains the contrary,

* *M. Guérin's* picture at Saint-Cloud. Look at the heads of Dido, Elisa and Clytemnestra at the exhibition of 1817. This great artist is making progress in the art of expression. What a pity he shows so little interest in chiaroscuro!

give him paper and ink, and ask him to write down what he can visualize so clearly.

The arts can only move us when they depict human passions, as you have just seen from the most touching spectacle offered by religion (Michelangelo's *Pietà*). The moment the least idea of religion enters our minds, our tears are checked as we admire the sublime paintings hanging in our churches. Fénelon's religion was no more than a mild form of egotism.

The representation of an event in which God himself is the actor may be strange, curious or extraordinary, but never moving. Canova could not possibly tackle Michelangelo's subject. He might increase the number of repentant women of Loreto, but he could never inspire us with new feelings. God may be bountiful; but since he makes no personal sacrifice in bestowing his benefits on us, my gratitude (as opposed to the hope of obtaining fresh advantages from the intensity of my delight) must inevitably be less than it would be towards a man. . . .

The only emotion which the divinity can inspire in feeble mortals is terror and this is the emotion Michelangelo seemed born to imprint into souls by means of marble and colour.

Now that we have seen the extent of art's power, let us come down to facts relevant to the artist himself.

CHAPTER CXLV

MICHELANGELO, THE MAN OF HIS TIME

Do we really want to understand Michelangelo? Then we must become Florentine citizens of 1499. For in Paris we do not force strangers to wear a band of red wax on the thumbnail; and we do not believe in ghosts, astrology and miracles. The English constitution has shown mankind true justice, and God's character has changed. As for intellectual progress, we have classical statues, everything that has been said about them by thousands of clever people and the experience of three centuries.

If the man in the street in Florence had already been on that level, to

what heights might Buonarroti's genius not have soared? But ideas which today seem simple would then have been supernatural. Where the men of that time leave us so far behind is in their strength of feeling, in their inner motive force. We can see the road to be followed more clearly, but old age has stiffened our joints, and, like those spell-bound princes in the Arabian nights, we waste our energy in aimless movement and cannot walk. For two centuries a so-called code of etiquette proscribed strong passions, and, by repressing them, finally stifled them; they only survived in country villages. The nineteenth century is going to restore these passions to their rightful place. If a Michelangelo were born in our enlightened days, imagine what heights he might achieve! What a torrent of new sensations and pleasures he would release among a public already well primed by the theatre and novels! Perhaps he would create a modern sculpture and compel the art to express passion, if indeed it *can* express passion. At least Michelangelo would make sculpture express the soul's moods. Tancred's face after the death of Clorinda, Imogen hearing of Posthumus's infidelity, Herminia's gentle expression as she arrives among the shepherds, Macduff's taut features when he asks to hear how his children were murdered, Othello after killing Desdemona, Romeo and Juliet waking up together in the tomb, Hugo and Parisina hearing their condemnation from Niccolo's[29] mouth—all these would appear in marble and classical Antiquity would drop to second place.

CHAPTER CLIII

THE SISTINE CHAPEL

People who have no special liking for painting can at least enjoy miniature portraits. They find the colours pleasant and the outlines are easily encompassed by the eye. Oil painting seems to them rather coarse and too serious in character and the colour strikes them as less attractive. Frescoes have the same effect on young art-lovers. It is a difficult kind of art to see properly, and the eye needs a special initiation which is only to be had in Rome.

At this stage of the sensitive soul's journey towards visual beauty stands a very great hazard: *admiring what in fact affords no pleasure.*

Rome is the city of statues and frescoes. On arrival you should go and see the scenes from the story of Psyche painted by Raphael in the vestibule of the Farnesina Palace. In these heavenly groups you will find a quality of hardness of which Raphael is not entirely guilty, but which is very instructive for young art-lovers and helps them to see the frescoes much more clearly.

You must resist temptation and close your eyes when passing in front of oil paintings. After two or three visits to the Farnesina Palace you may go to the *Farnese Gallery* by *Annibale Carracci.*

Then you can see the *Papyrus* room in the Vatican library, painted by *Raphael Mengs.* If this ceiling, with its limpidity and mannered charm, gives you more pleasure than the Carracci gallery, you must pause. For this preference is not based on a spiritual difference but on the defectiveness of your own vision. A fortnight later you may venture into the *Raphael Stanze* in the *Vatican.* At the sight of these sombre walls the uneducated eye will exclaim: *Raphael, ubi es?* All your efforts are wasted if you attempt to study oil-paintings when your receptive powers are already deadened by the vexations of your journey.

After a month's stay in Rome, during which you will have seen nothing but statues, country houses, architecture and frescoes, eventually, on a fine sunny day, you may set foot in the Sistine Chapel. Even now it is still doubtful whether you will enjoy it.

The Italian soul for which Michelangelo painted was moulded by those fortunate accidents which gave the fifteenth century almost all the qualities necessary for the arts. But, still more important, even among the inhabitants of present-day Rome (degraded by clericalism as they are), the eye is trained from infancy to seeing all the different types of art. However superior a Northerner may fancy himself, first of all he probably has a frigid soul, and secondly he cannot use his eyes and has already reached an age when the education of the body has become a difficult matter.

But let us now presuppose eyes which can see and a soul which can feel. Raising your eyes to the Sistine ceiling you will see compartments of different shapes and the human body reproduced in all guises. . . .

Greek sculpture never attempted to produce terrifying effects: there were too many misfortunes in real life. Nothing in the entire realm of art can therefore be compared to the figure of the eternal Being creating the first man out of a void. The attitude, draughtsmanship, drapery, everything is striking, and the soul is shaken by impressions to which the eye is unaccustomed. When, on our unhappy retreat from Russia, we were suddenly wakened in the middle of the dark night by persistent cannon-fire, which seemed to draw closer every moment, all our faculties were concentrated on the heart, for we were face to face with destiny; paying no heed to petty concerns, we prepared to do battle with fatality for our own lives. The sight of Michelangelo's pictures recalled for me this half-forgotten sensation. Noble souls are self-sufficient while others are afraid and go mad.

CHAPTER CLVII

THE SISTINE CHAPEL (CONT.)

The arrogant expression of the Sistine figures, the audacity and power which mark all their features, the slow stateliness of their movements, the strange unprecedented way the drapery covers them, their striking contempt for everything merely human—everything about them proclaims them to be beings addressed by Jehova, who pronounces judgement through their mouths.

This character of awesome majesty is most striking in the figure of the *Prophet Isaiah*. Lost in deep meditation while reading the book of the law, he has placed his hand in the book to mark the passage and, leaning his head on the other arm, he is entirely occupied with lofty thoughts when suddenly he is summoned by an angel. Without the slightest unpremeditated gesture or change of position at the sound of the angel, the prophet slowly turns his head round and seems reluctant to listen to him.

CHAPTER CLXIV

THE MOSES IN SAN PIETRO IN VINCOLI

The statue of Moses had an enormous influence on art. As a result of the curious fluctuations observable in men's opinions, nobody has copied it now for a long time and the nineteenth century is about to restore its popularity. . . .

Michelangelo was fully up to his subject. It is a seated statue in barbarian dress, with the arms and one leg naked, three times larger than life.

If you have never seen this statue, you cannot know the full power of sculpture.

CHAPTER CLXVIII

THE LAST JUDGEMENT

Painting, considered as a three-dimensional art or as the representation of light and colour, is not painting as Michelangelo understands it. There is nothing in common between himself and Paolo Veronese or Correggio. Like Alfieri, despising everything that is accessory and of secondary interest, he concentrated exclusively on painting man, and that rather as a sculptor than a painter.

It is rarely justifiable for painting to admit entirely naked figures. It should express emotion by means of the expressions and physiognomy of the man it has to represent, rather than by the form of his muscles. Painting achieves its finest effects by the use of foreshortening and the colour of drapery.

We find it quite irresistible when, to these advantages, the painter adds his most potent charm, chiaroscuro. If its fine body had been visible on a plane parallel to the eye, fully exposed, this angel would have been uninteresting; but Correggio makes it recede by foreshortening, and thus produces an effect full of intensity.*

* The *Madonna alla Scodella*, at the top left of the picture. The effect is even more striking in Barocci's *Annunciation*.

84

Painters who cannot paint give us copies of statues. Michelangelo would merit this criticism if, like them, he had stopped at the merely *unpleasing*; but he advanced to the point of *terror*, and what is more, the figures he portrays in his *Last Judgement* are quite unprecedented.

CHAPTER CLXIX

CRITICISMS OF MICHELANGELO

Books on painting are full of Michelangelo's shortcomings. Mengs, for example, roundly condemns him. But after reading his criticisms, go and see Mengs's *Moses* in the Papyrus room, and then the *Moses* in San Pietro in Vincoli. Here we are at one of those decisive peaks which for ever separate the genius from the commonplace artist. I would not like to assert that many of our artists today might not prefer the *Moses* by Mengs on account of its foreshortened arm. How can commonplace souls help admiring commonplace art?

CHAPTER CLXXII

THE INFLUENCE OF DANTE ON MICHELANGELO

It is not at all surprising that Michelangelo, formed by the mental habits of his country (which persist even today) and by his passion for Dante, should have imagined hell in the same way as the poet.

The proud genius of these two men is absolutely identical.

If Michelangelo had written a poem, he would have created Count Ugolino, and if Dante had been a sculptor he would have created Moses.

Nobody loved Virgil more than Dante, and yet nothing could be less like the *Aeneid* than the *Inferno*. Michelangelo was deeply impressed by classical Antiquity, and yet nothing could be more different than his own works.

Both men left the crude imitation of external reality to the mediocre artist. They understood the principle of *creating whatever gives the greatest pleasure to the men of their own time.*

Like Dante, Michelangelo does not merely give pleasure; he threatens us, crushes the imagination beneath the weight of suffering, and leaves us without enough strength to feel courage, so totally are we filled with a sense of catastrophe. After Michelangelo the sight of the most ordinary countryside is sheer delight, and rouses our benumbed sense. The sensation we felt was so strong that it verged on grief, but as it diminishes it turns to pleasure. (Other draughtsmen have illustrated Homer and Virgil with some success. All the engravings I have seen for Dante have been utterly absurd.* Because here power is indispensable, and this is a very rare quality today.)

CHAPTER CLXXXIV

MICHELANGELO WILL RETURN TO FAVOUR

Neither Voltaire nor Madame du Deffand could appreciate Michelangelo. To them his type of art was the exact synonym of ugliness and, worse still, pretentious ugliness; the most unpleasing thing imaginable. . . .

But once the talent for general mockery has passed from fashion, after entire generations have wasted their lives on the same frivolities with the same indifference to any interest other than vanity, without the slightest hope of achieving fame, then a radical change in men's minds can be predicted. Then light things will be treated lightly and serious things seriously; society will retain its simplicity and charm; but, taking up their pens, men will once again turn away in profound contempt from petty pretensions and manners and petty applause. Great souls will resume their rightful place; strong emotions will once again be sought and people will no longer shun the charge of coarseness. Then fanaticism will be revived and political fervour will enjoy its first real expansion. This, perhaps, is the state of France today. The presence of so many brave, unfortunate

* Reynolds's *Count Ugolino.*

young officers, forced back into separate social spheres, has changed our notion of gallantry. . . .

It is hard to fail to see what the nineteenth century is looking for; its true characteristic is a growing thirst for strong emotions.

It is therefore by the precise and passionate depiction of the human heart that the nineteenth century will distinguish itself from all previous epochs. . . .

The thirst for energy will bring us back to Michelangelo's masterpieces. I admit that he portrayed physical energy, which is today nearly always incompatible with spiritual energy. But we have not yet attained *modern beauty*. We must rid ourselves of affectation; the first stage towards this will be to sense that in the picture of *Phèdre* [by Guérin], for instance, Hippolyte stands for classical beauty, Phèdre for modern beauty and Thésée for Michelangelo.

Athletic vigour tends to banish passionate feeling. But since painting can only render the soul by means of the body, we shall venerate Michelangelo until art has given us emotional power completely free from physical power.

We have a long time to wait, since another fifteenth century is impossible; and even when that time comes odious and terrible natures will always be on the side of Michelangelo.

3 The Salon of 1824

PREFACE [*Scathing criticism of the Salon of 1824*]

Three people who didn't know each other before working together have been commissioned to review the Salon of 1824 in the newspapers. Irrespective of the political colour of these newspapers, the critics of the exhibition were asked to speak only the truth, and to make it as entertaining as they could. This last condition at first made me turn down the offer, but the next day the pleasure of seeing myself in print made me accept gratefully.

I am an *extreme radical* in my views on painting. Like MM. de Corcelles and Demarçay[1] I often have the pleasure of being alone in my opinions, and the satisfaction is often all the greater.

And like the respected deputies whom I have just named, I derive great satisfaction from seeing my adversaries, people well-known in polite society, at a loss to reply to my arguments and reduced to hurling insults.

People have said that I was crude, because unfortunately for myself I attach no importance to the elegant, vacuous phrases which have won M. Droz[2] a place in the Academy and M. Villemain[3] the reputation for eloquence. In the *Constitutionnel* and the *Pandore* I counted a hundred and forty-four examples of inflated praise which I would never use. The *summits of human thought*, the *needs of the epoch*, the *higher realms* and similar phrases will not be found, I am afraid, in this pamphlet.

Somebody else said that I criticized a painter because he was poor; such slander does not even deserve a reply. I am poor myself and have much more respect for poverty than wealth. I am always bored in a drawing-room where the master of the house has an income of more than a thousand pounds.

I have never set eyes on MM. Regnault, Taunay, Denou, Guérin, Lebarbier, Gros, Meyner, C. Vernet, Garnier, Lethière, Hersent, Bidauld, all members of the Royal Academy of Fine Arts. I have only once spoken to M. Le Baron Gérard, whose studio I was once privileged to visit with a friend. I have so little influence and live so much apart from the important people of the day that I could not even obtain a card to visit the Museum on Fridays. Admittedly, after writing to M. Le Comte de Forbin, the Director-General of the Royal Museums, and receiving no reply, I conceived the idea of making a copy of my letter and signing it: Viscount N . . . Immediately the next day this titled person received a card, which I was

tactful enough not to use, since it had after all been obtained under false pretences. Here, then, is the real reason for my reputation for being crude and despicable; in short, a pauper. I shall damage my own case still further when I declare in all seriousness that I consider M. David to have far out-stripped men like Mengs, Battoni, Solimena, Reynolds, West and all the other famous eighteenth-century painters. My own opinion is that you would have to go back to the century of the Carracci to find a rival for this illustrious man. It is a pity that such a painter cannot live in our country, but with his strength of character he will bear exile with stoical pride and it can be said of him, as of Napoleon before Saint-Helena, that his fame would have been incomplete without misfortune. . . .

In 1789 a man refused to copy slavishly his predecessors and found a new way of imitating Nature. His greatness was proclaimed by the applause of a generation notoriously critical and hard to please. Instantly a crowd of imitators rushed headlong in his footsteps. Instead of doing as he had done, of looking at Nature and Antiquity for the forms and facial expressions likely to give their contemporaries the greatest pleasure, they copied David's pictures and, when they turned round to face us, the critics, they are surprised when we deride them. They are sleepless with indignation, and there they are at seven o'clock on an October morning, off in cabs to go knocking at all the newspaper editors' doors in Paris. It was just these early morning visits and the fine unanimous articles of praise they produced which gave me the idea of publishing my own. I promised to be like the peasant from the Danube; odd, novel and original, because what we need above all is novelty, even if there was nothing else left.

Here, then, are my articles as they were before my two colleagues, MM. P. and L., had corrected my errors of style and propriety. I have no style, but I think everything I write. How many writers in Paris can say the same? As a result I am not even lucky enough to belong to the Geographical Society.

MUSÉE ROYAL: EXHIBITION OF 1824

Let us first cast a rapid glance at the Exhibition, and for the moment spare general considerations from the reader impatient to know our opinions, in

order to formulate his own on the most remarkable pictures which have attracted his attention. This first glance will be only a superficial one, the simple and artless expression of an initial impression.

This year it seems that the people engaged in criticism of the Salon are divided into two strongly opposed camps. War has already been declared. The *Débats* are going to stand for classicism, that is, to swear by nobody but David and to proclaim: 'Every painted figure must be the copy of a statue,' which the spectator must admire even if it bores him stiff. The *Constitutionnel*, for its part, makes fine-sounding, rather vague phrases—that is the vice of our century—but still it is on the side of new ideas. It has the courage to maintain that, even after M. David, art must be allowed to progress; that it is not a picture's only merit to portray a quantity of fine, correctly drawn muscles; and that it is unreasonable to expect the French school to remain *static* as Government shares, simply because it was fortunate enough to produce the greatest painter of the eighteenth century, M. David.

What immediately struck me on entering the main exhibition gallery was a kind of duel between two very similar reputations, those of MM. Granet and Horace Vernet, both painters who are popular with the public and make a lot of money. M. Granet's *Cardinal Aldobrandini* hangs next to a battle scene by M. Horace Vernet.

The attitude of Domenichino holding an enormous hat is clumsy in the extreme, a huge man with the manners of a coarse peasant. The Cardinal is almost ridiculous; the least attentive spectator can see this simply from the cardinal's hands. Is that what men's hands really look like from the distance the artist has placed us? They are painted like a fresco intended to be seen a hundred feet away. The faces are not like human faces at all. It is incredible that a man of such talent should make such mistakes; M. Granet ought to keep to his Capuchin friars.

In painting I have seen two or three thousand battles; in real life I have seen two or three, but that is enough for me to say that M. Horace Vernet's picture is a masterpiece beside M. Granet's. In the sky of this picture alone there is more truth and life than in twenty landscapes sanctified by the admiration of the connoisseurs.

Above this battle scene, there is a *Cardinal interrogating Joan of Arc in*

Prison [Plate 29],[4] a picture which will make a name for its author. The Cardinal is dressed in red, comfortably seated at the back of the chilly prison, and has all the impassivity and cunning we would expect. By contrast, poor Joan of Arc is chained down to her miserable bed and is asserting the truth of her replies with all the candour and passion of her heroic soul. The animation of this figure makes an excellent foil to the highly astute look of the interrogator.

On entering the main hall you will find on your right, against the door, first a rather heavy portrait by *M. Gros*, and further on, a mother's head being caressed by her son. I would commend this second picture to all mothers; it is *Andromache and her son Astyanax* [Plate 22]. What a charming smile on the mother's face, with all the seriousness of deep emotion, and how delightfully it contrasts with the child's gaiety! The classicists of art will say that this picture is woolly, and that the outline of a woman in the background is badly shown; but look at this mother's head from six feet away, and you will agree with me in mourning the death of the great artist who first portrayed this type of facial expression in France.

Look out for another picture by *Prud'hon*, a *Christ on the Cross*.[5]

There is a vast canvas representing *Romans paying their last homage to the remains left in a Westphalian valley by the legions of Varus*.[6] This is the kind of picture which will be praised by the *Journal des Débats*.

M. Schnetz's picture of *Saint Genevieve distributing alms to the poor during a famine* [see p. 155] contains some splendid passages. Here is a painter who knows how to handle colour, but what a pity that his picture suffers from the great defect of the French school, namely lack of chiaroscuro! Only give this picture some broad passages of light and shade as in *Domenichino's Communion of Saint-Jerome* [Plate 7], and it would attract hundreds of spectators. But still I recognize in M. Schnetz the fundamental qualities of a great painter. He possesses truth, and this is saying a lot today. Look, for example, at his *Shepherd in the Roman Campagna*.

I shall discuss portraits: *M. Belloc* has painted *Her Royal Highness the Duchesse de Berri* with a very light touch and delicate contour. The portrait of M. Lanjuinais by *M. Rouillard* is very good. I was greatly moved by *M. Scheffer's Girl looking after her sick mother*, in the Galerie d'Apollon.

A little picture by *M. Gudin* shows the *Waves of a stormy sea* with terrifying likeness. Once again, all honour to the truth! For this is what the French school most urgently needs in its present state; but will the public ever forgive the man who dares to say it?

FIRST ARTICLE

I have just left the Exhibition. When I went into the Louvre I deliberately avoided buying the catalogue which gives the subjects of the pictures and the painter's names. I wanted my eyes to be attracted by merit alone, regardless of the empty reputations of the past for which I have scant respect.

 M. Sigalon, a young man unknown up to now, has made his first appearance with a picture which might mark the beginning of a great reputation. *In front of the atrocious Narcissus, Nero's freedman, a poisoner is trying out on a slave the poison intended to kill noble Britannicus* [Plate 31]. This is an immediately striking and moving picture. Narcissus is very handsome, but the dying slave is paltry, particularly his chest; it recalls Poussin's large-scale figures. The woman poisoner is good, and it is appropriate that her crime should find expression in nervous contortions, in view of the unstable temperament of women. This figure reminds me of Walter Scott's Meg Merrilies.[7] But M. Sigalon committed an error of taste in revealing the character's naked bosom; that sort of horror ought to be left to Rubens.

 There is a *Massacre at Chios* by *M. Delacroix* [Plate 13], an excessively sad and gloomy picture, the equivalent of MM. Guiraud and Vigny in poetry. But the public is so bored with the academic style and the copies of statues which were so fashionable ten years ago that it pauses in front of the ashen, half-finished corpses shown in M. Delacroix's picture.

 It was only when I left the Salon, my eyes tired from so many crude colours, that I opened the catalogue and put names to the opinions you have just read.

 'But', people will say, 'who are you to dare to discuss the arts in such an arrogant, categorical way? Are you an artist? Have you won your spurs

at the Salon with two or three unsuccessful pictures? If so, I would listen to you with some respect.' The reply of the author of this article is that I was born about thirty years ago on the famous banks of the Rhine, not far from Coblenz.[8] I was trained for a profession closely connected with drawing, and at an early age I set out for Rome. I was to have stayed for fifteen months but I remained two years. Once I had attained my independence, I decided to see Paris, for the delights of her literature and inhabitants have won this city such a high place in the European esteem that it has become the only capital of Europe. I had scarcely been there a few months when I was asked to review the Exhibition of 1824 in a newspaper. I am only interested in the number of the paper's readers. I don't care in the least about its political doctrines, and I have strong views on everything: I owe this honest confession to my reader. This is the main defect which makes me unacceptable in society, and I have no desire to change. Content with my modest fortune, proud and asking for nothing, I spare only what I like; and I like only genius. 'Don't you like anyone, then?' people exclaim everywhere. 'Certainly. I like young painters with candid minds and passionate souls, who aren't secretly hoping to win their fortune and future promotion by going to spend dreary evenings with Mrs So-and-so or playing whist with Mr Someone Else. What is more, I haven't the honour of knowing personally a single painter I am going to talk about. I only know that, generally speaking, French artists are men of excellent character, independent in their behaviour and opinions, witty speakers, and that they perhaps have more sensitive souls than it would seem from their pictures.

We are on the eve of a revolution in the fine arts. Large pictures consisting of thirty naked figures copied from classical statues, and cumbersome five-act tragedies in verse are doubtless very estimable works. But, whatever people say, they are beginning to bore us, and if the *Sabines* were shown today the figures would be found passionless and people would consider it ridiculous to march into battle without any clothes on. 'But this is normal in classical bas-reliefs!' protest the classicists of art, those men who swear by nothing but David and never pronounce three words without speaking of *style*. And what do I care about classical bas-reliefs? We must try to do good modern painting. The Greeks liked the

naked body, but we, for our part, never see it, indeed I should even say that it disgusts us.

I shall ignore my opponents' outcry and tell the public, honestly and simply, what I think about each of the pictures to which it devotes some attention. I shall state the reasons for my own particular viewpoint. My aim is to make each spectator question his own heart, articulate his own feelings, and thus form a personal judgement and a vision based on his own character, tastes and predominant emotions—providing, that is, he *has* emotions, because unfortunately they are essential for the appreciation of art. My second aim is to cure young painters from imitating the school of David and Horace Vernet. I am prompted solely by the love of art.

The perfectly reasonable man of sound judgement has all my esteem in society. He will make an excellent magistrate, a good citizen and husband, in fact admirable in every way, and I shall honour him everywhere except in the exhibition rooms. The conversation I like to follow in the Louvre is that of the young man—with wild eyes, sudden movements and rather dishevelled dress. This morning I have just overheard twenty judgements on the same number of prominent pictures, and if I had not been afraid of being taken for an eavesdropper, I should have hurriedly copied them down in my notebook. The same ideas may come back into my mind but I shall never find the secret of saying them so well and with such passion.

SECOND ARTICLE

THE ARTIST AND STATE PATRONAGE

In Paris the more a painter works, the poorer he is. A young artist endowed with the least of the social graces and *savoir faire* (generally speaking young artists are charming, they love fame so openly and confess to it so delightfully) can easily manage between one exhibition and the next to establish some connection with newspaper editors. When he exhibits, he looks so well-mannered himself that it would make him miserable to be told the truth; so that, however devoid of merit his pictures, and however awkward his heroes, he can always rely on some well-disposed newspaper

to praise them and delude him. And so he sees his pictures described in grandiloquent style as minor masterpieces; but nobody buys them. Now, to paint a picture, you need models, and this is more expensive than people think; then you need colours and canvas, and you have to keep body and soul together. A young painter of the modern school can only meet these basic necessities of his art by contracting debts—always paid off honourably (I willingly do these young men this justice). But in the end the young painter is forced to take his pictures back home with him after the exhibition and his life is nothing but illusions, deprivation and disappointed hopes. Then one fine day he discovers a sure way of having some money to spare—by giving up work.

This is certainly an extraordinary fact in the history of art, which one would hardly suspect from the high-sounding tone of the usual pamphlets on the exhibition. Here, as in everything else, hypocrisy in ideas leads to misfortune in real life. For the young painter who has just made himself better off by throwing his brushes out of the window is already thirty. He has wasted—or at best devoted—the best part of his life to acquiring a useless talent. What can he do, and what profession can he take up now? Such questions invite depressing answers and I am loath to spell them out.

This is the disastrous result of the excessive promotion given to painting by the budget of the Ministry of the Interior. Here is what happens, contrary to the intentions of the sponsors, partly because of academic competitions and journeys to Rome. In all these competitions I can see elderly artists gravely deliberating how well the young have copied their own style of painting. Twenty pupils of David congregate to examine a young man's picture; and if the young artist, like Prud'hon, has genius and refuses to copy David because this style does not satisfy his own spiritual needs, all David's pupils stand up and, from the height of their authority, declare in a unanimous vote (which to the general public seems most impressive) that Prud'hon has no ability. To take another example from literature, look at the fuss the public makes of the speeches and poems which the French Academy infallibly consecrates every year. Whoever reads them or bothers about them? Do the speeches for which prizes were awarded fifty years ago have any place in our libraries today? And yet I think the gentlemen of the French Academy are quite as good as the

members of the Academy of Fine Arts. The only difference is that in literature the public is not so easily deceived. And also a sharp, knowing public like the French will never take seriously judges who are asked to pronounce on their own cause. Academicians always look at a young candidate's work to see if he is working in line with their own method and style. But genius imitates nobody, least of all academicians.

THIRD ARTICLE

GERARD'S CORINNE

A painter has a considerable advantage when the subject he has to treat is new and yet widely known. Madame de Staël's *Corinne* is read and admired throughout Europe, and M. Gérard seized his opportunity just before that fine passage from the novel—where Corinne improvises on Cap Miseno in front of her lover, Lord Oswald—had time to fade from people's imaginations. As a result his first picture of *Corinne* [Plate 20][9] was nearly as successful as the novel. Writers of all nations were keen to pay homage to the French King's foremost painter. In Germany M. Schlegel, rightly considered by our neighbours to be their most learned critic and their best qualified writer to appreciate beauty in all its forms, the man who, as Madame de Staël's friend, was entitled to judge with the utmost severity this pictorial translation of one of her finest pages, M. Schlegel devoted an article of rhapsodic praise to M. Gérard's first *Corinne*.[10]

This first picture, which is too well-known for me to describe, has just been reproduced by M. Gérard in a smaller version. It would offend my reader's imaginations if I made the feeble attempt to recall one of the most outstanding memories left by the Salon of 1822. In his second version M. Gérard decided to add some secondary figures; this was an excellent idea. I may be wrong, but I believe that the picture of the present exhibition is better than the original.

Corinne seems to me more inspired, and the proportions of her fine body, so skilfully drawn beneath the flowing drapery, recall those of the finest Greek statues. We sense great power behind that broad bosom around

which the air seems to circulate freely, and yet the passion and life expressed in the features of her noble head are wholly ideal, and not in the least physical, so to speak. This is not the kind of delirium which must have seized hold of Sappho as she recited poetry in front of Phaon, her lover. In Corinne's eyes I recognize the image of love as it has been experienced by people of our own age; something related to Werther's sombre passion. In short, I can foresee this inspired woman walking to her death along a path strewn with flowers.

The weakness of Madame de Staël's novel is Oswald, Corinne's lover. Up to now women writers have failed to give their male characters that quality which Madame de Staël so aptly called *strength in repose*. With his sad, sickly expression, Oswald is one of the least satisfactory figures of M. Gérard's picture. So we quickly avert our eyes from this frigid northerner, the sad victim of prejudices which he has neither the strength to overcome nor the courage to surrender to, and instead turn to the child-like, blissful happiness of the *lazzarone* whom the painter ingeniously placed in the left-hand corner of the picture. I find the young Greek listening with lowered eyes magnificent; it is an admirable portrayal of the passionate intensity with which the Southern nations listen to music. The working-class woman calling the Neapolitan fishermen to come and hear this fine woman improvising reminds me of the gestures made by certain figures in Raphael's *Stanza dell'Incendio* in the Vatican. Two English-women distinguishable in the background of the picture are, in my opinion, placed with perfect artistry. From their frigid, disdainful expressions I can foresee the fate in store for poor Corinne once she has left the beauties of Italy to go and bury herself in the chilly, northern land of propriety. Here the painter has given their full meaning to Madame de Staël's fine pages on those women from the North, with their respectability, class-consciousness and tea-making talents. In those two English-women I can see Corinne's entire fate, and I can hear their expressions of disdain as they meet a person of their own sex with a supreme gift: *Very shocking! Very improper!*

The only person to respond openly and completely to Corinne's talent, without any afterthought or reservation to spoil his enjoyment, is a pauper who lives from hand to mouth—a fact wholly typical of Italy and of

Madame de Staël's slightly exaggerated portrait of the country. And so, after a rapid survey of all Corinne's friends, the spectator's eye instinctively returns to his abject-looking but marvellously painted character; for everything can be ennobled by sincere emotion. The spectator dwells with admiration on Corinne's fine head—a great painter's masterpiece; her intensely moving eyes fill the spectator with passion, and when he needs a respite from such strong emotion he returns to contemplate the Neapolitan fisherman's spontaneous enjoyment. The fact is, this poor fisherman, despite his humble status, is the one character most in harmony with our innermost feelings. What truth everywhere in the picture! What passion in Corinne's attitude! And how splendidly her figure is silhouetted against the stormy Naples sky when Vesuvius is possibly about to erupt and the smoke already threatening Portici, Torre-del-Greco and the houses nearby. I repeat that I find this version better than the original picture; it has perhaps still more passion, and expresses the very essence of Corinne's soul. It is the ultimate achievement of a supreme artist.

GERARD: LOUIS XIV AND PHILIP V OF SPAIN

I come at last to the most important picture of the exhibition [Plate 21] . . . Louis XIV has just pronounced the words: Gentlemen, the King of Spain. Instantly the Spanish ambassador falls to his knees and kisses his monarch's hand. The young ruler is an admirable figure, full of charm and painted with a skill beyond all praise. Louis XIV is calm and dignified. This subject, which is so impressive in a historical narrative, presented the painter with a great difficulty in the quantity of embroidered costumes, since to our way of thinking today they seem incongruous. I noticed, however, that all the visitors admired the perfect ease with which the characters of this fine picture seem to carry clothes in which we should be so ill at ease. The materials are brilliantly conveyed, and despite the profusion of embroidery, gold and shining surfaces, the light is steady and firm. This picture of Louis XIV and Philip V thus meets the criticism made by some hypercritical people of the *Entry of Henry IV into Paris*,[11] which, they said, seemed to be lit like a diorama. On the contrary, in Gérard's picture the air circulates uniformly and the figures stand out clearly; and even

though the profound respect with which all Louis XIV's subjects approached *the most powerful king in the world* prevented them from revealing the slightest personal emotion, M. Gérard, with great subtlety of handling, has managed to give all the characters an intelligent expression. The spectator can easily gauge each of their reactions to the great decision the King is in the process of making irrevocable by this public action, which was soon to have repercussions throughout Europe. A French heart can reflect with pride that the King's decision was to throw governments throughout the world into disarray and confusion. . . .

The thought of the momentous war which was unleashed at that moment leads us naturally to look for the noble figure of the *Maréchal de Villars*, the victor of *Denain*. Then we are glad to see the *Marquis de Torcy*, a clever minister who was responsible for so many difficult negotiations; here he is explaining some points of procedure to *Boileau-Despréaux*, whose post as Historiographer Royal gave him access to cabinet meetings. Everything in this fine picture is historically accurate. It is reported that the painter was guided in this matter by a distinguished person; all the Frenchmen in the picture are portraits. These widely known facts greatly increase the pleasure taken by the public in this fine work. There are crowds every day, but on Fridays and Saturdays it becomes impossible to get far enough down the main gallery to see the picture. Everyone can understand *Corinne*, but to appreciate the subtle and accurate details cleverly devised by the painter in this picture, you need a thorough knowledge of the various events of Louis XIV's reign. . . .

But, I say again, this subject is the most difficult test that a great painter ever had to confront. Outside France it would have been impossible to find an artist with the courage to tackle it. I am happy to render this tribute to our school of painting (which elsewhere I shall criticize all too often), and M. Gérard has contended with such difficulties in a way which must enhance his great reputation still more.

FOURTH ARTICLE

THE CASE AGAINST DAVID'S SCHOOL

Take hold of a man in the street, without the least knowledge or art or literature—in short, one of the countless idle ignoramuses of which all capital cities are full—throw him into prison, and, once he has got over the shock, promise him he could have his freedom provided he can draw a correct, naked figure after David's precepts and have it accepted by the Salon, you will be surprised to see that the prisoner put to such a test will reappear in the outside world after two or three years. The reason for this is that correct, learned draughtsmanship copied from the Antique, as understood by the school of David, is an exact science no less than arithmetic, geometry, trigonometry etc.; in other words, with infinite patience and the shining genius of Barrême,[12] you will know and be able to paint the shape and precise position of the hundred or so muscles of the human body. During the thirty years of David's despotism, the public was charged with bad taste if it did not equate genius with the patience needed to acquire the exact science of draughtsmanship. Do you still remember those handsome pictures of naked bodies by Madame ***? The last excess in this style is M. Girodet's *Deluge*, which can be seen at the Palais du Luxembourg.

But to come back to our prisoner in a tower of the Mont-Saint-Michel. Tell him that he will be free once he can paint in a generally recognizable way a lover's despair on losing his mistress, or a kind father's joy in seeing his son return whom he believed dead; the miserable man will find himself condemned to life imprisonment, because unfortunately, for a great many artists, the emotions are not an exact science that the most ignorant man can master. To be able to paint the emotions you must have seen and felt their devouring flames. I am not saying, mark you, that all passionate people are good painters; but I *do* say that all great artists have been men of passion. This is equally true of all the arts, from Giorgione dying of love at thirty-three because his pupil, Morto da Feltre, had run away with his mistress, to Mozart, who died because he imagined that an angel appeared to him disguised as a venerable old man and called him to heaven.

The school of David can only paint bodies; it is decidedly inept at painting souls.

It is this quality, or rather the lack of it, in so many pictures praised to the skies in the last twenty years, which will prevent them from reaching posterity. They are well-painted, cleverly drawn, this I admit; but they *bore* us. And as soon as boredom rears its head among the fine arts, we might as well give up. . . .

People will protest that this is unfair denigration. Well, just go to this year's Salon and try to find a picture expressing some human emotion or spiritual impulse in a vivid manner intelligible to the general public. I tried out this disastrous experiment on Saturday with three friends. As soon as you look at the exhibition from this angle you feel stranded amidst more than two thousand pictures. I expect painting to have a soul; but this multitude of figures of so many different nations and styles, whose creators have ransacked history, mythology, Ossian's poems, M. de Forbin's[13] travels etc.—as soon as I look for a soul, all this looks like nothing better than a *vast human desert*.

At a distance, I can make out figures taking part in some action which ought to arouse all the most passionate feelings which ordinarily lie dormant in men's hearts. But when I come closer I only find impassive characters like the Romulus in M. David's *Sabine Women* [Plate 8]. This man is supposed to be fighting for his life and throne; there he is, face to face in armed combat with the rival determined to usurp and kill him, and yet all he can do is strike an attitude, show off his fine muscles and throw his javelin gracefully. Not one of our common soldiers isn't twenty times more expressive in his obscure battle to win the respect of his company, without the least personal hatred of the enemy. Romulus ought to offer us the ideal of a man's passion for power, fighting for everything most dear to him. But from this psychological point of view he doesn't even match up to the most commonplace reality, and he is ideal only in the handsome form of his correct, classical muscles. . . .

Do you want to know what it is instead of expression we find constantly at the Salon this year? *Imitation of Talma.*

For example, what about that *Oath of three men of Switzerland* pledging their country's freedom by M. Steuben? The effect of moonlight and mist

in the upper mountains is well done, I am glad to say. But nothing is easier to achieve than such effects simply because we have already seen M. Steuben's moonlight eight or perhaps ten times in our lives. Our memory of it is rather vague, and so, as soon as we find it conveyed in art with some degree of skill, we acclaim it as a miracle. And what about the three Swiss heroes? Is my heart moved by something *true*, based on real observation? No, alas, all I can see is the copy of a copy. These three nobly drawn heroes are merely three versions of Talma acting in different roles.[14] On the stage Talma would be superb in these attitudes because they last no more than an instant; but these fellows, by transforming Talma's fleeting gestures into an eternity, look no better than clowns. There is no simplicity or spontaneity about them. I know that it is easy to make mistakes in our age in trying to paint heroes. But hasn't M. Steuben ever read Plutarch?

If you want to see other copies of Talma, but bigger, go and see *Marius at Carthage* by M. Cogniet [see p. 151]. The envoy sent by Sextilius, the praetor, and Marius are still only two men playing to the gallery in the intoxication of tragic emotion. When a great actor wants to convey the feeling of reality he studiously avoids everything simple and spontaneous, and rightly so. But for this painter, on the other hand, simplicity and spontaneity are his greatest assets. . . .

FIFTH ARTICLE

COGNIET, SCHEFFER, SCHNETZ

My attention was drawn by public acclaim to an episode in the *Massacre of the Innocents* [Plate 26],[15] where a mother is trying to save her son from the executioner's fury by stopping him crying out loud. This picture by M. Cogniet is No. 334. When I went up and examined it more closely I found it was only a pastiche of the Carracci or, if you like, the portrait of a first-rate actress impersonating a mother in despair. If I were a great artist I could say what is wrong with this picture, but as a simple art-lover all I can do is put my hand to my heart and notice that it doesn't beat in response. Some months ago, however, I went to see *The Poverty-stricken*

Family [Plate 23], a small inconsequential work by the late **Prud'hon** exhibited two years ago. I had scarcely looked at it for two minutes before I felt overwhelmed with emotion; I had come to study Prud'hon's technique, his use of colour, chiaroscuro and drawing and so on, but I could only think of the despair of that unfortunate family. This is the electrifying effect of *truth*, and this primarily is what is lacking at the present moment: *truth in the portrayal of human feeling.*

I was expecting a lot from *M. Lethière*. In Rome I had long admired his fine picture of the *Death of the sons of Brutus* [Plate 24], now in the Luxembourg. This great work of a rather lifeless composition is full of magnificent heads drawn from life in Rome. After M. Lethière's great success in giving the truth, in the form of his heads and facial expressions at least, I had hoped to find the same most praiseworthy quality in his picture of the *Foundation of the Collège de France by François I*. But I was instantly struck by the commonplace look which the artist has given this brave and gallant prince. François I had the bearing of a soldier and something of the heavy figure belonging to very tall men, but he certainly wasn't insignificant as the painter has made him appear. There is nothing remarkable about the rest of the picture.

I am glad to come to *M. Scheffer*. Constant criticism gives me a bad conscience. I understand that art-lovers rate this artist's pictures very highly. This in my view says a lot for him. M. Scheffer, it seems, has successfully divined the public's taste. Everyone says that his picture of *Gaston de Foix killed at Ravenna* [Plate 32] is not properly finished, and I agree. I wouldn't have expected the artist to have painted the armour of Bayard, Lautrec, La Palisse and others with too much care; that would have made it lifeless. But the painter has gone to the opposite extreme. The coats of armour in his picture are painted in such rapid, careless strokes that instead of thinking of the Battle of Ravenna we think of the speed with which the artist executed his picture. Still, it is an attractive work, except for the theatricality of the future Leo X, who certainly never went to battle in a costume like that and never had that contrite expression. Giovanni de' Medici was a great nobleman, not an obscure country priest. The faces in this picture are interesting, intelligent-looking and true to life. What a pity the painter didn't think of showing us Gaston de Foix

bare-chested! He could have given us a picture of the prince's friends, finding his body in a ditch, removing his breastplate to see if his heart was still beating. Nothing could be more natural than this idea; a handsome, well-painted torso would have been restful to the eye after so much iron-mongery. As it is, this picture is well outside the ordinary run of exhibits and we can found great hopes on this artist. His style seems to me to be close to that of *M. Hayez*[16] of Venice, the foremost painter in Italy at the moment. . . .

In a later article I shall speak at length of *M. Schnetz*, the young painter who seems to me to have got the better of his rivals. I ask the reader to go and look for the *Young Roman peasant girl murdered by her lover*. This picture is wholly in Caravaggio's manner at his best. You should also see the *Shepherd in the Roman Campagna*,[17] near the Appian Way, and the *Brigand's wife fleeing with her child*. The restrained vigour of these last two pictures is the quality which leads me to place M. Schnetz in the first rank. I am told that all the pictures exhibited this year by this young artist were painted in Rome, and that is perhaps why the colour of his flesh is too brown.

M. Schnetz must have copied his models too literally. Since his pictures are intended for French eyes, he ought rather to have studied the colour of skin at the swimming-baths. As soon as M. Schnetz's pictures begin to darken with age they will lose much of their effect.

SIXTH ARTICLE

ON VIGNERON'S MILITARY EXECUTION

In my opinion, which may seem rather fanciful in the age we live in, the fine arts never ought to attempt to portray the inevitable misfortunes of humanity. They only succeed in making them seem worse, and this is an unenviable achievement. M. Vigneron's picture[18] is like a drama of the same order as the *Thieving Magpie*—good enough for vulgarians and Germans. The aim of true tragedy, like Schiller's *William Tell*, for example, is to move the most enlightened classes of society.

SIGALON'S NARCISSUS

Two pictures have achieved great success at this exhibition on account of the thought behind them: M. Vigneron's *Dying soldier* and M. Sigalon's *Narcissus* [Plate 31]. We can already see the death of noble Britannicus in the expression of the slave writhing in appalling agony; and, under Nero's cloak, we can foresee the young emperor poisoning his brother. This admirable picture is the first work of a young man who until recently kept his family by dashing off signboards for dealers on the rue Saint-Honoré.

Some people have said that in Nero's reign the Emperor's official poisoner wouldn't have been reduced to living in a cave. This is not a valid argument in painting, since here we have one of those deliberate falsifications demanded by art. To express Locusta's soul the artist must give her a hideous, half-naked body, painted in the nervous, broken manner of Salvator Rosa. This brings me to another criticism I have heard of M. Sigalon.

People have wanted this young man (who, thank heaven, isn't copying anyone yet) to acquire *smooth* brushwork to make it look like porcelain—which is why I dislike M. Mauzaisse's *Saint Stephen*.[19] They have even found fault with Locusta's convulsive movement. They base their criticism on one of those philosophical truths which the painter must have the wit to ignore, since his only means of expressing the soul is by bodily movement. It is perfectly true that an old hand hardened in crime doesn't make wild gestures at the sight of something so commonplace as a slave being put to death. In Imperial Rome, before the triumph of Christianity, killing a slave was the same as when we in Paris today slaughter a mongrel because its barking disturbs us. If you accept this typical argument of the men of letters who, for some reason best known to themselves, assume the role of art-critics, you will have an estimable piece of work no better than hundreds of other lifeless pictures hanging at the Salon. These artists are doubtless very clever men but hardly ten visitors stop in front of their pictures, whereas M. Sigalon will perhaps be a great painter precisely because he has had the courage to reject all this quasi-philosophy that bedevils the arts. He instinctively obeyed the pictorial truth of showing Locusta as a woman of hideous appearance driven half mad by her crime;

she is in the act of committing the crime, but if I can put it like this, she feels the emotional repercussion of it, because once she had a heart capable of noble and tender feelings. This is the kind of character we must have in painting, but such truth of *feeling* is almost completely lacking in the famous painters of modern times.

Another criticism made of M. Sigalon's picture seems to me justified: the artist ought not to have made the dying slave a *miserable wretch*. After the sad spectacle of Locusta, our eyes called for a strikingly handsome adolescent. In M. Girodet's *Déluge* there is a drowning woman who has always given me intense pleasure because of her beauty; and her beauty takes the terror out of my response, so that I am left with a feeling of noble, slightly consoled grief—this being the only kind of grief the fine arts should attempt to produce. I apologize to all prosaic souls for having spoken in these terms a moment. By spurning beauty, M. Sigalon has fallen into one of the principal mistakes of the 1824 painters. Whenever possible without prejudice to his subject, the painter should give us the highest degree of beauty he can attain.

THE FRENCH SCHOOL AT ROME

In my time, which was several years ago, the students at the École des Beaux-Arts in Rome never mixed in Italian society, and it is said that they held meetings specially to slander Italian artists with all the energy of unsuccessful rivals. One of those gentlemen said to me with a smirk when talking about Canova: 'He can't even make a statue look like a human being.' The French Academy is like an oasis in Rome, and the students live apart. Nothing could be more disastrous for a young artist new to Rome than the company of his fellows, except the advice given by the Director. With no friends there, the young Frenchman newly arrived in Rome needs courage to resist the charms of the company of the young artists who meet at the Café on the via Condotti. It would be hard to know where else such charm, wit and genuine kindness are shown towards the poor new-comers, who are always rather at sea the first few days. What I detest in those people are their doctrines on painting. I believe their precepts are fatal to the arts. I should suggest to the first art-lover with any influence

over the Ministry of Fine Arts that he should abolish the School of Rome, and grant 5,000 francs a year to the students sent to Italy on the sole condition that they spent one year in Venice, one year in Rome, six months in Florence and another six in Naples. The students would continue to send their pictures back to Paris.

SEVENTH ARTICLE

DELACROIX'S MASSACRE AT CHIOS

With the best will in the world, I can't admire M. Delacroix[20] and his *Massacre at Chios* [Plate 13]. This work always makes me think of a picture originally intended to represent a plague, which the artist then turned into a Massacre at Chios after reading the newspaper reports. All I can see in the large, living corpse in the middle of the picture is an unfortunate victim of the plague who tried to remove the deadly tumour himself; that, at any rate, is what the blood on the character's left flank suggests. Another incident which all young art-students infallibly put in their pictures of plagues is a child trying to suck from the breast of its dead mother; there it is in M. Delacroix's picture, in the right-hand corner. A Massacre *must* have an executioner and a victim. There ought to have been a fanatical Turk, as handsome as M. Girodet's as they sacrifice divinely beautiful Greek women and threaten the aged father before he falls after his daughters, the next victim to their blows.

M. Delacroix, like M. Schnetz, has a feeling for colour, which in this century of draughtsmen is saying a lot. I suspect he has studied Tintoretto, and there is movement in his figures.

Two days ago the *Journal des Débats* claimed that the *Massacre at Chios* is Shakespearian poetry. I feel that if this picture is only mediocre it is because it errs on the side of excess and not insignificance, unlike so many classical pictures I could name, but which I will not attribute to the school of Homer, whose shades would be appalled to learn what is said and done in his name. M. Delacroix always has the immense advantage over all the other artists exhibiting large pictures, of having attracted great attention

from the public. This is worth more than the eulogies of three or four reactionary newspapers, who parody the latest ideas because they cannot refute them.

This morning, as I walked down the Galerie d'Apollon, I heard a pretty voice say with feeling and not too much affectation: 'How charming!' I looked and saw the person was talking about the *Excursion of Saint-Preux and Julie on the Lake of Geneva* (from the fourth volume of *La Nouvelle Héloïse*). This picture by M. Le Prince[21] is, indeed, very charming. The effect of the mist on the lake and of the water on the boatman's oar are conveyed with perfect accuracy, and the motions of the two figures are very cleverly indicated. Saint-Preux here is certainly that wild, passionate character described so eloquently by Rousseau in one of the least affected letters of his famous novel. I am less happy about Julie; M. Le Prince has made her a young girl amazed at what she hears. Madame de Wolmar, on the other hand, tried to restrain the stormy emotions of the man she so dearly loved.

THE ACHIEVEMENT OF DAVID

Thanks to M. David the French school today is now the foremost in Europe. Remarkable for the strength of character which gave him the courage to spurn the Lagrenée and Vanloo sort of art, this great painter was a pioneer, and as such his fame will never die. But the artists who imitate his draughtsmanship today are merely copyists, and I fear that posterity will relegate them to the status of men like Vasari and Santi di Tito, who cut the same figure beside Michelangelo as these painters do beside M. David.

EIGHTH ARTICLE

PORTRAITS

The majority of the portraits at the exhibition seem to be play-acting. That most tiresome flaw of modern civilization, the *urge to create an impression*,

has leapt straight from the drawing-rooms of the Faubourg Saint-Honoré into the exhibition galleries of the Louvre. As soon as a young man with a candid, open expression, and the look of being hard to surprise, is congratulated on his *military appearance*, he immediately starts work on himself in front of the looking-glass, and eventually manages to make himself look like a drum-major in a bad temper. Or, if you see a man of forty with the simple and yet considered expression suited to his age, after a fortnight when you meet him he looks like Heraclitus. Naturally you ask him what misfortune has befallen him, and he replies in the tragic tone of Talma playing *Hamlet*: 'None!'

LAWRENCE AND CONSTABLE

Bad though Sir Thomas Lawrence's portrait of *M. de Richelieu* [Plate 17] is, it has a little more character than M. Hersent's. M. Lawrence's style is a caricature of the carelessness of genius. I admit that I can't account for this painter's reputation. For us there is this much to be said for him, that he tries to represent natural appearances by radically different means from those of the French painters. His figures don't look *wooden* (if you will forgive the technical jargon), but they really aren't very remarkable. In his portrait of a woman the mouth looks like a small piece of red ribbon stuck across the canvas. And a talent of this order wins men a top place in the arts in England! Either M. Lawrence must have considerable social know-how, or else our neighbours in London know very little about art. M. Horace Vernet, certainly, isn't at his best in his female portraits; he can't paint delicacies of complexion, and he uses the same brushstroke for his men and his women. But still, his portrait of a woman with her head in the shadow, opposite M. Lawrence's, to the left of the door in the main gallery, is vastly superior to the English painter's work.

Even though the top London portrait-painter is pretty mediocre and still working in the Carle Vanloo style, on the other hand the English have sent us some magnificent landscapes this year by *M. Constable*. I doubt if we have anything to compare with them. The *truth* of these charming works instantly strikes and delights us. M. Constable's brushwork is excessively free, and the planes of his pictures are carelessly observed.

Moreover there is no ideal in his work; but his delightful landscape with a dog on the left [Plate 14] is a mirror of nature, and it completely outshines a large landscape by *M. Watelet* hanging next to it in the main gallery.

CLASSICAL VERSUS NATURALIST LANDSCAPE

The landscape painters at this year's Salon are all suffering from an epidemic. Although several of these gentleman have visited the Italian sites, all of them have painted their so-called landscapes with a sky typical of the Vallée de Montmorency, choosing the moment when it is about to pour with rain. In my time in Rome the Pincio, the splendid walk created by the French at the expense of two or three monastery gardens, was as fashionable as the Bois de Boulogne in Paris. One of the landscapes at the Salon which struck me most was the *View of Rome from the Pincio*, by M. Chauvin,[22] I see from the catalogue. It would be hard to find more accurate draughtsmanship, and yet more curiously false colour—the sky from the outskirts of Paris transplanted over the monuments of Rome. Such degradation of something so beautiful makes me irritable: it is as if the painter had covered his portrait of an adored woman with pockmarks. . . .

I praised *M. Constable's* landscape enthusiastically because for me the truth has an immediate fascination and charm. The admirers of the Davidian school greatly prefer *M. Turpin de Crissé's* landscapes [Plates 15 and 16], especially the one showing Apollo exiled from the sky. I shall not criticize the hackneyed idea of representing Apollo and the Muses yet again, for that would be to misunderstand the nineteenth century. What struck me is that the partisans of traditional French taste praise M. Turpin de Crissé's landscapes as *truthful*. I will begin by saying that, in my opinion, the ideal landscape artist would *draw* views of Italy like M. Chauvin and paint them with M. Constable's freshness of colour. . . .

In M. de Crissé's landscapes the foliage clearly lacks truth and *vigour*, for strength, elegance and splendour *can* be conveyed in the leafage of a group of trees. If you enter the Tuileries Gardens by the Pont-Tournant, you can see a group of conspicuously impressive chestnut trees beyond the

central pond, to the left of the main avenue. But people capable of appreciating art will never discover this kind of sensation in M. de Crissé's landscapes. In the pictures of the classical school the trees are *stylish* and elegant, but lack truth. *M. Constable*, on the other hand, is as truthful as a mirror. I only wish the mirror reflected a magnificent site like the mouth of the Valley of the Grande Chartreuse near Grenoble, and not a hay wain fording a stretch of stagnant water. . . .

SCHNETZ: THE YOUNG SIXTUS THE FIFTH

One of the greatest rulers ever to have occupied the throne of St Peter's, Sixtus the Fifth, was a small child looking after his herd of swine in the country when a fortune-teller predicted he would become Pope. This story is famous in Italy but less familiar in France, and is the subject of M. Schnetz's admirable picture hanging on the right as you enter the main gallery—*Her child in her lap, the mother of young Sixtus offers his hand to the fortune-teller* [Plate 28]. The lifelike expression of the future Pope, half frightened by the fortune-teller's appearance, could not be too highly praised. The mother is obviously saying to her: 'So you think he will become Pope?' The mixture of doubt and hope in her expression makes her a charming figure. I believe that this last work has marked out M. Schnetz's place at the top.

But why isn't Sixtus's mother better looking? Is M. Schnetz afraid that by departing from his model he will succumb to mannerism and classical imitation? He could easily have given the young woman fresher lips. Hasn't M. Schnetz any feeling for beauty? Or, if he is afraid of being led astray by idealization, why at least can't he copy three or four heads of the beautiful women whom all the artists in Rome know? I can remember seeing Madame la marquise Flo . . . of Perugia on the Pincio in Rome, but I can't find anything at this year's Salon to equal her. Our painters are experts at idealizing muscles, but when it comes to painting heads they can't even rival nature. All Raphael's Madonnas are only idealized portraits. M. Schnetz's young woman is also a portrait, but he has left her with her blemishes. His large works, the *Battle of Rocroy* [see p. 155] in particular, show that he lacks a feeling for chiaroscuro. I urge him to look

at Correggio and, if it isn't expecting too much of a French artist, to go often to the Vatican and see Domenichino's *Communion of Saint Jerome* [Plate 7].

Almost every day there is a crowd in front of the *Mariner improvising on the Isle of Ischia* [Plate 25] by *M. Léopold Robert*. All the people in this pretty picture are giving themselves graceful airs; it has none of that crude Neapolitan vigour which exceeds all possible accounts. The Neapolitan peasant is so valuable for artists precisely because he never play-acts, tries to look impressive, or imitate anybody. If you ever have to paint the despair of a mother whose two children have just been taken from her, go to Naples and study an Italian mother.

I don't like the sky in M. Robert's picture; on the other hand I very much admire his *Death of the Brigand* [Plate 27]. This is real life, passion in the raw, not trying to be elegant. The picture also has all the best qualities of painting. I only regret that the two characters, the brigand dying of a shot in the chest and his grief-stricken mistress, should have been painted in such small proportions. Small proportions are a convenient disguise for those well-known painters who sketch forms in lightly because they don't know how to draw leg and arm muscles; their pictures are like lithographs, they never give pathetic situations a full treatment. M. Léopold Robert is far and away above these so-called painters; for the sake of his reputation, he can and must paint on the same scale as Poussin. . . .

GIRODET

Undoubtedly the portrait-painter's highest honour comes when he is requested to hand on to posterity the appearance of men famous for their energy and strength of character. *Cathelineau* the peasant and the *Marquis de Bonchamps* [Plates 18 and 19], both generals of the Vendée war, were a stroke of good fortune for the painter [Girodet], who has exhibited portraits of both these men in the long gallery of the Museum. A great artist never had a better opportunity to display energy and intelligence. Dare I say it? M. Girodet has failed to rise to the occasion, and this great painter has put the people whose job it is to record public opinion in an embarrassing situation.

Except for the accessories which are cleverly rather than well painted, it must be admitted that these two portraits are far beneath the genius who painted the *Entombment of Atala* and M. Girodet's other masterpieces. Art-lovers frequently complain of the total lack of chiaroscuro; this is one of the principal defects of the French school (which at the moment is undoubtedly the foremost in the world). M. Girodet seems to have understood this criticism intellectually but not in practice. He has exaggerated the chiaroscuro to such an extent that the portrait of M. de Bonchamps looks like a picture darkened with age. For an open-air figure, the shadows *cannot possibly* be as black as M. Girodet's sense of drama has made them. M. de Bonchamps has just been wounded in his right arm and is preparing to write. He is within close range of gunfire. The general's deep concentration and his military genius ought to have been shown in their most intense form, but instead the painter has presented M. de Bonchamps with a placid, almost genial expression.

HAZLITT AND FRENCH ART

While on the subject of our incontestable superiority over the other schools of painting, I shall quote a scathing manifesto against French artists from the *Morning Chronicle* of last October 25. We must, of course, allow for a little ill-humour in people who stake their national honour on M. Lawrence's portraits and M. West's history paintings, both of them of about the same calibre. The author of this diatribe, whom I am denouncing to the Parisian public, is one of the most distinguished men of letters in the English Parnassus. He is probably exaggerating when, in a manner, he rates M. Delacroix higher than M. Girodet, but there is often good sense and taste in his criticism. I noticed that he seems to be in an awkward dilemma. To painters who only know how to copy Greek statues, Mr W.H. says: 'When you do not alter the purity of the antique, your picture is merely a copy like M. Girodet's *Galatea* in the picture of *Pygmalion* (in M. de Sommariva's gallery). When you attempt to render passion, your characters' heads will be in perpetual conflict with the body, for the first condition of classical sculpture was PROFOUND CALM, without which there could be no ideal beauty with the Greeks.'[23] I should like to see this

113

diatribe from the *Morning Chronicle* translated into French and, better still, I should like somebody to reply, but with good arguments, not by telling us again about the eternal jealousy of the *perfidious English*.

INGRES

Next to M. Schnetz's young *Sixtus Quintus* I discovered two little pictures by M. Ingres. In the *Death of Leonardo da Vinci* [Plate 11] art-lovers will find the head of François I one of the finest historical portraits at this year's Salon. The expression of grief is combined with the most perfect likeness. This is the François I whom painters on enamel ought to copy henceforward whenever they have to paint this episode (the only disadvantage of it is that it is untrue). In histories of painting we can find the letter in which Leonardo's friend Melzi announced the great man's death to his brother in Florence. At the news of Leonardo's death François I shed some tears and that was all.

In another of M. Ingres's little pictures, *Henri IV playing with his children*, the Queen and the Spanish ambassador are good. M. Ingres, with his superior draughtsmanship and skilful painting, ought to treat this kind of historical subject on the scale of Madame Hersent's *Louis XIV blessing his great-grandson.* . . .

I was on my way to the Louvre to judge the reaction of Saturday's public to the pictures. I also wanted to see a new work which is very well spoken of: M. Ingres's picture—only recently hung in the main gallery— representing *Louis XIII placing France under the protection of the Holy Virgin* [Plate 12]. In my opinion, at least, it is a very dry piece of work and, what is more, a pastiche of the old Italian painters. The Madonna is beautiful enough, but it is a *physical* kind of beauty, incompatible with the idea of divinity. This is a psychological, not a technical defect, and is still more glaringly apparent in the child Jesus, who, although very well drawn, could not possibly be less divine. The celestial expressions and religious *unction* essential in such a subject are completely absent from the characters in this picture.

The catalogue states that M. Ingres lives in Florence. While he was studying the early painters, how can he have failed to see the pictures of

Fra Bartolommeo, the man who taught Raphael chiaroscuro? This monk's works are numerous in Florence and are models of unction. Do you want to know why? Fra Bartolommeo was so moved by Savonarola's sermons that, fearing damnation, he abandoned painting. But since he was one of the foremost painters of his time (and, in my view, of all times), after four years the superior of his monastery ordered him to take up painting again and, *out of obedience*, he began to produce new masterpieces. Here, it seems to me, we have the secret of the superiority of the fifteenth century to our own age. Two months ago somebody invented a new cannon which will fire twenty shells a minute to a distance of over two miles. We are brilliantly successful in technology, lithography and the diorama; but our hearts are cold, passion of all kinds has vanished—still more, I believe, from painting than everywhere else. Not a single picture at the exhibition has the fire of a Rossini opera.

I must quickly close this digression which, I am afraid, will have offended all erudite artists, and return to M. Ingres, who is himself one of the greatest draughtsmen of our school. As an intelligent man, how can M. Ingres have failed to see that when the action of a religious picture is not intrinsically moving, the painter must deploy still greater *unction* in order to captivate the spectator's emotions? The angels on either side of M. Ingres's picture holding back a heavy curtain are very dryly painted; the same is true of their draperies. The small cloud underneath the Virgin looks like marble, and there is a general crudity about the colouring.

Louis XIII's gesture is animated, but nothing about him suggests the king of a great realm imploring divine benevolence for all his subjects. His little Spanish moustache is practically all that we can see of his face and creates a somewhat mean impression. After so many criticisms of M. Ingres's work, I still think the *Vow of Louis XIII* is one of the best religious pictures at the exhibition. It greatly improves on a second viewing, and will improve still further when it is hung in a church and has to be looked at for an hour on end. I can see a depth of knowledge and study in this work which prove that M. Ingres is a man devoted to painting and a conscientious practitioner of his art. This is a valuable picture, especially at the present moment, now that so many young painters seem only to work to provide subjects for lithographers. If the artist had been endowed

with the divine spark necessary to put a little soul and expression in the face of his Madonna he might easily have attracted the public's attention. As soon as we begin to reflect on the work of the outstanding painters of twenty years ago, we constantly come up against this disagreeable truth, which it pains me to dwell on: M. David's school, expert at portraying the muscles of the human body, is incapable of painting heads which accurately express a given emotion.

We must therefore urge M. Ingres and his contemporaries to treat historical subjects which don't demand too much intensity of expression. Without going beyond the annals of Louis XIII, M. Ingres could show the moment when Bassompierre said to the king: 'Sire, the violins are ready. When your Majesty wishes, the ball will begin.'

The *Louis de La Trémouille* [Plate 30] by *M. Richard* of Lyon looks too much like a miniature, and the details are too precise. The Gothic columns appear to have been more carefully painted than the heads. It is precisely this shortcoming that will endear the picture (a very pleasant one moreover) to a lot of people. To be able to judge the expression of emotion you must have experienced it and, what is more, have had the necessary time and intelligence for self-analysis. But anybody can enjoy looking at a smart little Gothic staircase. Louis de La Trémouille's armour is a masterpiece of patience—the sort of patience which reminded me of the somewhat tedious descriptions in Walter Scott. The Lyon school has no passion, no soul. Although Lyon is on the threshold of Italy, the city's painters look towards Paris and caricature her art.

SURVEY OF THE STATE OF EUROPEAN SCULPTURE

Now I must give an account of the public's reaction to the statues admitted to this year's Exhibition. But before I attempt to classify the various merits of MM. Bosio, Bra, Gois, Cortot, Debay, Espercieux, Flatters and others, I think it would be useful to cast a quick glance at the state of sculpture in Europe. Rome has just lost Canova, who invented a new type of ideal beauty, closer to modern ways of feeling than the Greek. The Greeks prized physical strength above everything else, whereas we value intellect and feeling. For a long time the primitive Hellenic people were in the

same state as that to which their descendants have reverted today. And my own view is that for men like General Odyssée or the brave Captain Canaris[24] physical strength is more essential than the intellect of Voltaire.

Whether this theory is valid or not, Canova began with the exact imitation of nature, as the group *Daedalus and Icarus* shows.[25] This great man is perhaps worse spoken of in Rome than anywhere else, and, as was to be expected, he is execrated by the French school; for he was the supreme artist of *expression* (which the *Sommariva Magdalen* [Plate 34] clearly proves). He was graceful, and people still remember the *Hebe*, exhibited four years ago.[26] All this is absent from the school of David. This distinguished painter, the most proficient in the entire eighteenth century, exerted a greater influence perhaps on sculpture than on painting. During our discussion of the pictures, we have seen that a new school has arisen this year, to the great dissatisfaction of David's pupils. MM. Schnetz, Delacroix, Scheffer, Delaroche, Sigalon had the effrontery to win people's acclaim, and in my opinion at least, two or three of M. Schnetz's pictures will still be admired in a hundred years' time. A similar movement cannot be observed in sculpture. 'Good!' exclaims the David school. But the art-lover sighs regretfully as he leaves the sculpture gallery without any emotion whatever. . . .

The young German artists have even less good to say of Canova than the French. But at least they can justify their slander on the strength of two sculptors famous throughout Europe, M. Thorwaldsen, a Dane living in Rome,[27] and M. Danecker of Munich.[28] Some people consider that M. Thorwaldsen's statues never rise above the level of very skilled mediocrity, but his bas-reliefs are excellent. The *Entry of Alexander into Babylon* [Plate 36], an immensely long bas-relief with figures nearly two feet tall, is a magnificent piece of work, except for Alexander himself, whose pose strikes us as theatrical. The kind of exaggeration indispensable to the theatre merely looks ridiculous when translated into the static art of sculpture.

Several of M. Thorwaldsen's busts are excellent and their qualities are of an entirely different kind from Canova's—sure proof that he is a first-rate artist. You may find that in Canova's bust of the painter Bossi at Milan,[29] one of his masterpieces, and in his bust of himself (both enormous

works) there is too much idealized elegance.[30] This sort of charm is particularly out of place in the bust of Pope Pius VII, adorning the splendid room in the Museo Pio-Clementino which this same art-loving Pope built.[31] There is a famous bas-relief by M. Thorwaldsen representing *Sleep* [Plate 35] and reproductions or plaster-casts of it can be found in all the cities of Northern Europe. But this charming work has not yet penetrated France, where we make it a point of honour to reject foreign works. This may be all very well for cotton or nankeen, but if I were fortunate enough to be a French artist, this attitude towards the arts would seem to me degrading to the profession and not one to be encouraged.

ENGLISH SCULPTURE

England can count a large number of sculptors. Luckily for the fine arts, the aristocracy, in its vanity, is fond of erecting marble monuments in churches to great men. English sculptors would have had a fine subject for a statue if the Dean and Chapter of Westminster had not recently refused to allow the author of *Don Juan* and *Cain* to be buried in their church—a handsome young poet, tormented by fierce passions, the genius who described the frenzies of his own soul torn between imperious pride and tender emotions [Byron].

I could not even begin to describe the absurdity of the majority of the English sculpture on the tombs in Westminster and St Paul's. Unlike Sir Thomas Lawrence, who neglects detail, the English sculptors undertake to convey the noble lord's buckled shoes, stockings, trousers, even his wig, with a heart-rending precision. The way they carve the English decoration of the Order of the Garter in marble is utterly laughable. It is only recently, since the relaxation of Puritan severity and that kind of hypocrisy in daily actions which the English call *cant*, that it has been possible for sculptors to place naked angels by the tombs of great men. The tomb, near the north door of St Paul's Cathedral, of two naval captains killed off Copenhagen displays an angel with a profile worthy of Canova. A tomb of General Moore, next to it, isn't too bad either.[32]

But what are really outstanding are Chantrey's busts. This artist began some years ago as a shepherd, and from that rose to become the

most fashionable sculptor of his time. He must certainly make as much money as Sir Walter Scott, and like that other genius, Chantrey has all the skill, *savoir-faire* and adaptability necessary for success in London while never offending against contemporary hypocrisy. I find it hard to say how much I admired Chantrey's bust of *Walter Scott*.[33] I wish a plastercast of it were in the Louvre, next to M. Flatters' bust of Lord Byron. Thorwaldsen's statue of Byron[32] looks like a schoolboy's attempt compared with Chantrey's work.

PORTRAIT OF CHARLES X BY HORACE VERNET

M. H. Vernet combines *bravura* with genius. In this timid, finical age, he is *audacious*, and gets away with it; he paints well and rapidly, but is often slapdash.

The great failing of the French school, a total lack of *chiaroscuro*, is what consigns this large, long-awaited portrait among the class of mediocre works. M. H. Vernet had to represent the revered person of the King and the prince, who only had to make an appearance in Spain to win such fame; but it is impossible to see on which part of his picture the artist intended his main light to fall, and what should claim the spectator's first attention. The light is diffused over the Champ de Mars, where the scene is taking place. The spectator's eye follows up from this oddly placed source of light to the bottoms of the boots of the principal characters, and it is only by a *mental effort* contrary to the natural tendency of the eye (which painting ought to satisfy foremost) that the onlooker, remembering that he has come to the Louvre to see the King, finally manages to distinguish the principal figure's head. . . . His Majesty ought to have been immediately conspicuous, and his retinue painted in muted colours and half-tones, like the Dauphin's aide-de-camp in the former's portrait.

The great *physical* defect, so to speak, of this picture is the lack of chiaroscuro, and its great *moral* defect the lack of grandeur. If the painter had had to show a group of splendidly dressed horsemen returning from a day's hunting, he would have gone about it in the same way as he did in presenting Charles X to the French. Despite these faults, the King's portrait is a great success—a success which would hardly be contested if

this work were on the same scale as that charming picture of mounted grenadiers, admired by the whole of Paris two years ago in the painter's studio.

To paint a life-size portrait, a creative power and, indeed, *passion* are necessary, the lack of which is the only criticism to be made of the numerous masterpieces that have made M. H. Vernet's name so popular. I have seen such passionate strength only in the stubborn resistance of Spanish monks. It is this depth of feeling that often makes me prefer the works of the Venetian painter *Hayez* to those of M. H. Vernet. Several heads in the King's portrait are painted with insufficient vigour of impasto and look merely sketched in. A contemporary painter, M. Rouillard, would have put more strength into the work. Some of the other heads are not observed in correct linear perspective. Finally, it can be said of M. H. Vernet that nobody ever went further with the *talent for improvisation in painting*. He was the only man in Europe capable of painting such a large picture in a month and of doing it so well. . . .

A critic hostile to Romanticism [Delécluze] has foisted the strange epithet of *Shakespearian* upon M. H. Vernet's picture, while he calls the pictures of Raphael and David *Homeric*. He might as well say: '*I shall call Romantic everything of inferior quality.*' By this simple trick, the word Romanticism would gradually become synonymous with bad art in the eyes of the public.

Romanticism in painting is that masterpiece of M. H. Vernet, the *Battle of Montmirail* [Plate 33], which contains everything, even chiaroscuro. *Classicism* is a battle by *Salvator Rosa*, almost of the same size, which can be seen at the far end of the long gallery on the side of the Seine. *Romanticism* in all the arts is what represents the men of today and not the men of those remote, heroic times, which probably never existed anyway. If you want to take the trouble to compare these two battles I have just pointed out, and above all, to judge the amount of pleasure they give to the spectator, you will form a clear idea of what constitutes Romanticism in painting. Classicism, on the contrary, is those completely naked men in the *Sabines* picture. Granted equality of talent, M. H. Vernet's battle would be better than M. David's. What sympathy can a Frenchman who has never held a sword in his life feel for people fighting in the nude? The

most ordinary common sense tells us that the legs of those soldiers would soon be covered in blood and that it was absurd to go naked into battle at any time in history. Romanticism can take consolation from the attacks of the *Journal des Débats* in the fact that common sense applied to the arts has made great progress these last four years, especially among the highest ranks of society.

I must leave this digression on Romanticism, which was not provoked by me. The *Débats* have often returned to the debate, but, whatever the outcome, Heaven preserve us from the great word *Shakespearian*!

I hasten to point out to the public two charming works by M. Ingres. The *Portrait of M. N. . .*[36] seems to me a masterpiece, notable in the art of the diffusion of light. What skill in rendering the expression of the eyes! This, in my view, is Sir Thomas Lawrence's only merit, and how vastly superior is M. Ingres! What a bold idea, in a century in which beauty of *colouring* has been stifled by timidity, to make the character stand out against a red background! I prefer this head to the excellent portrait by M. Paulin Guérin, and to the various portraits by MM. Rouillard and Hersent. This last artist, especially, would suffer greatly in the comparison. If M. Ingres does not go back to Florence we can hope for a crowd of very fine portraits at the next exhibition and, better still, in view of the state of our school of painting, which is reverting to the manner of the Bouchers and Vanloos, portraits treated in the style of Andrea del Sarto and of Raphael.

4 The Salon of 1839[1]

WHEN YOU GO TO THE EXHIBITION, my dear friend, you will perhaps find it more interesting after reading the following malicious comments. Don't forget to let me know when you come to Paris. . . .

People are talking a lot about M. Fogelberg's *Mars and Venus*.[2]

We ought to have tickled Swedish vanity a little, so that they might have paid the expenses to have these statues transported to Paris, where they would have filled a conspicuous void at the exhibition—I mean the absence of anything ideal or sublime.

Scheffer's pictures, which make the fine ladies of the Faubourg Saint-Germain swoon with delight, are no more than a pastiche of certain pictures of the Venetian School, minus the colour, of course. They are all the colour of wine, and grave in a depressing sort of way. The *Margaret* from *Faust*,[3] considered to be the artist's masterpiece, is merely a buxom German woman with a protruding stomach and sagging cheeks. The figure as a whole has a certain naturalness, but is quite the opposite of ideal. Faust's expression in love would make an excellent character in a genre scene; the devil is merely sardonic, not really evil. The great defect of all Scheffer's figures is, as I have said, that they look like a distillation of Tintoretto and Paolo Veronese, or rather, of the works of their pupil, Carlo Veronese, Paolo's son. What the ladies find so attractive is the serious and dignified appearance of these figures, which cannot be denied.

A serious and dignified appearance is completely lacking in Vernet's three huge pictures of Constantine;[4] indeed, they are far less impressive and serious than real life. This is life seen by a man of enormous talent but completely insensitive to everything noble. And so the public, dull-witted as usual, admires these battle-scenes for their truth to life. The soldiers look like horrible frogs, and have no flesh on their bodies. The prince, naturally, is at the centre of everything. The huge figure in the middle is the most hackneyed of all, the small one on the right the least so.

I have seen several uninspired Gudins, and one admirable one: a view of a church in Normandy on the coast, when the tide is beginning to turn. I have never seen such a transparent sea on the Normandy coast.

So far I haven't been able to see a single one of the fourteen Decamps. Last night, at the concert given at the Cercle des Arts, the music was horrible, raucous, and, for some extraordinary reason, loudly applauded.

People were praising to the skies Decamps's *Turkish Guard* and his *Torture* scene,[5] in which men are being hurled over a high wall, topped with iron spikes, and impaled at random.

The devotional pictures turned out on the Pincio have not met with the least success. People find them dreadfully banal, and show no respect for their profound skill. Moreover, since they bore me, I only looked at them in passing.

In my view M. Flandrin's masterpiece is still *The Envious* from Dante; his *Saint Clair*,[6] which I saw at Nantes, is very dry and depressing.

One picture at the Salon is enough to make you split your sides with laughter: an allegory by M. Mauzaisse. This painter ought never to have been allowed to profane the figure of a distinguished and venerated person. In the foreground I saw a naked woman, blatantly seductive, with a band around her eyes; she is carrying a torch, to set fire to everything. You must have guessed—it is Liberty. It is a very good, well-painted figure; in fact, I should like to cut it out with scissors. Another very comic figure is presenting a crown to the King.

There are some charming portraits of pretty women by M. Court in the style of Domenichino. I can't understand why this man isn't a great painter.

My eyes were tired after an endless succession of reasonably good portraits. M. Amaury-Duval has painted a chocolate-coloured portrait of an ugly girl, and it is considered a masterpiece of draughtsmanship; but I couldn't find it.

On the whole, all these painters seem to me like skilful craftsmen, but devoid of intelligence, to say nothing of soul; they see dignity in mere affectation. I except, of course, Eugène Delacroix, who has had three pictures turned down by those jealous swine at the Institute! Also M. Court and perhaps M. Decamps (*Raphael talking to Ariosto*), whom I haven't seen. The artist-craftsmen who fill up the Louvre ought to try addressing themselves to men of intelligence, then we might perhaps find some shred of an idea in their canvases.

5 Stendhal, Critic of the Critics[1]

DE BROSSES [*Lettres du Président de Brosses sur l'Italie*, 1739–40]

M. le Président de Brosses left Dijon in 1739 for Avignon, Genoa and Italy with MM. de Lacurne de Sainte-Palais[2] and Loppin, who, like himself, belonged to the *noblesse de robe* of Dijon (a town of clever, by no means prudish men, which in less than a century has produced Buffon, Crébillon, Bossuet, Carnot,[3] Rameau, Guyton de Morveau[4] and many others). Our traveller's three companions were, it seems, always gay, erudite and ready to enjoy themselves.

During his journey, which lasted a year and seven months, M. de Brosses, who was then thirty, wrote endless letters to his friends in Dijon. They greatly regretted that they could not visit Italy with him. To each of his correspondents, M. de Brosses wrote about what was most likely to interest him; with the learned President Bouhier, for example, the subject was archaeology, and with M. de Neuilly opera. He describes the Italian customs and way of life, and, by implication, compares them with France.

No other traveller, to my knowledge, apart from Duclos, has tried to show us the habitual way Italians go in search of pleasure. This interesting but delicate subject is usually quite forgotten in accounts of Italian journeys, and is replaced by the discreditable exaggerations of lackeys, and anecdotes from the lives of the great painters. Writers totally neglect the way the Italian people look for happiness in everyday life, and their social habits which are so unlike our own. . . .

Nothing, by comparison, could be clearer than the Président de Brosses's style. Admittedly he is usually expressing readily understood ideas. It is only when he comes to talk about the fine arts that he is profound and original, but there is never any danger of dense minds finding him obscure.

The really incredible, amazing thing is (and I can find no satisfactory explanation for it) that a Frenchman of 1739, the contemporary of MM. Vanloo, Coypel, Restout, Pierre and Voltaire, . . . should have understood not only Raphael and Domenichino (who was not properly appreciated in France until forty years later), but even Correggio, who even today is still hardly known. I am inclined to think that in this matter M. de Brosses was something of a genius.

M. Delalande,[5] the atheist and Jesuit protégé, was certainly a clever man. He made a journey in 1768, twenty-eight years after M. de Brosses. He published eight or nine volumes on Italy, and on the whole they are quite remarkable. But when he talks about the country's painters, his judgements are no more enlightened than those of the famous draughtsman, M. Cochin. Nobody could be more entertaining than M. Cochin talking about Michelangelo and Correggio. But mistakes and gross blunders of this kind will not offend the public of 1836, for it has already been hardened to them by the newspapers. This is not the question which will decide the success of the present edition of de Brosses.

(From *Mélanges de Littérature*, vol. 3)

The style I like best is that of de Brosses, for it says a lot of very pungent things in few words, clearly, gracefully and without pedantry. I think this preference must be related to something deep-seated in me, namely my love of comedy and aversion for tragedy, especially the kind in which the tragic emotions are buried under a pile of grandiloquent rhetoric.

(From the *Journal*, 5 January 1815)

I have always had a particular affection for the Président de Brosses. Why? I can't say. But he is perhaps the man I love best after Mozart and Cimarosa. I love him almost as much as Correggio, and, as you know, love is the begetter of all folly!

(Letter to Domenico Fiore, 25 November 1835)

COCHIN, VASARI AND REYNOLDS

If you feel inclined, you could enhance the pleasure of your journey to Italy by reading beforehand the lives of Michelangelo, Guido Reni, Domenichino, Leonardo da Vinci and Annibale Carracci.

With the lives of these five men, who lived from 1460 to 1560, you will know quite enough. Their biographies were written by a contemporary painter called Vasari. You will find his Italian easy to understand, but he is full of useless information. Will you ever have the patience to wade

through him? Vasari must be in the library. Don't ruin your judgement with the inanities of a certain Cochin; but *do* read the *Discourses* by the London painter, Sir Joshua Reynolds.

(Letter to Pauline, 29 October 1811)

DUBOS *Réflexions critiques sur la Poésie et la Peinture* (1719)]

Soon afterwards I won a prize for drawing from the round. Since two or three of us won prizes, they drew lots, and I was given the *Essai sur la Poésie et la Peinture* by the Abbé Dubos, which I read with the keenest pleasure. This book coincided with my own deepest feelings, of which I was unaware myself.

(From *Vie de Henry Brulard*)

MADAME DE STAËL

The French like only what is fashionable. . . . North of the Alps people never respond to the arts in sudden impulses from the heart. I think it could even be said that the North feels only after it has thought: its people can only understand sculpture when it is explained to them philosophically. For the general public to acquire some feeling for the arts, it needs that inflated, poetic language of *Corinne*, which to noble minds is so repellent and, what is more, excludes all possible degrees of qualification.

(From *Promenades dans Rome*)

Have you read *Corinne*? The passages with grandiloquent phrases and artificial sentiment are detestable, but otherwise it is excellent and contains a lot of very true things. Mme de Staël intends to write a work on the Spirit of the Laws of Society in the eighteenth century.[6] As soon as she tackles this subject she is first-rate, but she is mediocre as soon as she departs from it. What she says about the complete lack of vanity in Italy

is perfectly true. I notice it all the time in the Italians here [i.e. Grenoble], and what a long way it is from Paris to Rome.

(Letter to Pauline, May 1810)

For all its grandiloquence, this book is basically excellent. It is called: *De l'Influence des Passions sur le Bonheur*, by Mme de Staël, and it is her best work. Although the book is in my own territory, it took me a fortnight of laborious reading to get through it. As soon as I have the courage, I shall go through it, extract the good ideas and translate them into French. There are two or three glaring defects in this work, all of which can be attributed to a single cause; the author's exaggerations. Mme de Staël isn't a very sensitive person, but she thinks she is, and she has tried to seem hypersensitive. Deep down in her heart, she made this sensitivity her pride, her point of honour and her justification. So she gave herself body and soul over to emotion (at least this is what I presume, since I only know her from her work) and was surprised to find that it didn't bring her the same happiness as it does to more passionate people. One of the reasons for her disappointment was probably that she hadn't imagined happiness the way it is really experienced (there, you see, I am beginning to write like her). Once or twice a year we have those ecstatic moments when the entire soul is radiant. She supposed that this was happiness, and was disappointed when it didn't turn out to be like that in real life. The most cursory study of man's moral and physical faculties shows us that this delectable state is extremely rare. To produce it we need a sustained irritation of the nerves —like a violin tuned to its highest pitch, beyond which the strings finally snap. The state of ecstasy puts such a strain on the nerves that it cannot be endured without terrible pain.

(Letter to Pauline, 20 August 1805)

A. W. SCHLEGEL AND GERMAN ROMANTICISM

M. Schlegel, a man of intelligence, tries to persuade us that Molière's comedies are no more than dreary satires.

Admittedly M. Schlegel would have made a better apostle than literary

critic. He begins by proclaiming that he despises reason: a good start. Then, in order to follow his chosen path with a clear conscience, he adds that Dante, Shakespeare and Calderon were apostles sent by Our Lord Jesus Christ with a 'special mission'; and that for this reason we cannot omit or criticize a single syllable of their works without committing sacrilege. This fine-sounding theory is easily explainable by the so-called 'inner sense'. The man whose misfortune it is to be deprived of this 'inner sense' is incapable of responding to poets with a mission. If you want to know whether you possess this faculty, M. Schlegel will tell you; he is so well endowed himself that after five minutes' conversation, he prides himself that he can tell whether you belong to the elect.

The difficulty here is that you mustn't laugh; that is the reason these honest Germans don't appreciate Molière. It must be granted, however, that they are as scholarly as one could wish, and scholars with the 'inner sense', unlike the other sort, are not opposed to the energetic qualities in art.

I suppose that posterity will summarize the Quarrel of the Romantics and the Pedants as follows:

The Romantics were almost as ridiculous as La Harpe; their only advantage was that they were persecuted. Basically they treated literature in the same way as they treated religions, seeing only one as the right one. In their vanity they wanted to depose Racine, but they knew too much Greek to see that Schiller's sort of drama is as good at Weimar as Racine's was at the court of Louis XIV.

For the French, Racine had some delightful touches, which a foreigner will never attain. The most sensible criticism made of him was that a poet's sphere of influence is in proportion to the penetration of his mind, which, in its broad portrayal of the human heart, makes detail seem irrelevant; the difference between a painter like Vanderwerff and Poussin.

The Romantics, devoid of all knowledge of history, failed to see that the civilization of their feudal race came after that of France. These men, who, in their pursuit of the spirit, forget all about common sense, neglected the fact that their German literature was no more advanced than ours at the time of Ronsard and that, if you want fine literature, you must start by having civilized values.

They had only one name on their side, and they misused it. For they did not look at civilizations from a high enough vantage-point to see that Shakespeare was nothing but an inexplicable diamond among sand.

There is no semi-Shakespeare in England. His contemporary Ben Jonson was a pedant like Pope, Johnson, Milton and the rest.

After this great name, who remains unrivalled, they only had his imitator, Schiller. They had no Ossian, which is only Macpherson grafted on Burke. They had nobody to hold up to Molière: so they decided against laughter, either because they found it more convenient to despise what they lacked, or else because their frigid national genius, with its love of pontification, was genuinely insensitive to the comic muse. Unable to appreciate comedy as a creation, they even failed to understand its workings. They could not see that comedy can only arise in a state of civilization that is sufficiently advanced for people to forget their immediate needs and look for happiness in the pleasures of vanity. . . .

And yet the Romantics had such a just cause that they won. They were the blind instrument of a great revolution. A true knowledge of mankind brought literature back from the affected vignettes of love to a grand portrayal of all the passions. They were like Scanderberg's sword, blind both to what they destroyed and to whatever might replace it.

(From *L'Histoire de la Peinture en Italie*, Chapter XCVI)

SCHLEGEL

My note on the Romantics in the chapter on Temperaments is very bad. Those Germans, consistently banal, stupid and verbose, have laid their hands on the idea of Romanticism, christened the movement and ruined it. As understood by Lord Byron (the young peer and Lovelace of thirty-six) and taught by the *Edinburgh Review*, Romanticism is sure to carry mankind along with it. Schlegel is an absurd pedant. He says that if French literature had only one head, he would cut it off, that perfection in all the arts was achieved before the Greeks and that today we are in a steady decline. Only the Germans have preserved something of the sacred

passion, Italian Romanticism being only a corruption of the German movement.

<div align="right">(Letter to Louis Crozet, 28 September 1816)</div>

Notes on a copy of Schlegel's *Vorlesungen über dramatische Kunst und Literatur*.[7]

An infuriating mixture of fine truths and stupid blunders.

Lack of physiology and the notion of self-interest.

The extremely vague, unclear style detracts from the ideas.

I find this writer repellent in the extreme.

<div align="right">(From *Marginalia* vol. 1)</div>

WINCKELMANN

This, in my opinion, was Winckelmann's mistake. Instead of looking at Nature first and then the Greeks, he looked at the Greeks first and Nature afterwards: he only admired Nature when it had been represented by Greek sculptors. . . . I don't say judgements of this kind are true for the reader, but they are for me, H.B., born in 1783, and knocked around by eleven years' experience. That's what *I* think.

<div align="right">(From the *Journal*, 1811)</div>

Dominique [one of Stendhal's pseudonyms] hates study because it reminds him too much of the absurdity of schoolmasters. He read this book [*Die Kunst des Altertums*] in 1797 or 1798 and again in 1840 (14 May). He did not read it in 1816 while writing the *Histoire de la Peinture en Italie* since it would have paralysed his imagination.

<div align="right">(From *Marginalia*)</div>

The *Apollo Belvedere* was found at Antium towards the end of the fifteenth century and placed here by Julius II (it was previously thought that the god is shown just after throwing a javelin at the serpent Python, but now people believe that the statue is Apollo destroying Evil). The sight of the *Elgin Marbles* on show nearby in plastercast will, in my view,

greatly detract from the Apollo's supremacy. The god's majestic stance seemed slightly theatrical to the ladies in our company. We read the description of it by Winckelmann, the German sun-god and most insipid of all their gods. Isn't there a description of the Apollo in *Corinne*?[8]

(From *Promenades dans Rome*)

We tried hard to make clever conversation, but Canova scarcely listened to us. He had scant respect for philosophical talk on the arts, and probably preferred to enjoy the delightful images of his own fantasy. The son of an ordinary workman, the lack of an early education fortunately kept him immune from the poetic rhapsodies which started with Lessing and Winckelmann on the *Apollo* and led up to M. Schlegel, who would have taught him that classical tragedy is pure sculpture.

(From *Promenades dans Rome*)

Today all people with pretensions to sensibility quote Winckelmann. In twenty years' time, with any luck, they will be quoting *Opus* [i.e. *L'Histoire de la Peinture en Italie*].

(Letter to Louis Crozet, 20 October 1816)

6　Travel Literature

SCULPTURE IN PUBLIC SQUARES

Even though it is a perfect likeness, this statue of Louis XIV[1] is merely trite from a human point of view. It is Louis XIV seen by Voltaire—as remote as possible from the calm and natural dignity of the *Marcus Aurelius* on the Capitol. This is the level to which equestrian statues have descended.

There are, moreover, as I see it, two very difficult professions in question here: the ruler's and the sculptor's. To create an impression of dignity without looking ridiculous is a hard task today. If I were the mayor of a small town, and you wanted to impress me with your power, you would perform certain gestures and carry your head high. But if you were alone you wouldn't bother to do this. I immediately ask myself: is this man a convincing actor? Do I find him impressive? Merely to pose the question is enough to destroy any spontaneous feeling.

A long time ago now people stopped gesticulating and spontaneity vanished from polite society. The greater the importance a person attaches to his remarks, the more impassive he must seem to be. In circumstances like these, how will the unfortunate art of sculpture manage, when it depends exclusively on gesture? It won't survive. When it tries to represent the energetic deeds of great men of the day, it is reduced to copying mannerisms. Look at Casimir-Périer's statue in the Cemetery of Père Lachaise: there he is, speaking in a pompous and affected manner, and he has just drawn the cloak over his uniform in readiness to address his fellow members of the Chamber. If this gesture conveys anything at all, it is that our hero is afraid of being rained on in the debating chamber.

Now look at the gesture of Louis XIII in M. Ingres's picture, at the moment when he is placing his kingdom under the protection of the Blessed Virgin. The painter has tried to create a movement of deeply felt emotion but, for all his talent, has only given us the action of a street-porter. M. Calamatta's superb engraving failed to redeem the defects in the original. In an attempt to look serious and respectful, the Madonna is merely pouting. She doesn't have the natural gravity of Raphael's Virgins which M. Ingres copies.

Then consider the statue of Henri IV on the *Pont Neuf*; he's no more

han a raw conscript, afraid of falling off his horse. The one of Louis XIV in the *Place des Victoires* is more successful and looks like M. Franconi making his horse perform in front of a crowd of people.

Marcus Aurelius, on the other hand, simply raises his hand to address his soldiers, and has no need to assume important airs in order to be respected. . . .

Technically all the arts are moving towards perfection. Artists can model marvellously lifelike birds, but the kings and great men we put up in the middle of our squares look like actors, and, what is worse, bad actors.

<div style="text-align: right">(From *Mémoires d'un Touriste*, vol. 1)</div>

ROMAN ARCHITECTURE

LA PORTE D'ARROUX AT AUTUN

If you want an idea of this grand, simple monument, you must find an engraving of it. I cannot describe impressions; and as I don't want to launch into hyperbole and fine phrases, I can only make a few comments on an engraving. I can't replace one.

This venerable relic of Roman antiquity is nineteen yards wide and seventeen high. As soon as I saw it, I felt I was back in Italy. After the saddening spectacle of Gothic churches, my heart breathed freely again. Instead of images of absurd miracles, which often merely lower our opinion of the Supreme Being they are designed to honour, and carved figures of the Damned being bitten by devils on the capitals of every column and in every corner of Christian churches, I was reminded of the sovereign people and its victories—in other words, of everything most impressive in mankind. In my eyes the notion of God was degraded by the grotesque sight of all the stupidity he allowed to be committed in his name. But here the idea of man is restored in my sight. . . .

The solidity of the construction is matched by the admirable majesty of the architecture. There is no cement to bind the stones together, and the joints are the merest slits which it would be impossible to fit the blade of a penknife into. It is probably the extreme solidity of this monument

which enabled it to withstand the destructive fury of the Huns, Normans and many other barbarian tribes.

(From *Mémoires d'un Touriste*, vol. 1)

LE PONT DU GARD

As you know, this monument, designed as a simple aqueduct, rises majestically out of the most complete solitude. The sight of it instantly plunged me into long and profound amazement. Even the Colosseum in Rome hardly stirred my imagination more deeply.

The arches we admire today were part of the twenty-mile-long aqueduct which carried water from the Fontaine d'Eure to Nîmes. It had to be made to cross a deep and narrow valley, and that is why the monument was built.

There is no luxury or trace of ornament about its appearance. The Romans created such amazing things not to win admiration, but simply for their utility. It is an eminently modern concept: all thoughts of striving to create an effect are banished far from the onlooker's mind. If this modern craze comes to his mind at all he will immediately dismiss it. We are overwhelmed by the kind of emotion which, rather than exaggerate it, we prefer not to express in words. True passions have their own modesty.

Three superimposed rows of round arches of the Tuscan order go to make up this grandiose mass, six hundred feet long and a hundred and sixty high.

The first row, which fills the lower part of the narrow valley, consists of only six arches.

The second row is higher up, in a wider section of the valley, and has eleven arches. The third consists of thirty-five very small arches; it was designed to reach just up to the level of the water. It is the same length as the second, and carries the canal immediately above; this is six feet wide and six feet deep. I shall not try to write fine phrases on a sublime monument. You must find an engraving of it, not for its beauty, but to understand its form, which, moreover, is very simple and calculated exactly for its purpose.

Fortunately for the art-loving traveller, in whichever direction he looks,

he will find no traces of habitation or of agriculture. The only plants to grow in this barren region—thyme, wild lavender and juniper—exhale their solitary perfume under a dazzlingly clear sky. Here we can abandon our spirits to meditation, for the sight of this creation of the Roman people before us automatically reclaims our attention. I suspect that this monument must have the same effect as sublime music; for a few privileged spirits it is a great event, while the others gape with wonder at the amount it must have cost.

(From *Mémoires d'un Touriste*, vol. 2)

GOTHIC ARCHITECTURE

For a hundred and fifty years the word Gothic was synonymous with ugliness. So it was high time for a change of public opinion. But since polite society has become the arbiter of everything today (especially of books), it has been appointed both judge and jury in this matter.

Society lives in fear of a return of 1793. It applauds all books, provided they are pious; and, moreover, it is proud of its pedigree.

It imagined—or at least the *éminences grises* of society imagined—that veneration for Gothic architecture would lead the faithful back to the priests, since they for the most part officiate in Gothic buildings; and that, out of gratitude, the priests would bring the good people of France back to the same degree of stupidity and servility which it exhibited, for example, in 1744, on the occasion of Louis XV's illness at Metz. As if a nation's feelings could be put back like a clock! Love of the Du Barry government indeed!

It was thought that the study of Gothic would create reverence for ancient lineage and could restore religion in France. 'Let us therefore worship Gothic architecture, which witnessed the great deeds of our ancestors; we will allow only those sheep-like writers to call themselves *scholars* who know how to curse Voltaire and enthuse over the Gothic.' Don't you remember this decree being pronounced around 1818? . . .

For me, I admit, Gothic architecture is like the sound of a harmonica; the first time you hear it, it produces an effect of surprise, but it has the

same disadvantage of monotony, making it unsuited to playing mediocre tunes.

I find that the church of *Saint-Ouen* at Rouen and the spires of *Cologne Cathedral* or *Milan* inspire me in the same way as the *Maison Carrée* at Nîmes or *St Peter's*, Rome. But the commonplace Gothic church, such as the cathedrals of Lyon, Nevers or Vienne, are no better in my view than mediocre pictures, and when I see a scholar getting excited about them, I think: 'This man must be anxious to become a member of the Academy.' Don't you agree?

I can only really respond to the effect of an ordinary Gothic church when it is a humble chapel, set deep in the middle of woods, amid pouring rain, with a few poor peasants coming to the summons of a little bell to worship God in silence. As they kneel in prayer, nothing can be heard except the sound of falling rain. But this is a musical, not an architectural effect.

(From *Mémoires d'un Touriste*, vol. 1)

CANOVA AND THE STATE OF THE ARTS IN ITALY

Painting here is dead and buried. Canova has emerged quite by chance out of the sheer inertia which this warm climate imposes on men's spirits. But, like Alfieri,[2] he is a freak. Nobody else is in the least like him, nobody even approaches him, and sculpture in Italy is as dead as the art of men like Correggio. Only engraving is still doing reasonably well, but this is merely a trade.

7 January 1817: How can I describe two whole mornings I spent in the Marquis Canova's studio, where I stayed until I had a frightful headache? In France our impressions of beauty in nature and art come in a thin trickle and we have to make the most of them. But here it is a vast torrent, even though the trees on its banks do not always face one another. *The Farewell of Venus and Adonis*:[3] here at last we have sculpture which is both expressive and sublimely beautiful.

17 March 1817: I have seen Thorwaldsen, a Dane whom people have set up as Canova's rival. He is as powerful as the late Chaudet,[4] and has done quite a good frieze at the Quirinal Palace [Plate 36], as well as some bas-

reliefs at his own house, including the *Sleep* [Plate 35]. Canova has produced thirty statues and is the inventor of a new type of beauty. He always carves the upper lip very small, sacrificing it to the beauty of the nose; whatever his work may lose in facial expression, he tries to compensate by the size of his children's heads and the beauty of their foreheads.

<div align="right">(From Rome, Naples et Florence)</div>

STENDHAL AS CICERONE

There is certainly nothing particularly commendable in having been to Rome six times. I simply recall this small fact in the hope that it may win me a little of the reader's confidence.

The author of this itinerary is at a great disadvantage; nothing, or practically nothing, seems to him worth speaking seriously about. The nineteenth century thinks exactly the opposite, and has its reasons for doing so. Countless worthy people who now enjoy freedom of speech, but haven't the necessary time to form their own opinions, find themselves compelled to adopt a serious air, which impresses the vulgar and which the wise, in view of the times, have to excuse.

<div align="right">(From the Author's Preface, Promenades dans Rome)</div>

MONTEROSI, 3 AUGUST 1827

After leaving Paris and travelling through the ugliest countryside in the world, which fools call La Belle France, we arrived at Basle and from Basle went on to the Simplon Pass. We all devoutly wished that the Swiss spoke Arabic. Their exclusive passion for newly minted money, and for working conditions in France, where people are well paid, quite ruined their country for us. What can I say about Lake Maggiore, the Borromean Islands and Lake Como, except pity the people who don't rave over them?

We went quickly through Milan, Parma and Bologna; the attractions of these places can be glimpsed in six hours. At that point my duties as cicerone began. Two hours were enough for Florence, three for Lake

Trasimeno, where we took out a boat. Now here we are at last, twenty-five miles from Rome, twenty-two days after leaving Paris. It would have been possible for us to have done the journey in twelve days to a fortnight. The Italian mail-coaches served us well, and we travelled comfortably in a light landau and a barouche, with seven postmasters and a servant. Two other servants are coming by the mail-coach from Milan to Rome.

The ladies in the company intend to spend a year in Rome and we shall make the city our general headquarters. From there we shall make excursions to Naples and the whole of Italy beyond Florence and the Apennines. There are enough of us to make up a small party in the evenings, which can be tiresome when one is travelling. We are also going to try to gain admission to Roman society.

We hope to find the true Italian way of life and customs, which in Milan and even in Florence have been somewhat spoiled by the imitation of Paris. We want to discover the social habits of the inhabitants of Rome and Naples, and the way they go in search of daily happiness. Our society in Paris is doubtless superior, but we are travelling in search of novelty, not like the intrepid adventurer who penetrates the Tibetan mountains or the South Sea islands in order to observe barbarian tribes. We are looking for subtler contrasts, modes of behaviour closer to our own state of refined civilization. For instance, how does a well-educated man with a hundred thousand francs income live in Rome or in Naples? Or how does a young married couple spend its evenings with only a quarter of this amount?

In order to fulfil my duty as cicerone honourably I shall point out the things of interest, but I deliberately reserve the right not to express my own opinion. Only at the end of our stay in Rome shall I offer to show my friends in a slightly more serious fashion certain works of art which are difficult to appreciate when you have spent your life among the pretty houses of the rue des Mathurins and coloured lithographs. With trepidation, I hazard my first blasphemous remark: the main obstacle to our enjoyment of frescoes in Rome is the kind of art we see in Paris. Small comments such as these are purely personal, and in no way reflect the opinions of my agreeable travelling companions.

I shall nevertheless keep to the order we have adopted, since it needs a little method to find one's way round the enormous number of things to be

seen in Rome. Each one of us placed the following headings on the first six pages of his pocket notebook:

1. Classical ruins: The Colosseum, the Pantheon. The triumphal arches, etc.
2. Masterpieces of art: the frescoes of Raphael, Michelangelo and Annibale Carracci. (The two other great painters, Correggio and Titian are poorly represented in Rome)
3. Masterpieces of modern architecture: St Peter's, The Farnese Palace etc.
4. Classical statues: the Apollo and the Laocoon, which we have seen in Paris.
5. Great works by two modern sculptors: Michelangelo and Canova: the Moses in San Pietro in Vincoli and Pope Rezzonico's tomb in St Peter's.
6. The government and its influence on the way of life.

(From *Promenades dans Rome*)

LETTER TO PAULINE PÉRIER-LAGRANGE, 8 DECEMBER 1811

My dear sister,

You asked me to give you some general details on my travels in Italy; I haven't got much time.

As a rule, there are four things to be observed in Italy:

1. Conditions of soil and climate.
2. The character of the inhabitants.
3. Painting, sculpture and architecture.
4. Music.

I found the Italian landscape very well described by Arthur Young.[5] As far as the national character is concerned, nobody has written about it. To find it you must turn to history: M. Sismondi,[6] the uninspired pupil of an excellent school, has portrayed the Italian character in his *History of the mediaeval republics*.

He is sensitive, passionate, vindictive, but free of vanity, and practically incapable of the kind of wit we associate with Voltaire and Duclos.

As for music, I am expecting a book from Naples on the subject, and I shall translate twenty pages or so of it for you. You will see what a state of decline music is in at the moment. 1778, when Voltaire, Rousseau and Garrick died, was a significant year; in France all the arts were in the last stage of decadence. But musically it was a peak: Pergolesi, Cimarosa and Jommelli were writing melodies unequalled by anyone except Mozart, but they were all in a sad strain.

As far as painting goes, I have been lucky enough to make the acquaintance of one of the foremost Italian painters. He dictated the list I enclose with this letter, where he has numbered the artists to indicate the rank he thinks they deserve.

I have realized that my knowledge of Italian is far worse than I thought. To start studying the language again, I am translating in an abridged form a history of the Florentine school, the first of the five schools on my list. If ever I have the patience to finish this tedious work I shall send it to you.

I don't know any reasonable French book on painting. I have heard of a work by Félibien,[7] but since it won't teach me Italian, I shan't read it and doubt if I shall miss much. You could borrow the *Lives of the Painters* by Vasari, an Italian work full of gossip. All the same, you might find some enjoyment in learning about the adventures of the great painters, namely: Michelangelo, Leonardo da Vinci, Raphael, Correggio, Titian, Annibale Carracci, Guido Reni, Domenichino and Guercino.

The friend who accompanied me to Rome and who taught me to appreciate its masterpieces thinks that Raphael is the best, Correggio second and Annibale Carracci third. The last of the great painters is Raphael Mengs, who was born in Saxony and died in Rome in 1779.

Note that the two greatest artists of the eighteenth century, Mozart and Mengs, are Germans.

LETTER TO MESDAMES PAULINE PÉRIER-LAGRANGE AND BAZIRE-
LONGUEVILLE, 10 OCTOBER 1824

Advice to light-hearted travellers in Italy. Read first of all Lalande and
de Brosses; second Valandi's journey. Otherwise you won't understand
anything about anything.

If you can, read a history of painting and something on music, or you
will find everything boring.

Try not to fall out before you get to Geneva.

When your companion bores you pretend to be asleep.

In every large Italian town like Bologna and Florence, buy the local
guide-book, *la Guida*, otherwise you will be bored and won't understand
anything.

Before arriving in a town read the relevant article in Lalande, de
Brosses and the notes by Childe Harold, Valandi etc., or you won't know
anything about anything.

Always sign a written agreement with the *veturini*; Pollastri of Florence
is an honest man, and so is Minchioni. . . .

What are the pleasures of an Italian journey?

1. To breathe a gentle, pure air.
2. To see magnificent scenery.
3. To have a bit of a lover.[8]
4. To see fine pictures.
5. To hear fine music.
6. To see fine churches.
7. To see fine sculpture.

7 Aphorisms from the *Filosofia Nova*

THE AIM of the *Filosofia* is to bring out to their best advantage several moral truths I have discovered that I believe to be original.

This work will consist of descriptions and truths. Express these truths as clearly and precisely as possible.

When I come to descriptions of detail, I must go and consult pictures by the Old Masters in the Museum.

A dramatic poem must be composed like a picture. First a rough sketch; then fill it in, creating the different roles irrespective of the scenes. Finally, once the prose work is finished, set the different parts to verse, taking care to respect the emotions of the particular character in question. Practise style by studying similar roles in great painters. (Note: This is the most likely method to stifle all feeling, hence to obstruct any possible merit. 21 November 1803.)

On Sunday 1 July 1804 I went to the Museum. I can visualize painting far more perfect than it is in reality. I imagine how the pictures in my mind would look translated into painting. Develop these ideas and put them in the *Filosofia*.

A fine subject for a picture: Tancred baptizing his mistress Clorinda, whom he has just killed. This would perhaps make the finest picture imaginable. I must write to Guérin in Rome.

We must not miss Tasso's fine contrast between battle and rustic life.

As a general rule, enlighten myself by making frequent comparisons between poetry and painting. In painting I can see the disastrous effect of manners; so poetry must do without manners. I shall form my taste on Sophocles, Euripides, Homer, Virgil, Seneca, Alfieri, Shakespeare, Corneille, Racine and Crébillon. Work hard at this during my stay at Claix.

My own view is that the painter set on winning the prize for his art ought first to study noble classical forms and the expression of the emotions in

commonplace figures, then later attempt to portray figures as beautiful as possible, moved by the strongest passions.

This is what I do. The art of verse, which is the same as colouring, I studied in Racine and La Fontaine; noble forms in Shakespeare or Alfieri. I study human passions in society, history and memoirs.

In each play, allow only one ridiculous character, who, apart from his ridiculous aspect, is a man of the very highest qualities.

All the subsidiary characters should be calculated to bring out his absurdity; at the same time, they should be as intelligent as possible and form the most delightful society amongst themselves. Thus my pictures will have a perfect principal figure, with simple and useful secondary ones, as in Guérin's (*Marcus Sextus* and *Phèdre*).

Medea is a marvellous subject, which has not yet been treated. It is the clash of the two strongest passions that exist in women, maternal love and vengeance.

Love has made men and women perform equally great acts, except that in women they are more moving. Women have much greater self-esteem than we do; this is the characteristic feature of the weaker sex. Since vengeance is motivated by self-esteem, the protagonist in a play about vengenace must be a woman. I shall therefore write a fine play, Medea, a tragedy in five acts.

Notes and References

1. *Introduction*

1. 'The admirers of a pretty woman in a picture regard her with Stendhal's eyes as the promise of the same face in real life—it cannot be otherwise, since living prettiness is so overwhelmingly attractive. Prettiness is thus little more than a pictograph, and is scarcely an art quality at all, seeing that the figure arts have for their materials the only elements that in vision can cause direct life enhancement—form, movement, space, and colour—and of these prettiness is practically independent.' Bernard Berenson, *The Italian Painters of the Renaissance*. London, Phaidon, 1952, p. 184.
2. Prosper Mérimée, 'H.B.', in *Portraits historiques et littéraires*, p. 164.
3. 'Vie de Henry Brulard', *Oeuvres intimes*, p. 38.
4. Quoted in F. W. J. Hemmings, *Stendhal: a study of his novels*, pp. 100–1.
5. 'Vie de Henry Brulard', *Oeuvres intimes*, p. 233.
6. Ibid., pp. 175–6.
7. 'En écrivant des plans je me glace'. Letter of 16 October, 1840. *Correspondance*, vol. 3.
8. Quoted in the Introduction to P. Arbelet's edition of the *Histoire de la Peinture en Italie*, Vol. I, p. 23.
9. Letter of 30 September 1816. *Correspondance*, vol. 1.
10. Charles Baudelaire, 'The Salon of 1859', *Art in Paris 1845–1862: Salons and other exhibitions*, trans. and ed. Jonathan Mayne, London, Phaidon, 1965, pp. 155–8.
11. Jean Baptiste Dubos, *Réflexions critiques sur la Poésie et la Peinture*, Paris 1719. Fourth edition, Paris 1740. Section I, p. 3.
12. On this question see A. Fontaine, *Les Doctrines d'art en France de Poussin à Diderot*, Paris, 1909; R. W. Lee, 'Ut pictura poesis: The Humanistic Theory of Painting', *The Art Bulletin*, 1940; J. Seznec, *Essais sur Diderot et l'Antiquité*, Oxford University Press, 1957, pp. 58–78.
13. *Mélanges de Littérature*, vol. 3, p. 118.
14. Ibid., vol. 3, p. 98.
15. Jules Michelet, article on the Sistine Chapel first published in *L'Artiste*, 1855; reprinted in Vol. 7, *La Renaissance* of his *Histoire de France* (Nouv. édit, Paris 1852–1867) pp. 226–42.
16. Emile Zola, *Les Trois Villes: Rome*, in *Oeuvres Complètes* (ed. Maurice Le Blond, Paris 1927–9), Vol. 36, pp. 206–10.
17. Quoted in Harry Levin, *The Gates of Horn*, p. 110.
18. Letter of 25 August, 1832; quoted in Brookner, *The Genius of the Future*, p. 55.
19. Baudelaire, 'The Painter of Modern Life', *The Painter of Modern Life and other essays*, trans. and ed. Jonathan Mayne, London, Phaidon, 1964, p. 3.
20. These were first detected by Margaret Gilman in her study *Baudelaire the Critic*, New York, 1943. They were restated by Gita May in *Diderot et Baudelaire*,

critiques d'art, Droz, Geneva, 1957, in which the author shows that Stendhal acted as intermediary between the ideas of the other two critics.

21. Baudelaire, 'The Salon of 1846', *Art in Paris 1845–1862*, p. 46.
22. Ibid.
23. On the alignment of the critics in the 1820s, see works by Rosenthal and Grate (mentioned in Bibliography).
24. Jean Prévost, *La Création chez Stendhal*, pp. 48–9.
25. Letter to Balzac, 16 October 1840. *Correspondance*, vol. 3.
26. Jean Seznec, article in the *Gazette des Beaux-Arts*, 1959.
27. Marcel Proust, 'La Prisonnière', *A La Recherche du Temps Perdu*, Édition de la Pléiade (ed. Clarac and Ferré), Paris, 1954, vol. 3, p. 377.

2. *L'Histoire de la Peinture en Italie*

1. An episode in Rousseau's *Confessions*, 1782–9.
2. Sculpture by Canova, dated 1787–93, Louvre.
3. Masaccio frescoes in the Brancacci Chapel, Santa Maria del Carmine, Florence.
4. Correggio's *Night*, painted about 1500, usually known as *The Adoration of the Shepherds* (Dresden).
5. Antoine Louis Claude, Comte Destutt de Tracy (1754–1836), French philosopher and follower of Condillac. He wrote *La Logique* in 1805.
6. Charles Pinot Duclos (1704–72), novelist and aphorist, author of *Considérations sur les Moeurs*, 1754.
7. Charles Pierre Colardeau (1732–76), poet and member of the Académie Française.
8. Correggio, *Madonna alla Scodella*, about 1528–9 (Galleria Nazionale, Parma).
9. Raffaello Morghen (1758–1833), Italian engraver.
10. François Joseph Dussault (1769–1824), man of letters and critic of the *Journal des Débats*; Charles Nodier (1780–1844), Romantic short story writer; Martin, possibly Louis-Aimé (1781–1847), writer and literary historian.
11. Jean François de La Harpe (1739–1803), critic and dramatist, author of a work frequently attacked by Stendhal entitled *Lycée, ou Cours de Littérature ancienne et moderne*, 1799.
12. The first years of the nineteenth century saw a great revival of interest in the art and monuments of early civilizations. In 1802 Vivant Denon published his *Voyage dans la Basse et la Haute Egypte*, and in 1822 Champollion successfully deciphered Egyptian hieroglyphs.
13. The *Torso Belvedere*, Vatican Museum, Rome.
14. An episode from Tasso's epic poem *Gerusalemme Liberata*.
15. Poussin's *Coriolanus* is now in the Hôtel de Ville, Les Andelys.
16. Stendhal is referring to passages in the *Aeneid*, Books II and V.
17. Canova's *Pâris*, 1812 (Pinakothek, Munich).

Notes and References

18. Charles Mercier Dupaty (1746–1788), Président à Mortier of the Bordeaux Parlement, 1778–88; author of *Lettres sur l'Italie*.
19. Georg Christoph Lichtenberg (1742–99), German writer and aphorist, author of a book on Hogarth's Engravings, 1794–9.
20. Antinous, favourite of the Emperor Hadrian and ideal of youthful beauty. There are various statues of him, including a version in the Capitoline Museum, Rome.
21. *Borghese Gladiator*, Louvre, probably a copy after the original of the first century B.C.
22. Raphael, *Calumny of Apelles*, a drawing now in the Cabinet des Dessins of the Louvre (Cat. no. 12).
23. *Milon de Crotone*, a marble group by the Baroque sculptor Pierre Puget (1620–94), showing Milo devoured by a lion (Louvre, Paris).
24. Alceste and Philinte, characters in Molière's play *Le Misanthrope*, 1666.
25. *Meleager*, a classical statue in the Vatican Museum, Rome.
26. *Le Mariage Secret*, comic opera by the Italian composer Cimarosa (1749–1801).
27. Cardinal de Fleury (1653–1743), Bishop of Fréjus and a Minister under Louis XV.
28. Quotation from a popular comedy, *L'Esturgeon*.
29. Hugo and Parisina, characters in Byron's poem *Parisina*, 1816. Stendhal has presumably confused Niccolo with Azo, Parisina's husband, who condemns his wife's lover, Hugo, to be executed in her presence.

3. *The Salon of 1824*

1. Claude Tircuy de Corcelles (1768–1843) and Marc-Jean, Baron Demarçay (1772–1839), both radical politicians and opponents of the restored Monarchy.
2. François Xavier Droz (1773–1850), philosopher and historian, elected to the Academy in 1824.
3. Abel François Villemain (1790–1870), literary historian. Professor at the Sorbonne from 1816 to 1830. Appointed by Guizot to the Ministry of Public Instruction in 1839.
4. Two versions of this picture exist in the Wallace Collection, London. The first, signed 'Delaroche 1825', is a replica of the original shown at the Salon of 1824 (now in a private collection). The second was painted in 1829.
5. Prud'hon, *Christ on the Cross* (Louvre). The artist's last work, painted in 1824, the year of his death.
6. Abel de Pujol, *Germanicus on the field of Varus*. This picture is now in the Palais de Justice at La Rochelle.
7. Meg Merrilies, old gipsy in Scott's novel *Guy Mannering*.
8. Another of Stendhal's numerous alibis.
9. The most familiar version of this picture is the one of 1819 (shown at the Salon of 1822), once owned by Madame Récamier and given by her to the Museum of Lyon,

146

where it now hangs. The whereabouts of the slightly later variant discussed by Stendhal is not known.

10. Schlegel's article on Gérard's *Corinne* was written at the request of Sulpiz Boisserée and published in the *Kunstblatt* in 1821.

11. Gérard, *Entry of Henri IV into Paris*, exhibited at the Salon of 1817 (Museum of Versailles).

12. Bertrand François Barrême (1640–1703). French mathematician.

13. Forbin, Comte de (1777–1841), artist, archaeologist and museum administrator. Director of Museums under the Restoration. Travelled widely in Syria, Greece, Egypt and Sicily, of which he left written accounts and illustrations.

14. François-Joseph Talma (1763–1826), famous tragic actor whom Stendhal had greatly admired, especially in the Corneilian roles of *Horace* and *Cinna*.

15. Cogniet's *Massacre of the Innocents*. The original painting has not yet come to light.

16. Francesco Hayez (born Venice 1791, died Milan 1881), an artist who achieved great popularity with paintings inspired by the Italian national past, strongly influenced by Milanese Romanticism.

17. Schnetz, *Shepherd in the Roman Campagna*. Probably the picture in the Musée Magnin, Dijon (Cat. no. 880).

18. Pierre Roch Vigneron (1789–1872), history-painter, genre-painter and miniaturist.

19. Jean-Baptiste Mauzaisse (1784–1844). *The Martyrdom of Saint Stephen* was commissioned for Bourges Cathedral. It is not, apparently, there now; it may have been transferred to the municipal Museum of Bourges. The painting was engraved in Landon, *Annales du Musée, Salon de 1824*.

20. For the sake of completeness, it would be misleading not to quote Stendhal's more enthusiastic comments on Delacroix's exhibit at the Salon of 1827 (*The Death of Sardanapalus*): 'It is courage that has won a special place in the public esteem for this young [De] Lacroix, who may make mistakes, but who at least dares to be himself, even at the risk of being nothing at all, not even an academician.' This review earned Stendhal a cordial letter of thanks from Delacroix (October 1828). Henceforward the admiration was reciprocal, and Stendhal was the only modern writer, apart from Mérimée, who met with Delacroix's approval. Moreover, Delacroix may well be directly indebted to Stendhal's art-criticism; he copied out several passages from the *Histoire de la Peinture en Italie*, and in a piece of his own criticism of Michelangelo (in the *Revue des Deux-Mondes*, 1837) he acknowledged Stendhal's account of the *Last Judgement* as 'the work of a genius, one of the most striking and poetic I have ever read'. (See Julius Starzynski, *Du romantisme dans les arts*, pp. 69–72).

21. Le Prince, Baron Crespy (born Paris 1784), pupil of David and Vigée-Lebrun. The picture of *Julie and Saint-Preux* was formerly in the Collection of the Duchesse de Berry.

22. Pierre-Athanase Chauvin (born Paris 1774, died Rome 1832), landscape painter, pupil of Valenciennes.

23. Stendhal's mention of a 'scathing manifesto' by M.W.H. refers to a series of articles published in 1824 by William Hazlitt in the *Morning Chronicle*, under the title *Notes of a Journey through France and Italy* (collected in Vol. X of Hazlitt's *Complete Works*, ed. P. P. Howe). In these articles Hazlitt adopts a consistently hostile attitude towards French artists, notably Girodet and Guérin, criticizing them for their hard, statuesque outlines, and neglect of chiaroscuro etc. His criticisms are most virulent in Chapter VIII on the paintings in the Luxembourg Gallery. Chapter VI is a review in the form of a dialogue of the Salon of 1824 and makes an interesting comparison with Stendhal's own *Salon*. Stendhal's quotation, however, has no exact counterpart in Hazlitt's article, and seems to be merely a paraphrase of his opponent's general meaning.

This would not be the place to enter into a detailed comparison of Stendhal and Hazlitt. It is perhaps worth noting, however, that Stendhal's *Salon* did not escape Hazlitt's attention, for in 1825, in an article published in the *New Monthly Magazine*, on *Madame Pasta and Mademoiselle Mars* (Hazlitt *Complete Works*, Vol. XII), Hazlitt took up and endorsed Stendhal's criticisms of the two portraits by Girodet of Generals Bonchamps and Cathelineau [Plates 18, 19]: 'In one of the Paris Journals lately, there was a criticism on two pictures by Girodet of Bonchamps and Cathelineau, Vendean chiefs. The paper is well written, and points out the defects of the portraits very fairly and judiciously. . . The French critic observes that M. Girodet has given General Bonchamps, though in a situation of great difficulty and danger, a calm and even smiling air, and that the portrait of Cathelineau, instead of a hero, looks only like an angry peasant. In fact, the lips in the first portrait are made of marmalade, the complexion is cosmetic, and the smile ineffably engaging; while the eye of the peasant Cathelineau darts a beam of light such as no eye, however illustrious, was ever illumined with.'

Hazlitt then sums up his charge against the French artists as follows: 'A premature and superficial sensibility is the grave of French genius and of French taste. Beyond the momentary impulse of a lively organization, all the rest is mechanical and pedantic; they give you rules and theories for truth and nature, the unities for poetry, and the dead body for the living soul of art. They colour a Greek statue ill and call it a picture: they paraphrase a Greek tragedy and overload it with long-winded speeches, and think they have a national drama of their own.' Even though Stendhal felt bound to come to the defence of French art against such attack, he was basically in agreement with Hazlitt's criticisms and frequently acknowledged his debt to the latter's views on Romanticism in the *Edinburgh Review*.

24. Odysseus (1785–1825) and Kanaris (1790–1877), Greek generals in the War of Independence against Turkey.

25. Canova's *Daedalus and Icarus* (1779), a group in marble, is in the Museo Correr, Venice.
26. Canova carved four statues of *Hebe*. The first, completed before the end of 1799, is now in East Berlin; the second, finished before 1805, is in the Hermitage, Leningrad; the third, begun about 1808, is at Chatsworth, and the last version (finished 1817) is in the Pinacoteca Comunale, Forlì.
27. Bertel Thorwaldsen (1770–1844), Danish Neoclassical sculptor and Canova's main rival.
28. Johann Heinrich von Dannecker (1758–1841), German Neoclassical sculptor.
29. Canova executed two versions of the bust of *Giuseppe Bossi*, one in plaster at Possagno, the other in marble at Milan (Ambrosiana). Both are dated 1817.
30. Canova's self-portrait in marble of 1812 is at Possagno.
31. Two versions of the bust of Pope Pius VII exist, both dated 1807; the plaster model is at Padua and the bust in marble is in the Capitoline Museum, Rome.
32. The tomb of the two naval captains, Riou and Mosse, is by Rossi (1801) and that of General Moore by J. Bacon (1815).
33. Chantrey's bust of Scott (1820) is at Abbotsford, Roxburghshire.
34. Two versions of Thorwaldsen's bust of Byron exist, both of 1817.
35. It is impossible to be quite certain which picture Stendhal is referring to, but the most likely candidate seems to be the *Portrait of M. de Norvins*, in the National Gallery, London. Dated by Delaborde and Lapauze to 1811, this portrait was probably shown at the Salon of 1814, and might have been re-exhibited in 1824.

4. *The Salon of 1839*

1. Although this *Salon* is only a rapid survey in a letter (of 21 March 1839) to a friend, Mme Jules Gaulthier, it is worth quoting, partly because it shows that Stendhal retracted his earlier admiration for Horace Vernet, and partly for its attacks on the 'artisans of painting'. Soon after this, in his *Salons* of 1845 and 1846, Baudelaire was to endorse these criticisms of French painting.
2. Bengt Erland Fogelberg (1786–1854), Swedish Neoclassical sculptor.
3. Ary Scheffer, *Faust seeing Margaret for the first time*, possibly the picture mentioned by Bénézit in the Museum of Calais.
4. Vernet in fact exhibited four pictures of the *Siege of Constantine* at the Salon of 1839; all are now at Versailles.
5. Alexandre Gabriel Decamps (1803–60) exhibited eleven pictures at this Salon. The work referred to by Stendhal, *The Punishment of the Hooks*, signed and dated 1837 and shown at the Salon of 1839, is now in the Wallace Collection.
6. Hippolyte Flandrin (born Lyon 1809, died Rome 1864), pupil of Ingres. The picture of *Dante and Virgil* was shown at the Salon of 1836, and is now in the museum at Lyon. The *Saint Clair healing the blind* (Salon of 1837) is in Nantes Cathedral.

5. *Stendhal, Critic of the Critics*

1. Stendhal was in the habit of annotating the books in his possession, including his own novels. These marginal comments, published by H. Martineau in the *Mélanges intimes et Marginalia*, usually unflattering except towards a select few writers (notably Dubos and de Brosses), record Stendhal's immediate reactions to various treatises on aesthetics, including works by Burke, Richard Payne Knight and Winckelmann. Some of the following comments are from this source. The article on de Brosses, *La Comédie est impossible en 1836*, was intended as the preface to a new edition of the President's Letters prepared by Stendhal's cousin, Romain Colomb, in 1836 (published by Levavasseur); but Stendhal's remarks evidently displeased Colomb, and were not included in the edition.

2. De Brosses's correspondents. Jean-Baptiste de La Curne de Sainte-Palaye (1697–1781), born at Auxerre, philologist and archaeologist.

3. Lazare Carnot (1753–1823). Born at Nolay (Côte d'Or), a distinguished geometer. During the Revolution Carnot was a member of the Committee of Public Safety, and was exiled by the Restoration as a regicide.

4. Baron Louis-Bernard Guyton de Morveau (1737–1816). A chemist, native of Dijon.

5. Joseph-Jérôme de Lalande (1732–1807), astronomer and archaeologist, author of *Voyage d'un Français en Italie* (1769, 8 vols.).

6. Madame de Staël never wrote a work of this title. It is possible that Stendhal is referring to her *Considerations on the principal events of the French Revolution* of 1818.

7. Stendhal used the French translation of Schlegel's lectures by Madame Necker de Saussure.

8. Madame de Staël's novel *Corinne* (1807) does not contain a full description of the *Apollo Belvedere*; but it is mentioned briefly in Book VIII, in which Corinne takes her lover Oswald on a guided tour of the Vatican Museum.

6. *Travel Literature*

1. The statue of Louis XIV in the Place Bellecour, Lyon.
2. Vittorio Alfieri (1749–1803), Italian author of tragedies.
3. Canova, *The Farewell of Venus and Adonis* (1793–5), at Possagno.
4. Antoine-Denis Chaudet (1763–1810), French Neoclassical sculptor.
5. Arthur Young, author of *Political Arithmetic* (1774) and *Travels in France* (1792).
6. Simonde de Sismondi (1773–1842), Swiss historian and economist.
7. André Félibien (1619–95), *Entretiens sur les vies et les ouvrages des plus excellents peintres anciens et modernes*, Paris, 1666–88.
8. Stendhal's original English.

1.
Apollo Belvedere. About 350–320
B.C. Roman copy. Vatican Museum

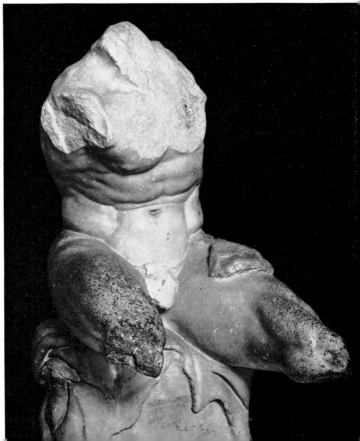

2.
Torso Belvedere. About 150 B.C.
Roman copy. Vatican Museum

3. Michelangelo: *The Last Judgement*. 1536–41. Fresco. Vatican, Sistine Chapel

4.
Raphael: *Madonna della Sedia*.
1514–15. Florence, Palazzo Pitti

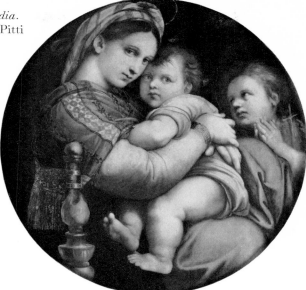

5.
Correggio: *Leda and the Swan*. About
1530. Berlin-Dahlem, Staatliche
Museen

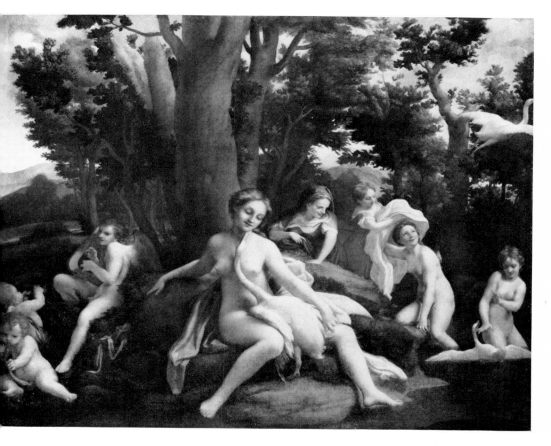

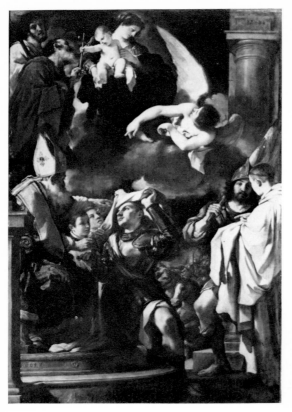

6.
Guercino: *St William of Aquitaine taking monastic orders*. 1620. Bologna, Galleria

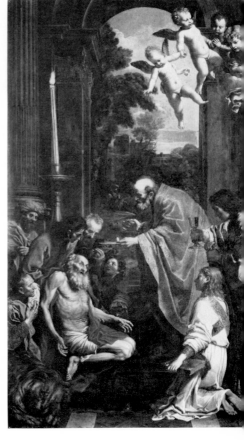

7.
Domenichino: *The Last Communion of St Jerome*. 1614. Vatican Museum. Stendhal constantly refers to this painting as a model for nineteenth-century French artists

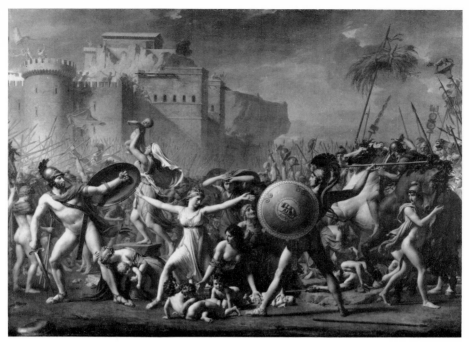

8. David: *The Sabine Women*. 1799. Paris, Louvre

9. Gros: *Napoleon visiting the plague-stricken at Jaffa* (detail). 1804. Paris, Louvre.
In Stendhal's eyes, the most outstanding achievement of recent French painting.

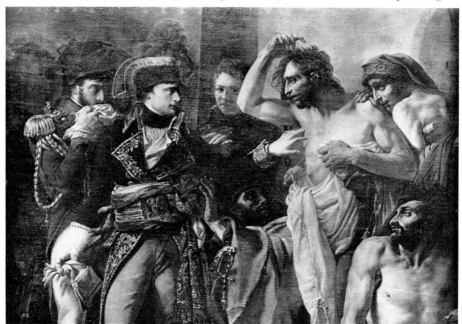

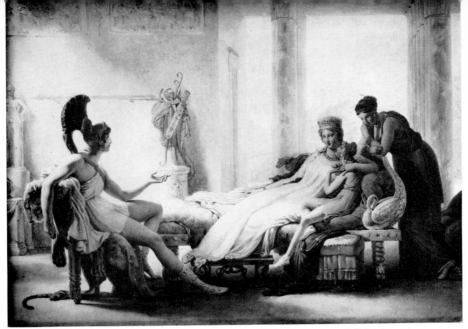

10. Guérin: *Dido and Aeneas*. Sketch for the large painting exhibited at the
Salon of 1817. Paris, Louvre

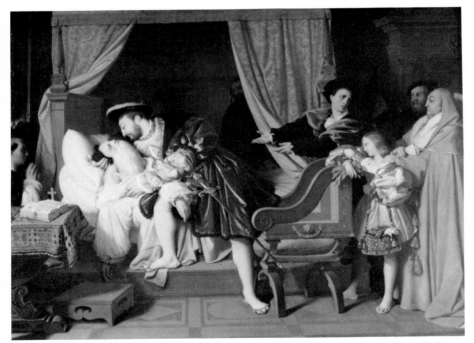

11. Ingres: *Death of Leonardo*. 1818. Exhibited Salon of 1824. Paris, Petit Palais

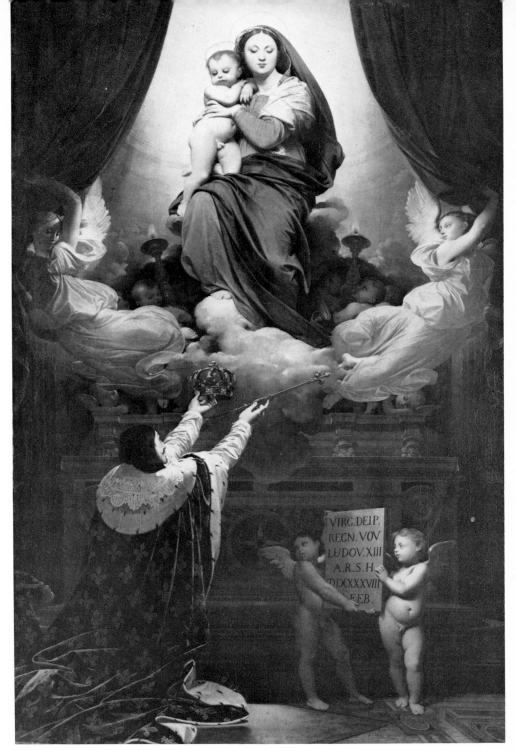

12. Ingres: *Vow of Louis XIII*. Exhibited Salon of 1824. Montauban, Cathedral

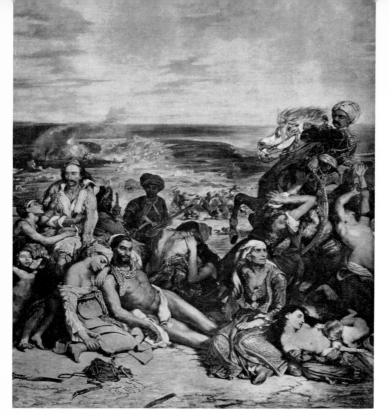

13.
Delacroix: *Massacre at Chios*. Exhibited Salon of 1824. Paris, Louvre

14.
Constable: *The Hay Wain*. 1821. Exhibited Salon of 1824. London, National Gallery

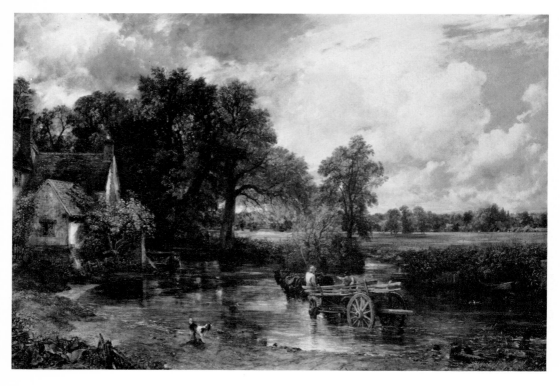

15. Turpin de Crissé: *View of Capri*. Exhibited Salon of 1824. Cologne, Wallraf-Richartz Museum

16. Turpin de Crissé: *Apollo and the Shepherds*. Exhibited Salon of 1824. On loan to the Museum of Carpentras

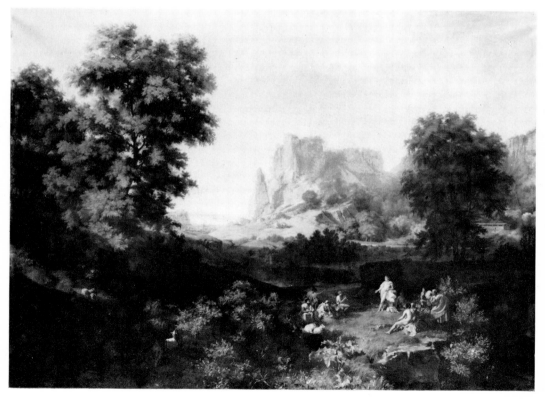

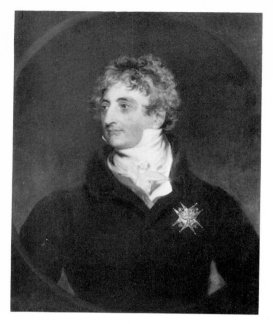

17.
Lawrence: *Portrait of Richelieu*. Exhibited Salon of 1824. Besançon, Musée Beaux-Arts. There is a larger version of this picture at Windsor Castle.

18. (*below left*)
Girodet-Trioson: *Portrait of General de Bonchamps*. Exhibited Salon of 1824. Cholet (Maine-et-Loire), Museum

19. (*below right*)
Girodet-Trioson: *Portrait of General Cathelineau*. Exhibited Salon of 1824. Cholet (Maine-et-Loire), Museum

20.
Gérard: *Corinne au Cap Misène*. 1819. Exhibited Salon of 1822. Lyon, Musée des Beaux-Arts

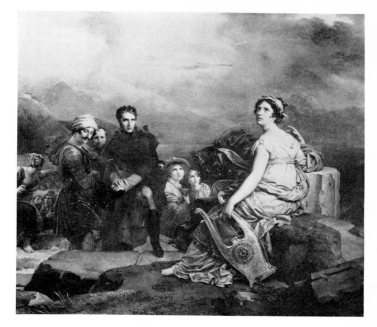

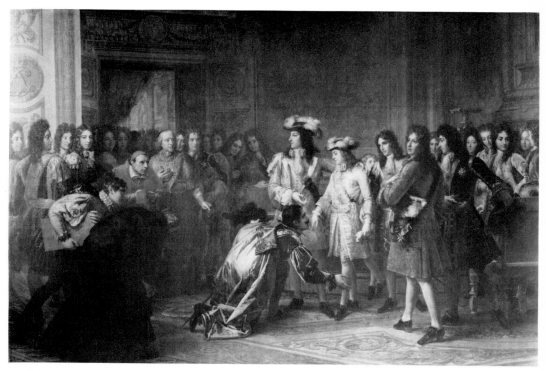

21. Gérard: *Philip of Anjou declared King of Spain*. Exhibited Salon of 1824. Versailles, Museum

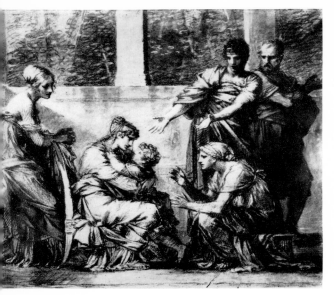

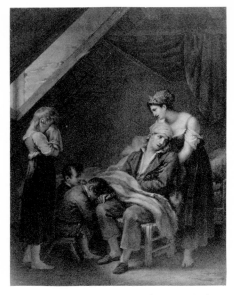

22. Prud'hon: *Andromache and Astyanax*. Paris,
Louvre. Study for the picture exhibited
(unfinished) at the Salon of 1824.

23. *The poverty-stricken family*. Litho-
graph by Lecomte after the painting by
Prud'hon exhibited at the Salon of 1822.

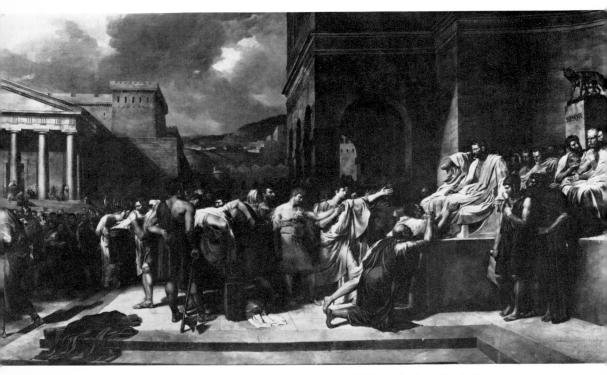

24. Lethière: *Brutus condemns his sons to death*. Exhibited Salon of 1812. Paris, Louvre

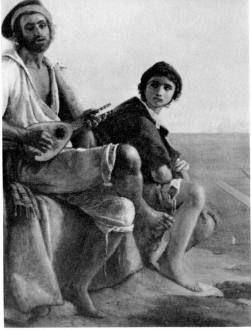

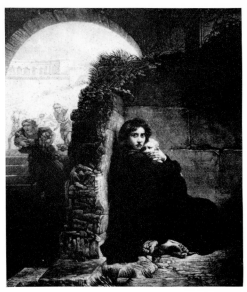

25. Robert: *The Neapolitan fisherman impro-vising at Ischia* (fragment). Exhibited Salon of 1824. Neuchâtel, Musée d'Art et d'Histoire

26. *Massacre of the Innocents*. Engraving by Lucas after the painting by Léon Cogniet exhibited at the Salon of 1824.

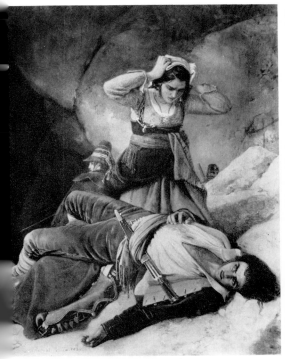

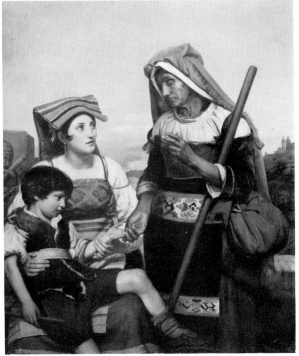

27. Robert: *The death of the brigand*. 1824. London, Wallace Collection

28. Schnetz: *The fortune-teller and the future Pope Sixtus V*. Exhibited Salon of 1824. Arras, Museum

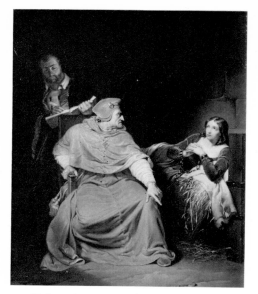

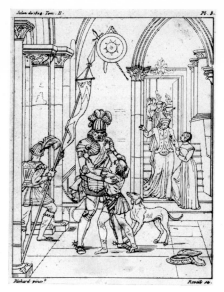

29. Delaroche: *Joan of Arc in prison.*
1825. London, Wallace Collection

30. *Louis de la Trémouille returning to the Château de Thouars.* Engraving by Reveil after the painting by Richard exhibited at the Salon of 1824.

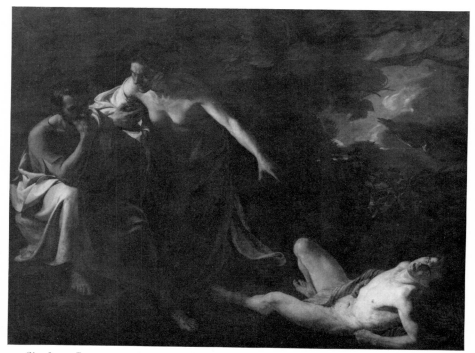

31. Sigalon: *Locusta trying out poison on a slave in front of Narcissus.* Exhibited Salon of 1824. Nîmes, Musée des Beaux-Arts. Inspired by Racine's *Britannicus.*

32. Scheffer: *Death of Gaston de Foix at Ravenna* (detail). Exhibited Salon of 1824. Versailles, Museum

33. Horace Vernet: *Battle of Montmirail* (detail). 1822. Exhibited Salon of 1824. London, National Gallery

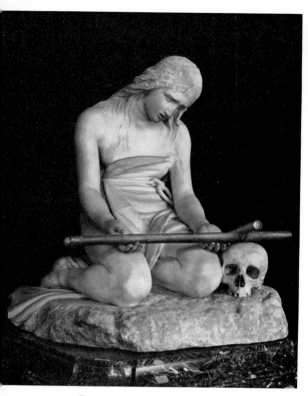

34. Canova: *Sommariva Magdalen.*
1796. Marble. Genoa, Palazzo Bianco

35. Thorwaldsen: *Night with her children, Sleep and Death.* 1815. Marble. Copenhagen, Thorwaldsen Museum

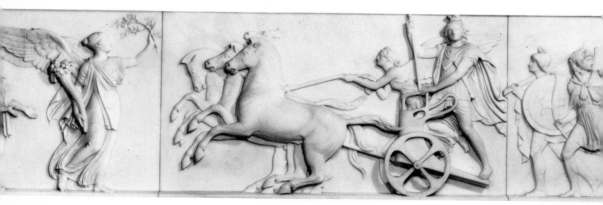

36. Thorwaldsen: *Alexander the Great's triumphal entry into Babylon.* Detail of marble frieze. Copenhagen, Thorwaldsen Museum. Modelled in 1812 for the Quirinal Palace to celebrate the expected visit of Napoleon to Rome.

Appendix

Short notes on some of the artists exhibiting in 1824

COGNIET, Léon (1794–1880)

History-painter and portraitist. Pupil of Guérin; won the Rome prize in 1817. The great reputation enjoyed by Cogniet dates from the vast canvas, *Marius on the ruins of Carthage* (Toulouse), exhibited in 1824. He is perhaps better known, though, for the *Tintoretto painting his dead daughter* (Bordeaux) of 1843, a melodramatic work which created a sensation when it was first shown; it strongly recalls Guérin's *Return of Marcus Sextus*, 1799. A perpetuator of the heroic Davidian style, Cogniet enjoyed great honours in his lifetime, with official commissions for decorations at Versailles and the Louvre. He was a Professor at the École des Beaux-Arts, and in 1849 became a Member of the Institut. He was an influential teacher, and among his many pupils was Léon Bonnat (1833–1922).

CRISSÉ, Turpin de (1781–1859)

Landscape and genre-painter, architect and antiquarian. A typical aristocratic amateur of the period, like the Comte de Forbin, he was both practising artist and museum administrator. Turpin de Crissé was well known in his own day for illustrated topographical books, notably the *Souvenirs de Naples* (1826), the *Souvenirs du vieux Paris* (1835) and *Le Moyen Âge Pittoresque* (1836). In addition he painted many individual landscape paintings, views of Rome, Tivoli, Pompeii, Naples etc., all of them executed in a precise, hard-edged style. His main exhibit in 1824, *Apollo and the Shepherds* (Plate 16), is clearly related to the late Claudian tradition, and stands in sharp contrast to the naturalistic landscape of Constable. Turpin de Crissé was Inspector-General of Fine Arts, and left his collection of antique bronzes and medallions to the Musée Pincé at Angers.

GRANET, François-Marius (1775–1849)

The son of a stonemason in Aix-en-Provence, Granet first studied at the Drawing Academy of Aix, then from 1799 to 1801 under David in Paris. In 1802 he left Paris with his friend Forbin for Rome, where he discovered the beauty of classical ruins, and in 1813 he became a member of the Academy of St Luke. With his scenes of monks, cloisters and sombre vaulted passages, Granet quickly rose to be one of the most popular artists of his generation; his formula combined the advantages of Mediterranean beauty with the poetry of religion. At the same time Granet shared the early nineteenth-century fondness of idealizing artists of the past: examples are *Stella tracing an image of the Virgin on the walls of his prison*

of 1810 (Pushkin Museum, Moscow) and a *Death of Poussin* (Aix-en-Provence), shown at the Salon of 1834. Both these paintings are reproduced in the article by Francis Haskell, 'The Old Masters in nineteenth-century French painting', *The Art Quarterly*, Vol. XXXIV, No. 1, 1971. In the latter half of his career Granet held various official posts, including the Directorship of the Galeries Historiques at Versailles. During the 1840s he showed his supremacy as a landscape-painter in a series of remarkable, impressionistic sketches of the countryside around Paris. Granet's appearance is familiar from Ingres's famous portrait showing the artist as a young man against the Roman background.

The picture exhibited in 1824 of *Domenichino and Cardinal Aldobrandini* has not yet come to light, but an idea of it may be obtained from the engraving published by Landon (*Annales du Musée, Salon de 1824*, vol. I). There is also a preliminary sketch for it in the Cabinet des Dessins of the Louvre. (Cat. Vol. VI, No. 4349.)

LETHIÈRE, Guillaume (1760–1832)

Born in Guadeloupe, Lethière came at an early age to Paris, where he studied under Doyen. After winning second prize, he was sent to Rome in 1784, where he stayed until 1788. In 1807 he was appointed Director of the French Academy in Rome. One of the most orthodox painters in the classical tradition, in subject-matter and style his work follows closely in David's footsteps, and there is an obvious affinity between the *Brutus condemning his sons to death* (Louvre), exhibited in 1812, and David's own *Brutus*. Another example of Lethière's belated Neoclassical manner is the *Death of Virginia* (also in the Louvre) of 1828.

PUJOL, Abel de (1785–1861)

The son of Alexandre de Pujol, founder of the drawing-school in Valenciennes. His first picture won him David's admiration, who took him into his studio. With his *Lycurgus* he won the Prix de Rome in 1811, but bad health soon forced him to return to Paris. After the success of a *Britannicus* (1814) (Museum of Dijon), he obtained regular commissions, and was awarded all the usual official recognition. He replaced Gros at the Institut, and participated in the formation of the Musée de Versailles. He was also responsible for the decoration of the Salle des Antiquités Égyptiennes in the Louvre in 1827. Abel de Pujol was a good example of the conscientious David pupil, producing the kind of art praised by Delécluze in the *Journal des Débats* and condemned by Stendhal.

RICHARD, Fleury François (1777–1852)

Together with his almost exact contemporary, Pierre Revoil (1776–1842), Richard was the typical representative of the so-called Troubadour style, which flourished in France in the first two decades of the nineteenth century. By 1824 the novelty of the genre was already beginning to wear off, and Stendhal's criticisms reflect a general dissatisfaction with its polished, miniaturist qualities. Like Revoil, Richard originated from Lyon: in Paris, he studied under Grognard, then, in 1796, under David. Inspired by Alexandre Lenoir's *Musée des Monuments français*, Richard's pictures mark the beginning of the Romantic vision of the Middle Ages, and when his *Valentine de Milan* was first shown at the Salon of 1802 it immediately became an enormous, popular success. Until his last exhibit in 1846 Richard continued to exploit the genre, with subjects drawn from romance and many periods of French history: François I (Salon of 1804), Bayard, Henri IV with Gabrielle d'Estrées (both Salon of 1810) etc. In all of his pictures there is a deliberate intention of illusionistic effect, and the small, mannered figures often appear secondary to the accessories and architectural setting.

ROBERT, Léopold (1794–1835)

Of Swiss birth, Robert began life as a business employee and only later turned to painting. He came to Paris in 1810 to study engraving, and a year later entered David's studio. Unable to compete for the Prix de Rome on account of his nationality, he returned to Switzerland in 1816 and earned a living by painting portraits. Finally, in 1818, with the support of a Swiss patron, he was able to realize his longing to live and work in Italy. Henceforward this country was to provide the inspiration for all his work, and his numerous scenes of Italian peasants, brigands and fishermen against a Roman or Neapolitan background won him universal fame and success.

For the Salon of 1822 Robert intended to exhibit a version of *Corinne improvising on Cape Miseno*, but he was unable to complete the two central figures and changed it into the *Neapolitan Fisherman* of 1824. His most ambitious project was a cycle of the seasons, allegorized by the different activities of four Italian cities: spring in Naples was the subject of the first, *The Return from the Pilgrimage* (1827); summer in Rome of the second, *Harvest in the Pontine Marshes* (1830); autumn in Florence of the third, *Vintage Time*; and winter in Venice of the last, the *Carnival*. But the last two were never completed, for the painter fell victim to a disastrous passion for the Princess Charlotte Bonaparte, which finally drove him to commit suicide. Robert was one of the great popular favourites of his own

day with critics of all tendencies, partly because of his exotic subject-matter, and because he seemed to combine 'correct' drawing with the appeal of bright colour. Later in the nineteenth century, the tragic element in Robert's life was to exert a strong fascination over the writer Maurice Barrès (*La Mort de Venise*, in *Amori et Dolori Sacrum*, 1903).

The main work by Robert exhibited in 1824, *The Neapolitan Fisherman*, was destroyed by fire in 1871; all that remains of it is the central fragment (Plate 25). This, and many other paintings by Robert, are in the Museum at Neuchâtel, except for the two remaining Seasons, both of which are in the Louvre. (Bibliography: E.-J. Delécluze, *Notice sur la vie et les ouvrages de Léopold Robert*. Paris, 1838.)

SCHEFFER, Ary (1795–1858)

Born in Dordrecht, the son of a painter of German origin, Scheffer showed precocious talent and first exhibited in 1805. In 1811 he entered Guérin's studio in Paris, and thereafter continued to work and exhibit in France. During his own lifetime, Scheffer owed his popularity to sentimental genre subjects with such titles as *The Soldier's Widow* and *The Sister of Mercy*. The rest of his work is inspired either by history, including the two pictures of 1824, *Gaston de Foix* (Plate 32) and *St Thomas Aquinas preaching during the tempest* (Dordrecht), which won for Scheffer a doubtful place among the Romantics, or by literature, notably many different versions of *Paolo and Francesca* from Dante, and scenes from Goethe's *Faust* (e.g. *Margaret at the Well*, 1858, Wallace Collection). Scheffer's reputation has suffered most, perhaps, from such pictures as *Saints Monica and Augustine* (Tate Gallery), exhibited in 1846, which caused Baudelaire to dismiss the painter as one of the 'Apes of Sentiment'. But Ernest Renan, more favourably disposed to Scheffer, admired his *Temptation of Christ* as the appropriate expression of an enlightened mid-nineteenth-century religious temper (*Études d'histoire religieuse*, 1857. Renan, *Oeuvres Complètes*. Paris, Calmann-Lévy, Vol. VII).

SCHNETZ, Victor (1787–1870)

Schnetz first studied under Regnault, then under David. He began by exhibiting classical subjects in the manner of David, but after about 1820 turned to modern history and Italian rural life. Together with Léopold Robert, with whom he was always associated in his own lifetime, Schnetz is the typical eclectic artist of the period, who managed to satisfy nearly all the critics. While his subject-matter is

usually of the Romantic historical kind (e.g. *Charlemagne receiving Alcuin*), his style conforms to the Davidian requirements of clear outlines and fully modelled contours. After some prominent exhibits at the Salons in the 1820s, Schnetz executed a number of mural decorations for various Paris churches, including Notre-Dame de Lorette and Saint-Séverin. He finished his career as Director of the Académie de France in Rome. Stendhal did not hesitate to place Schnetz in the first rank among contemporary painters, and his prediction that the artist would still be admired in a hundred years' time has not proved correct.

Of the principal works by Schnetz mentioned by Stendhal, the *Saint Genevieve distributing alms to the poor* was commissioned by the Ministry of the Interior, exhibited at the Salon of 1822, again in 1824, and allocated to the church of Notre-Dame de Bonne Nouvelle in Paris, where it now hangs. *The fortune-teller and the future Pope Sixtus V* (Plate 28), shown at the Salon of 1824, was bought the same year by the Comte de Forbin for the Collection of Charles X; it then passed from the Luxembourg to the Louvre, and has recently been sent to Arras. The *General Condé at the Battle of Rocroy* (Salon of 1824) is at Versailles. (Bibliography: *Notice sur Victor Schnetz* par M. Beulé. Institut de France, Académie des Beaux-Arts, 1871.)

SIGALON, Xavier (1787–1837)
A native of Uzès (Gard), Sigalon first studied at the local Drawing Academy at Nîmes, then in Paris under Guérin and Souchot. The *Locusta and Narcissus* (Nîmes) of 1824 (Plate 31) received a mixed reception, but was generally praised by critics sympathetic to the Romantic cause. But the appearance of Sigalon's *Athalie* in 1827 was greeted with such violent abuse that the painter lost heart and returned to Nîmes to earn a living as a portrait-painter. He was, however, remembered by Thiers, who, as a Minister in Louis-Philippe's government, commissioned from him a copy of Michelangelo's *Last Judgement* (in the École des Beaux-Arts). Sigalon was one of the most promising artists of the 1820s, and might have become a great painter if his career had not been so abruptly terminated.

Select Bibliography

I. WORKS BY STENDHAL

Letters:

Correspondance Edited by H. Martineau and V. Del Litto. 3 vols. Paris, Éditions de la Pléiade, 1968.

Fiction:

Armance, ou quelques scènes d'un salon de Paris en 1827. Paris, 1827.

Le Rouge et le Noir, Chronique du XIXe Siècle. Paris, 1831.

Lucien Leuwen, written 1834–5. Paris, 1855.

La Chartreuse de Parme. Paris, 1839.

These four novels, together with the *Chroniques Italiennes, Lamiel* and various unfinished fragments, are now most conveniently available in the *Romans et Nouvelles*, edited by H. Martineau. 2 vols. Paris, Édition de la Pléiade, 1959.

Autobiography and criticism:

Œuvres Intimes (*Vie de Henry Brulard, Journal, Souvenirs d'égotisme, Essais d'autobiographie* etc.). Edited by H. Martineau. Paris, Éditions de la Pléiade, 1955.

Histoire de la Peinture en Italie. Paris, Didot, 1817. Edited by Paul Arbelet. 2 vols. Paris, Champion, 1924.

Rome, Naples et Florence. Paris, 1817. Edited by H. Martineau. Paris, Le Divan, 1956.

Racine et Shakespeare. Paris, 1823. *Racine et Shakespeare No. II, ou réponse au manifeste contre le romantisme prononcé par M. Auger*. Paris, 1825. Edited by P. Martino. 2 vols. Paris, Champion, 1925.

Vie de Rossini. Paris, 1824. Edited by H. Prunières. 2 vols. Paris, Champion, 1923.

Mélanges d'art (*Salon de 1824; Des beaux-arts et du caractère français* etc.) Edited by H. Martineau. Paris, Le Divan, 1932.

Promenades dans Rome. Paris, 1829. Edited by A. Caraccio. 3 vols. Paris, Champion, 1938–40.

Mémoires d'un touriste. Paris, 1838. Edited by L. Royer. 2 vols. Paris, Champion, 1932.

Écoles italiennes de peinture. Edited by H. Martineau. 3 vols. Paris, Le Divan, 1932.

Pensées. Filosofia Nova. Edited by H. Martineau. 2 vols. Paris, Le Divan, 1931.

Mélanges de Littérature. Edited by H. Martineau. 3 vols. Paris, Le Divan, 1933.

Mélanges intimes et Marginalia. Edited by H. Martineau. 2 vols. Paris, Le Divan, 1936.



II. LIFE AND ASSESSMENT OF STENDHAL

Arbelet, P. *L'Histoire de la peinture en Italie et les plagiats de Stendhal*. Paris, 1914.

Barrès, Maurice. *L'Automne à Parme*, 1893. Collected in *Du Sang, de la volupté et de la mort*, Paris, 1895.

Bourget, Paul. *Essais de psychologie contemporaine*. Paris, 1885.

Brookner, A. *The Genius of the Future*. Studies in French art-criticism. London, 1971. Chapter on Stendhal.

Del Litto, V. *La vie intellectuelle de Stendhal*. Paris, 1958.

Giornate Stendhaliane: Catalogo della Mostra. Parma, 1950.

Hemmings, F. W. J. *Stendhal: a study of his novels*. Oxford, 1964.

Jourda, P. 'L'Emotion stendhalienne et le Corrège.' *Études Italiennes*, 1934.

Levin, H. *The Gates of Horn*. New York, 1963. Chapter III on Stendhal.

Martineau, H. *L'Oeuvre de Stendhal*. Paris, 1951.

Mérimée, Prosper, *Portraits historiques et littéraires*. Edited by P. Jourda. Paris, 1928. Text of 'H.B.' first published in 1850.

Natoli, G. *La peinture italienne et les personnages de Stendhal*. Journées stendhaliennes internationales de Grenoble, 1955.

Prévost, J. *La Création chez Stendhal*. Editions du Sagittaire, Marseille, 1942.

Seznec, J. 'Stendhal et les peintres bolonais.' *Gazette des Beaux-Arts*, 1959. VIe période, No. 53.

Starzynski, J. *Du romantisme dans les arts*. A selection of Stendhal's art-criticism in French, with introduction. Editions Hermann. Paris, 1966.

Taine, Hippolyte. *Nouveaux essais de critique et d'histoire*. Paris, 1865.

Tillett, M. *Stendhal: The Background to the Novels*. Oxford University Press, 1971.

III. BACKGROUND

Baschet, R. *E.-J. Delécluze, Témoin de son temps 1781-1863*. Paris, 1942.

Boyer, F. *Le monde des arts en Italie et de la France de la Révolution et de l'Empire: études et recherches*. Turin, 1969.

Delécluze, E.-J. *Journal 1824-28*. Edited by R. Baschet. Paris, 1948.

——. *Louis David, son école et son temps*. Paris, 1855.

Folkierski, W. *Entre le classicisme et le romantisme*, Paris, 1925.

Gilman, M. *Baudelaire the critic*. New York, 1943.

Gould, C. *The Trophy of Conquest*. London, 1965.

Grate, P. *Deux critiques de l'époque romantique*. Stockholm, 1959.

Hautecœur, L. (editor) *Le Romantisme et L'Art*. Paris, 1928.

Hubert, G. *Les sculpteurs italiens en France 1790–1830*. Paris, 1964.

Jacoubet, H. *Le genre Troubadour et les origines du Romantisme*. Paris, 1929.

Jal, A. *L'Artiste et le Philosophe: Salon de 1824*. Paris, 1824.

——. *Esquisses, croquis, pochades ou tout ce qu'on voudra sur le Salon de 1827*. Paris, 1827.

Landon, C. P. *Annales du Musée: Salon de 1824*.

Martino, P. *L'Époque romantique en France, 1815–30*. Paris, 1944.

May, G. *Diderot et Baudelaire, critiques d'art*. Geneva, 1957.

Rosenthal, L. *La Peinture romantique*. Paris, 1900.

Index